First published 2009 by
Liverpool University Press
4 Cambridge Street
Liverpool L69 7ZU
and
the Bluecoat
School Lane
Liverpool L1 3BX

ISBN 978-1-84631-083-6

British Library Cataloguing-in-Publication data
A British Library CIP record is available

Designed by March Graphic Design Studio, Liverpool
Printed and bound by Gutenberg Press, Malta

Front cover, Martin Creed's Martincreedworks exhibition at the Bluecoat, 2000.
Back cover, Dhruva Mistry's red concrete Indian sacred bull, *Sitting Bull* (1984),
originally commissioned for the Liverpool International Garden Festival, now
sited at Otterspool. Photographed by Angela Mounsey.

The City of Liverpool

ART IN A CITY REVISITED

Edited by Bryan Biggs and Julie Sheldon

the Bluecoat.

Contents.

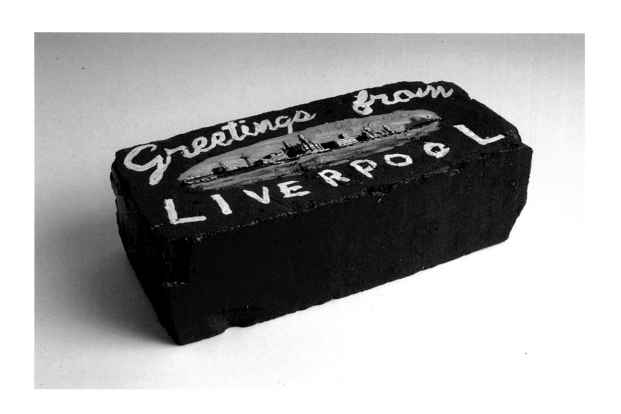

Introduction. Bryan Biggs and Julie Sheldon.

In 2007 Liverpool University Press and the Bluecoat re-published John Willett's study into visual art in Liverpool, *Art in a City*. It seemed timely, forty years after the book first appeared, to bring it once again into circulation. The year of its re-publication was Liverpool's 800th birthday, a time of reflection for a city that had recently been awarded the designation of World Heritage Site by UNESCO, but also a period of anticipation as plans took shape for celebrating European Capital of Culture the following year. Publications such as *Liverpool 800: Culture, Character and History*, edited by John Belchem, with their focus on Liverpool's heritage and its cultural development, provided an historical context for 2008, a backdrop against which the year's programme would be played out. The re-publication of *Art in a City*, with its focus on a specific aspect of the city's culture – its visual arts environment in the 1960s – was therefore pertinent in that it provided a useful overview and set of arguments about how Liverpool could engage with contemporary art.

The introduction to the new edition of Willett's book was entitled 'Art in a city is not a static affair', a quote from the author, whose belief in Liverpool's potential to have a significant relationship to art, particularly through public art, has proved prescient. For since the book's initial publication in 1967 much of Willett's vision for the visual arts in the city has been achieved, and to an extent his expectations have been exceeded. The city now boasts a visual arts infrastructure unrivalled in the UK outside London; artworks in the city's public realm are a common feature; and art is increasingly part of everyday life for local people through participation and education programmes

Leo Fitzmaurice, *Brick*, 1994, painted brick.

(Image courtesy of the artist)

John Willett, *Art in a City*, published 1967 by Methuen for the Bluecoat Society of Arts. The book was republished in 2007 by Liverpool University Press in association with the Bluecoat.

provided by the Liverpool Biennial, the Bluecoat, FACT, Tate Liverpool, National Museums Liverpool and other institutions and agencies. So changed is the cultural fabric of the city that it seemed appropriate to revisit *Art in a City* and look at the infrastructure for visual art today and the issues it faces – hence this companion volume. And like its predecessor, while the thrust of the new book is rooted in the local, it also looks outside this context to connect with agendas beyond the city, touching as it does on broader themes such as cultural policies of government, art as a tool for urban regeneration, shifts in art education, and artists' practice in the era of globalisation.

As an analysis of the prospects for contemporary art in a provincial English city, *Art in a City* remains a seminal work. It influenced later research into art's relationship to place and to society, despite its focus on one city, Liverpool. The book began as a study commissioned from Willett by the Bluecoat Society of Arts in 1962 into the impact of art on the port, from its mercantile heyday when its wealth was used to establish institutions such as the Walker Art Gallery, through to the 1960s when Liverpool attracted global attention through its export of the cultural phenomenon of the Beatles. Willett, as assistant editor of *The Times Literary Supplement* and known principally as the leading English-speaking scholar and translator of Bertolt Brecht (and not perhaps an obvious choice for the job), was invited to come up with a plan of action for how art might more strategically and effectively be supported in the city. His assignment was not only to make recommendations for how the Bluecoat could develop its role nurturing contemporary artists, but also what form patronage by the local authority might take. Willett envisaged a lead role here for the city council in commissioning public art, improving the quality of both design in the city and art education, and generally developing a wide public appeal for new art, for which a commercial market would grow.

Frustratingly, however, the blueprint set out at the end of *Art in a City* was not taken up, though some of the recommendations were eventually realised, somewhat circuitously, and emerging from a very different set of circumstances than those that Willett

ART IN A CITY

John Willett

experienced during his research. Ambitious public art in the city, for instance, happened not as a result of local authority daring or aesthetic enlightenment, but through the initiative of arts organisations and the process of urban regeneration, aided by the availability of substantial public funding, regional, national, and in some cases European (Merseyside was awarded EU Objective One status in 1994). Willett identified the sizeable gap between art and everyday life as the problem to be addressed in his study, and the changing demographic over the past forty years of visitors to museums and galleries, and a broadening of the social base of those interested in contemporary art, came not from any paternalistic, top-down measures for working-class improvement. It came about instead through curriculum development in the teaching of art, coupled with an explosion in arts participation activity provided by arts organisations working both in partnership with schools and outside formal education. Under pressure to demonstrate greater access to their work, such publicly funded institutions have also moved in this direction in response to a growth in artists working in the area of socially engaged practice. Liverpool, whose arts venues, particularly its visual arts ones, were among the first to develop programmes of artists working with communities, has provided a fertile environment for arts participation, a subject worthy of an in-depth study that is beyond the scope of this book.

Willett's advocacy that Liverpool should utilise contemporary art in the public sphere, even employ it to articulate the city's hopes and aspirations, is starting to be realised, while the city's potential to become a distinctive locus for contemporary art is now reflected in the international standing of this offer. It is worth revisiting Willett's chapter headings and his concluding plan of campaign, since it was by measuring today's visual arts situation in Liverpool against these that the scope of *Art in a City Revisited* was mapped out. In his opening chapter, 'Problem and Place', Willett set out to challenge approaches to art that set it uncritically on a pinnacle:

> ... starting at the bottom, taking a single city and
> trying to establish the past importance, present

function and future potentialities of the visual arts there. It takes the situation on the spot, with its art institutions, its local artists, its factories, buildings and people, and relates what it finds there to the problems of patronage in our own country and in comparable cities abroad, setting the whole in the framework of 150 years of argument about Art and Society. It is a new approach for artist, architect, planner, social scientist and local politician alike, and could well spark off further investigations of the same kind.

Willett's underlying thesis that art and society cannot be separated, and that production and consumption of art are inextricably linked, has become increasingly central to cultural agendas over the past forty years. We therefore felt that a study of art in Liverpool today could usefully take up some of the themes of *Art in a City* with its unconventional art history relating art to place, to see what lessons could be learned from Liverpool's experience of engaging with contemporary art.

Though this new volume further investigates the subject of Willett's enquiry, it is different in its approach and does not claim to cover the same territory. In other words it is not an update of *Art in a City*, from which it differs in several respects. First, it comprises essays from several writers rather than a single authorial voice, to give multiple points of view. Academics, researchers, curators and artists have been invited to contribute based on their expertise in a particular area that relates in some way to Willett's chapters, and they include writers based locally, from the rest of the UK, and abroad, their responses ranging from detailed focus on the Liverpool context to more global perspectives. Secondly, although this volume allows us to see how the cultural landscape has shifted since the 1960s, it is not a mapping exercise of all that has happened in the fortunes of visual art in the city over the past forty years – there are useful accounts contained in the bibliography, such as the *Factor* series, which tells the story of FACT, or the publication for Tate Liverpool's *Centre of the Creative Universe* exhibition, while Willett's second chapter,

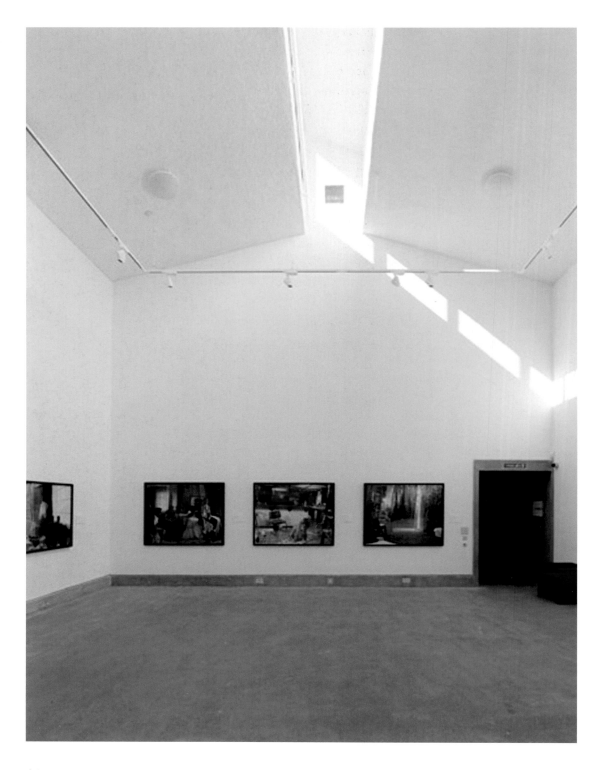

Introduction. Bryan Biggs and Julie Sheldon

'Views of the Past', remains an excellent introduction to the city's patronage, public collections and its artists and institutions up until the mid-1960s when he finished his research. And thirdly, the book does not offer a set of aspirations for the years ahead, even less a plan of action. Instead *Art in a City Revisited* presents a snapshot of art today in Liverpool and issues that concern it and connect it to wider agendas. It investigates some of the circumstances that gave rise to visual art's pre-eminence as an art form among the city's cultural offer in 2008, and how it might develop post-Capital of Culture.

Nine artists, writers, curators and researchers have revisited Willett's findings for this book, in order to uncover how far the visual arts have developed since the late 1960s in Liverpool, against a changing backdrop of economic decline through to current regeneration. Sarah Selwood reviews Willett's conclusions of 1967 and asks how firmly the burgeoning of visual arts is embedded in Liverpool's renaissance. Raising the 'chicken or egg' question of which came first, the city's transformation or the burgeoning of Liverpool's visual arts, she assesses the city's losses and gains since 1967. Selwood raises the vexed question of measuring intangible culture, garnering statistics, government reports and impact studies to examine the increasing political influence on funding agendas for the arts to be more accountable in delivering on social outcomes. Leaving open to speculation the question of how Liverpool will retain its position as an 'Art City' when that status is heavily reliant upon public subsidies, Selwood draws upon economic forecasts to predict that the future will be a difficult one for the visual arts.

Pam Meecham looks at visual art as a regenerative tool, tracing the change in local and national attitudes, looking in particular at the view that regeneration is a process that should engage sections of the community with their own regeneration. Arguing that what works best should not be a blueprint developed centrally, standardised and disseminated to other regions and urban centres, Meecham asks what role the arts and culture more generally can or should play in regeneration, especially in a city where there has always been a history of strong civic art

Variable Capital exhibition, showing works by Larry Sultan, in the new gallery at the Bluecoat designed by Biq Architecten, Rotterdam, 2008.
(Photograph, Stefan Müller)

institutions that have been more than just tourist venues and have a long and productive history of use by local communities, schools and colleges. Meecham argues that it was not the culture of Liverpool that was in need of rejuvenation but the solid infrastructures such as transport, schools, housing and employment. Finally Meecham looks back at other attempts at using sculpture in renewal (in particular reviewing the International Garden Festival of 1984) and also at the arrival of Tate Liverpool in 1988 to see what might be learned from the local and international, suggesting that arts' role in regeneration may be to individualise increasingly homogenised, corporatised city centres.

Liverpool now occupies an important position as a visual arts centre, regionally, nationally and internationally, and claims to be the 'most significant UK centre for art outside London'. This positioning is assessed by Lewis Biggs, particularly in a UK context, where the centres of economic power, the media and the art world remain firmly fixed in London. Biggs examines the key institutions that make up the Liverpool visual arts infrastructure: Biennial, the Bluecoat, FACT, Open Eye, Tate Liverpool, Walker/NML and now Greenland Street, and their impact both within and beyond the city. Drawing upon Willett's prescient claim that the visual arts had intrinsic as well as instrumental value, what he called 'an indelible human habit', Biggs explores Willett's ideas for the visual arts as an instrument of action. Amid the growth in the number of institutions in Liverpool Biggs observes a growing interrelation between arts organisations in the last twenty years, augmenting and supplementing Willett's 'main framework'. He acknowledges that such collaboration 'does not appear to have come easily' but is sanguine about the city's healthy art ecology, largely on the grounds that 'individuals, not institutions ... make institutions work'. However, Biggs points to the proliferation of exhibition spaces and cheap accommodation for artists as a crucial motor of continued success. He remains pessimistic, however, about the likelihood of Liverpool ever creating a vibrant market for art, but upbeat about the twin presence of gallery-based and agency models of its institutions.

Sean Cubitt discusses the connections between Merseyside and the rest of the world: the relationships between the local and the global, connections forged through trade, media communications and disease. Appealing to writers such as Sassen and de Duve, Cubitt argues that cities are the new frontier. Drawing upon de Duve's notion of the distinction between the *glocal* (marked by exchanges between city-based institutions and the global art scene) and the global, Cubitt asserts that if there is to be a new global public, then it will emerge from encounters between locals and locales. In Cubitt's view, Liverpool is distinctively placed in this respect and he notes the 'informal politics' of Liverpool's art and culture scenes that lead it to resist the 'top-down globalising' imperatives that dominate planetary affairs, for 'the bottom-up transnations of hip-hop and electronic beats, literary and cultural translations'. Discussing projects such as the Liverpool Big Screen and *tenantspin*, Cubitt suggests that projects in Liverpool have had the capacity for engaging local communities and being internationally networked.

Nina Edge shares Cubitt's assertion that being in Liverpool is being in the world. In an interview with Robert Knifton, Edge describes her engagement with the city and with the processes of its regeneration. The six Liverpool-based artists interviewed by Knifton share the belief that they work from a city which permits them to be networked to a globalised art community. Most share perspectives on artists' practices, the spaces they work in, the need to reach beyond the local and connect with global ideas, and the critical impulse of questioning and exploring identity and place through their work. Alan Dunn sees himself 'as making work about and principally for Liverpool … bringing in a global perspective on the local'. Leo Fitzmaurice explores the everyday, addressing the conditions of urban existence in a local and global context. Pete Clarke's politically engaged art practice revisits modernist art strategies to explore Liverpool's simultaneous cosmopolitanism and isolationism. Paul Rooney adopts narrative forms, such as songs and stories, to present the voices of marginalised figures in society. And Imogen Stidworthy draws upon rich local vernacular to explore aspects

of community and communication. Collectively, Knifton's interviews contribute to a snapshot of current art practice in the city, articulating the hopes, dreams and fears of some of its best-known artists.

Mary Jane Jacob considers the local affection for public art in the city in a discussion of the changing nature of public art, in a climate where artists' practice has shifted from the permanent to more process-based, temporary, site-specific approaches. Referencing public art commissions and programmes in Liverpool, Jacob demonstrates how a public art piece can be simultaneously evocative of place and people, and how meanings are accrued and invested into it by successive audiences. Looking at *Another Place* on Crosby Beach, Jacob argues that public art is a site for a coupling of place and of people. She examines the twin imperatives of consensus and collaboration in the public art from the 1990s, showing how previously unpalatable truths about colonial history have been revisited to allow for multiple readings. The emergence of a robust public education programme in museums and galleries and the arts sector by the 1990s made the relevance of art to the lives of gallery visitors a crucial aspect. Jacob cites the growth of site-specific and constituent-specific projects in Liverpool to show the best aspects of public art.

Julie Sheldon examines the provisions for art education in Liverpool, examining key pedagogic shifts since the 1960s aligned to development in creative practice and cultural policy. She examines the substitution of 'education' in the museum and gallery sector by terms such as 'learning', 'inclusivity', 'participation', 'interpretation' and 'access'. Examining the pioneering work in Liverpool's cultural organisations, she demonstrates how debates about audience, access and the changing nature of visual arts practice have come to reinvigorate and inform best practice.

Cathy Butterworth pursues John Willett's assertion that Liverpool is a city that engenders interdisciplinarity in the arts and permits artists to work across boundaries. Reviewing collaborative and multi-media events such as those hosted by the Bluecoat, she argues that Liverpool was an important constituent

in the development of a British live art scene. Looking at live art practice since the 1970s, Butterworth shows how its chief proponents in the city resisted the 'institutionalising' tendencies of other cities (most notably those where live art was allied to art schools) to develop an autonomous and distinctive art form that transformed artists and audiences into active participants in visual culture, with a rich variety of contexts and voices.

Colin Fallows asks thirty people about the sustainability of the visual arts sector post-2008. Is European Capital of Culture the beginning or the end, and what needs to be in place to protect and sustain what we now have? Their responses provide an insight into the thoughts of artists, curators, writers, academics and cultural commentators about Liverpool's status as an 'art city' and their predictions for the future potential for the visual arts in Liverpool.

Collectively these essays discuss the unique characteristic of the arts scene in Liverpool – its development of encounters between and among institutions, individuals and its commerce with global and national culture. The particularity of the arts scene in Liverpool, informed by local politics, functions in several ways, most meaningfully perhaps as mediations between the local and the global. Although the writers recognise, as Cubitt puts it, that Willett was 'the intellectual captive of his generation', each has found much to commend him to the history of the arts in Liverpool. He was remarkably prescient in his comments and despite his occasionally outdated language he finds, as Cubitt puts it, 'a way to be visionary in that grim post-war reconstruction that was still incomplete in the 1960s'.

Art in a City was written in the context of the city's redevelopment plans of the 1960s and coincided with Liverpool Corporation's recognition that in tackling the wartime dereliction still visible in the city, there lay the prospect of physical and spiritual renaissance (though the following decades witnessed evaporation of such hopes as the city underwent a spiral of decline). Today the city's leaders are again optimistic about its future, exemplified by the major regeneration of its central area, re-branded Liverpool One, a more profound re-

shaping of the retail core than the largely unrealised 1960s plan of Shankland and Bor. It could be argued that this latest commercially driven development represents a missed opportunity to integrate the sort of ambitious public art that Willett called for. Imagine, for instance, the impact had a percent-for-art scheme been in place in the city when this multi-million pound scheme was being developed. Instead it has been left to predominantly publicly funded initiatives just outside the new retail area, such as Richard Wilson's temporary intervention *Turning the Place Over* or Jorge Pardo's permanent sculpture *Penelope*, to enliven central Liverpool's public realm with contemporary art, alternatives to the bland landscaping and generic street furniture found elsewhere. And it is not just public art, but also the development of institutions to house and present new art, that reflects an increasing dependence of the sector on state funding, a trend that is discussed here, with Liverpool very much a barometer of the changing nature of UK arts funding.

Willett highlighted the contrast between earlier patronage in the city in the nineteenth century and the absence of contemporary buyers for Liverpool's progressive artists in the 1960s (apart from sales generated through the John Moores painting competition at the Walker Art Gallery). This lack of a serious market for contemporary art in the city remains today, in common with most UK metropolises, and is in stark contrast to the global positioning that the London art world occupies, which is why commercial initiatives such as Ceri Hand's gallery, opened during 2008 just outside the city centre off the Dock Road, are so welcome. The powerful pull that the capital exerts on the nation's artists also means that the retention of art graduates and emerging artists in the city remains a challenge. The interviews included here with a sample of six practitioners currently working in the city, however, demonstrate that contemporary practice is arguably more diverse and certainly more international than it was when Willett researched what was then a vibrant but relatively small bohemian community.

Out of this scene Willett perceived the possibility of a

Richard DeDomenici, *Free Balloons*, in Liverpool One, 2008. The purple stilt walker seen here was part of the entertainment at the retail development's opening weekend. (Photograph, the Bluecoat)

distinctly Liverpudlian art developing, and he pointed to particular characteristics such as a relationship to place – the streets and haunts of Liverpool 8 – and to popular culture and the burgeoning poetry scene, citing links to performance art and pop music principally through Adrian Henri's interdisciplinary endeavours and Stuart Sutcliffe's brief career oscillating between art and pop. Studio complexes such as the Bridewell, Arena and more recently the Royal Standard continue to act as a catalyst for groups of artists, but it is hard to identify in the plural and fragmented environment of contemporary practice any distinct 'Liverpool art'. A distinct grouping of artists did emerge in the 1970s, championed like the 'Mersey Poets' by critic Edward Lucie-Smith, consisting of painters working within photorealism: Henri, Maurice Cockrill, John Baum and Sam Walsh, though their subject matter was not exclusively about Liverpool. And there have been other prominent tendencies among the city's artists, such as expressive painting (Mike Knowles, Dick Young and others influenced by Frank Auerbach and Leon Kossoff). Yet stylistically these were hardly breaking new ground, and one has to look elsewhere to find artists forging a specific practice rooted in the city but engaged with wider critical discourse. One such grouping in the 1980s was the Liverpool Artists Workshop, most prominently Pete Clarke, one of the artists interviewed in this book, and David and Susan Campbell, the former now part of artists' group Common Culture. Their paintings and mixed media work – drawing on the conceptual rigour of Terry Atkinson and Art & Language – responded to the politically charged Liverpool environment of this period. Similarly David Jacques interrogated the city's rich history of agitation and struggle through paintings, banners and murals, and he continues today to draw on Liverpool's past and its contradictory present using different media and multi-layered processes.

With the presence of Open Eye Gallery, photography emerged through the 1970s and 1980s as an important element in the city's visual arts, the approach of the gallery's early director Peter Hagerty in particular bringing in an eclectic mix of lens-based art from the UK and abroad while nurturing home-

grown artists. Documentary photography would always be a mainstay in a city as photogenic and 'newsworthy' as Liverpool; however, Merseyside has continued to exert a powerful pull on photographers working in other ways, with memorable bodies of work produced here by Tom Wood, Martin Parr, John Davies, Will Curwen and Sean Halligan, among others. Over the past two decades, moving image culture has also taken root in the city, Eddie Berg developing Moviola (now FACT) into a major player at the intersection of art, culture and creative technology. Commissioning and showcasing video art from around the world has had an impact on practitioners in the city, with artists like Clive Gillman and Simon Robertshaw creating significant work here. The Bluecoat's role too has been important, developing far beyond what was thought possible when Willett's book was first published. Unlike the specific focus of Open Eye (lens-based) or FACT (moving image / creative technology), it has been able to reflect a broader range of practice, providing many young artists with their first showing opportunity, contributing to the nascent Black art scene in the UK, developing international links, most notably with Liverpool's German sister city of Cologne, and providing a focus for live art and interdisciplinary work.

Willett's belief, then, in an art feeding off and reflecting the city is being realised today, not so much through the work of a homogeneous group of artists, but through individual practices in which the city, its history, sense of place and cultural self-awareness provides a stimulus, and through its visual arts infrastructure. Crucial to Liverpool's reputation as an art city, and of greater significance outside the city than its artists, is the strength of this infrastructure. The already existing cluster of galleries and museums in Liverpool is one reason why the Tate decided to set up its Northern gallery on the banks of the Mersey. The city's visual arts ecology – the way galleries, agencies and individuals interconnect, complement each other and generally work together, rather than in competition – helped facilitate initiatives such as Video Positive and the Liverpool Biennial. And today a consortium of leading Liverpool organisations, Visual Arts in

Liverpool (VAiL), is positioning Liverpool and the wider
Merseyside and North West region as a significant visual arts
presence nationally and internationally. One outcome of VAiL,
its bimonthly *Art Update* gallery guide, pairs Liverpool's
exhibitions listing with those of New York, London, Paris, and
other centres for art, putting the city literally on the art map. It
will be interesting to see if this and other efforts to entice the
art world and its media out of the capital pay off, and we start
to witness more regular interest beyond that generated by big
events like the Biennial or Tate Liverpool blockbusters.

A conference, 'The Architecture of Art in Two Cities', held
at Tate Liverpool in 1989 compared the visual arts in Liverpool
and Cologne, then arguably the most significant European centre
for contemporary art. Unsurprisingly, Liverpool came off as the
poor relation, with its handful of galleries in contrast to its twin
city's hundreds, its relatively small community of artists, none
with a profile like that of Cologne superstars Gerhard Richter or
Sigmar Polke, and its paltry market for art. Today, the contrasts
remain, Liverpool's artists' community, for example, a fraction of
the 1,200 or so listed in the 2008 Cologne artists' directory.
However, a measure of the distance that the city has travelled
since then, and since Willett's vision for art to drive Liverpool's
ambitions fell on deaf ears twenty years before, is that now
representatives from Cologne are visiting the city to learn about
arts-led regeneration and engaging audiences in contemporary
art, as part of a delegation from Essen, Germany's successful
bidder for European Capital of Culture 2010, representing the
North Rhine-Westphalia region, which includes Cologne.

During Liverpool's year as European Capital of Culture, the
city council drew up a cultural strategy for the next decade and
a half. This represents a similar opportunity to that offered to
the corporation when Willett presented his recommendations
in *Art in a City*. Except that this time there is abundant
evidence available that the arts, in particular the visual arts,
can and do have a vital role to play in the city across a wide
range of agendas, in addition to the intrinsic value of art and
the creative experience. There are specific challenges that the

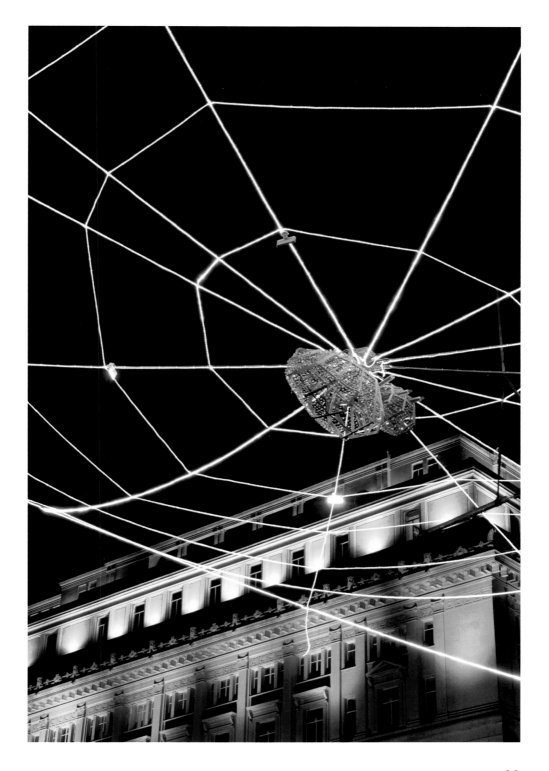

city will, however, need to address as it seeks to map out its cultural ambitions, in order to ensure that 2008 represents not a culmination but a springboard for an even greater engagement with the arts, post-Capital of Culture. For Liverpool to truly attain the status of a thriving 'world city' it will have to embrace internationalism and become more outward-facing. Through international reciprocity and exchange, visual arts initiatives in the city have shown it is possible to counter Liverpool's predilection for self-reflection. To achieve such a position the city's cultural strategies need to be robust, consistent and, most importantly, to possess the very conviction that Willett believed was necessary, and possible, in the 1960s. And this requires a vision that – as this present collection of essays argues – visual arts institutions and individuals in Liverpool have already forged, largely independently from local authority cultural decision-making.

For there to be a meaningful engagement with culture, rather than using it purely as 'local colour' to feed tourism, the city will have to face up to key issues: how, for instance, to retain its creative talent by addressing the needs of artists through graduate retention, business incubation or provision of affordable property? Will it go beyond its 'arm's length' role in relation to the arts institutions it funds, becoming more of a catalyst and advocate for the arts, as well as developing a relationship with those key national institutions it currently has no stake in, NML and Tate Liverpool, and yet which are integral to the city's arts ecology? Will the city further invest in a visual arts infrastructure that has already proved so effective in bringing international talent and attention to the city, allowing its organisations to raise their ambition and realise long-term sustainability? How might there be real synergy with the largest funder of the independent arts sector in the city, Arts Council England, whose *The Turning Point* strategy recognises the significance of the visual arts nationally and internationally? And, finally, how might integration of arts participation by local communities into the mainstream cultural offer, a process to a large degree pioneered by the city's visual arts organisations, be rolled out?

Art in a City Revisited does not provide answers to these questions. However, its examination of aspects of the visual arts in Liverpool, prompted by John Willett's still-pertinent investigation four decades ago, does hopefully provide some lessons for a city still enjoying the challenge of contemporary art. This new volume is intended to contribute to continuing debates about a city's relationship to its art. We hope that it also demonstrates that a strong, independent, local expression of culture can have value, and perhaps even increase in value, within the context of both cultural and media centralisation in the UK, and globalisation's pull towards homogeneity.

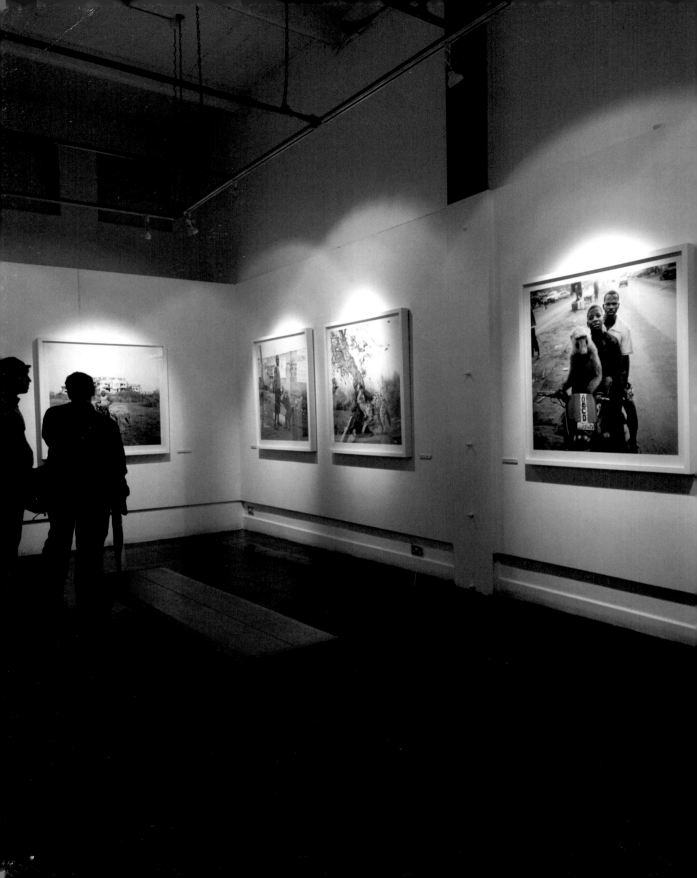

Chapter 1. Individuals and Institutions in Dialogue. Lewis Biggs.

When he wrote *Art in a City*, John Willett dismissed what he saw as the patronising or 'improving' approach encapsulated in the notion of 'art as education' or 'art as a sign of a civilised society'. He simply wanted

Pieter Hugo – Portraits, at Open Eye Gallery, 2008.
(Image courtesy of Mark McNulty Photography)

> to see art associated with the general drive for better living: to see it as a hope rather than an implied reproach. For this reason in a city like Liverpool it should above all be linked firmly to the great schemes for replanning and redevelopment. If people are certain not to want it in that context, then it should not be forced down their throats. [William] Morris saw … that art might just as well die out as develop on a false footing. For of course art does not die; it is an indelible human habit.[1]

In government circles, orthodox opinion in the last thirty years has been more instrumentalist: various attempts have been made to ensure that art funded from the public purse should deliver government policy – especially education, but also social inclusion, health and specific campaigns concerning crime, alcohol and so on.

This is a critical moment to re-read Willett's study for a number of reasons. At a global level, a re-evaluation of urbanism is taking place, consequent on cities having taken centre stage from nation states in how human beings identify

themselves (this can be dated perhaps from the end of the Cold War, and the moment, now, that urban human beings are for the first time the global majority). Secondly, just in the last few years, government in the UK appears to have rediscovered art as Willett understood it – something to which everyone has a right and for which everyone can take responsibility, valuable (intrinsically not instrumentally) 'an indelible human habit'. Thirdly, Liverpool, having been in most respects in the doldrums since Willett wrote his book, has for the past decade finally shown signs of resurgence as a city, epitomised by its position as European Capital of Culture 2008. And finally, the city's arts institutions, as Willett foresaw, have developed and changed dramatically 'linked to the great schemes for replanning and redevelopment'.

The growing interrelation between these institutions in the last twenty years is the subject of this chapter. Willett described the 'main framework of the Liverpool art organisations as we know them today' as being the Walker art gallery and collections, the Art School, the Liverpool Academy, the Sandon Society and the Bluecoat. He also notes 'the disappearance of any kind of art or art historical department at the university'.[2] The Sandon Society and the Liverpool Academy were both artists' exhibiting societies. The Sandon is defunct, although it might be said to have been absorbed into the Bluecoat, and the name of the Liverpool Academy is still in use, although the exhibitions in Seel Street are a poor vestige of the illustrious annual event that used to take place in the Walker.

The last forty years have, however, brought several new institutions to Willett's 'main framework' (Open Eye Gallery (founded on Whitechapel in 1977), Tate Liverpool (opened 1988 on Albert Dock), Liverpool Biennial (founded 1998, of no fixed address) and Merseyside Moviola/Video Positive which transmuted over a fifteen-year period into the FACT Centre (opened 2003 on Wood Street). The University of Liverpool now has a professor of Art History, but still lacks an Art History Department; and Liverpool John Moores University does offer a BA(Hons) History of Art and Museum Studies programme in collaboration with Tate

Liverpool as well as MRes and MPhil/PhD postgraduate research programmes for the study of Art History.

In the same paragraph, Willett noted that, thanks to the continuing postwar centralising tendencies in government, only the [Liverpool Academy could be seen as 'a purely local enterprise'. This was important to Willett, since [the tension between 'local' and 'regional' or 'national' found a parallel in the relation between the individual and the State/society: ... the real question in the arts in a city like Liverpool is how far the shift in patronage and policy making into <u>municipal</u> hands can be used to stimulate rather than merely alienate the artist⁄ He saw responsibility for patronage and policy shifting from individuals with standing in the local community (whether academics or business people) to the relatively impersonal 'municipality' at precisely the time that the municipality was itself losing powers to central government. And he was only too aware that in the 1960s [the art institutions had been relegated to insignificance in terms of their impact on popular taste by the more powerful newspapers and television] (Arthur Dooley, local sculptor, was rocketed to celebrity by virtue of his TV appearances, with a Liverpool survey showing his name was known to one in twelve of the population.) Willett saw 'local' artists being (disempowered and alienated;) he saw that '<u>civic pride</u>' was being deeply challenged by social mobility, the mobility of capital and mass communication. He remained hopeful that life would get better for everyone (including artists) but [perhaps he did not foresee the degree to which community based on locality (the city) would be eroded by the many and various forms of <u>non-topographic</u> community that have emerged in the last forty years through globalisation and inter-culturalism.]

Artists everywhere have had to be aware that the market and the discourse of art are no longer 'national', whether that meant local, regional or that form of parochialism known as '<u>metropolitan</u>'; nor are they what used to be unquestioningly seen as 'international' (roughly translated as mainstream for the G8 countries). [Both market and discourse are now truly global: artists must position themselves within inter-culturalism.] It has

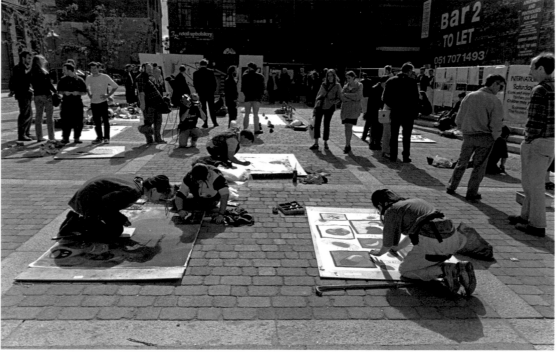

Chapter 1. Individuals and Institutions in Dialogue. Lewis Biggs

become orthodox for institutions, as well, to try to think globally and locally at the same time.

If art is an 'indelible human habit', art institutions can encapsulate those habits – articulate and embody traditions, standards, conventions and deeply held values. The idea of an institution is closely connected to 'civic life' and community. Dying institutions are those that have lost their original values by reacting to events, fashion or politics, have become an empty shell by failing to embody or communicate successful habits. This chapter explores the degree to which Liverpool's art institutions reflect the inter-connectedness and inter-culturalism that have become habitual to artists in the last forty years, and relate these to civic life.

Artist-led Initiatives and Commercial Galleries

Artist-led initiatives often aim to make a market, but perhaps more importantly also provide the mutually supportive competition fundamental to artistic activity. Artists are the subject of Chapter 5, and so I shall mention only a handful here, without comment. Pete Clarke and Dave Campbell's Liverpool Artists Workshop in Hope Street; Ben McCall and David Jacques' Artskills at Kirkby Unemployed Centre; Terry Duffy's British Art and Design Association in Colquitt Street; Arena Studios in Duke Street; Parr Street Print Workshop; Paul Sullivan's Static Gallery in Roscoe Lane; Janine Pinion's Acorn Gallery in Newington; Ethel Austin's Gallery and artists' studios in Hanover House, Hanover Street; The Hub Café in Berry Street; Parking Space Gallery; Three Month Gallery; Ben Parry's Jump Ship Rat/Metropole; Soup (artists working at Tate Liverpool); Royal Standard; Mercy; Red Wire; 11 Wolstenholme Square; The Artists Organisation (at various addresses belonging to Frensons developers). Some of these have lasted for more than a decade, some for less than a year, but all have contributed to the self-confidence of artists.

A special mention is deserved by June Furlong, who has organised selling exhibitions over many years on behalf of the

The *Milk Float*, created by Ben Parry from Jump Ship Rat, in collaboration with Jacques Chauchat for the 2006 Liverpool Biennial Independents programme. (Image courtesy of Myriam Tahir)

International festival of pavement art in Concert Square, 1994. During the life of Visionfest there were five such events, which presented conceptual, performative and installation work alongside more conventional approaches to the genre. (Photograph, Sean Halligan, courtesy of Visionfest Archive, Liverpool John Moores University)

artists for whom she modelled. Also, the Bridewell Studios on Prescot Road has since the 1970s been a centre of activity including live art, painting, printmaking and sculpture. The presence of artists with national reputations such as Maurice Cockrill, Adrian Henri and the Walker Art Gallery artists in residence (Ian McKeever, Anish Kapoor, Jonathan Froud, Graham Ashton and Adrian Wisniewski) gave it both prominence and weight.

But the greatest challenge has been the collapse of the local market for art, from the end of the 1960s, as many people with disposable income left the city. Willett described the Liverpool Academy, with its annual exhibition at the Walker, as 'one of the most flourishing provincial societies of professional artists', with 80 members and 900 works by non-members sent in each year.[4] Within a few years, the exhibition was no longer held at the Walker, and in the 1980s the association collapsed amid claims of maladministration, although the name survives, as mentioned above.

Already in the 1960s, despite the flourishing Academy, Willett wrote: 'there is no gallery in Liverpool such as artists and students would like to visit, or the leading painters to show in, or the chief patrons to support'.[5] Murdoch Lothian ran the eponymous commercial gallery for five years during the 1980s from his home in Liverpool 8. It was an ambitious attempt to bring art of international currency to Liverpool, but on his own admission most sales were to overseas customers by mail order, and the gallery had closed by 1987. Martin Ainscough's gallery at his café No 7, Faulkner Street survived for five years or so in the 1990s, for part of that time as the Merkmal Gallery, but in reality it depended on the revenue generated by the café, and when Ainscough sold the business, the gallery did not survive. Ken Martin, formerly professor of architecture at Liverpool John Moores University, opened the View Gallery in Gostins Building in Hanover Street in 1991. Again it was operated for love of art, and did not make money for its owner despite its success. The same is true of its successor, View Two Gallery in Mathew Street, which presented a fine programme of shows in 2008.

Higher and Further Education

As Willett pointed out, after a promising start at the beginning of the twentieth century, The University of Liverpool never committed to teaching Art History. During the 1980s and 1990s it did so through the efforts of David Thistlewood and Ann McPhee in the Department of Continuing Education, now discontinued, but it has instead a Chair in Art History, held by Jonathan Harris, with no undergraduate course. However, it continued to provide an opportunity for quiet study through the 1970s and 1980s in the form of the University Gallery and Collection (usefully supported by the Granada Foundation) in Abercromby Square. In the 1990s the curator, Ann Compton, took initiatives to find a larger audience, including collaboration with Liverpool John Moores University, and brought a more outward-looking energy to the institution. But it took the personal interest in art of Drummond Bone, the now retired Vice-Chancellor, to enable the current curator, Matthew Clough, to oversee the move of the art collection, along with the other University collections, to the grander and better adapted Victoria Building by Alfred Waterhouse on Oxford Road, which opened in 2008. The gallery's recent arrangement with Liverpool Museum of a retrospective by Tony Phillips, and Harris's active involvement with organising conferences and publications with Tate, both suggest that the University may play a more prominent role in the contemporary art ecology of the city in the future.

Liverpool Art School became a part of Liverpool Polytechnic, now Liverpool John Moores University. It occupies several buildings along Hope Street (now sold for development as apartments) and Myrtle Street. In the 1960s it acquired a purpose-built exhibitions gallery at 68 Hope Street. Not surprisingly, this was used to promote the work of the incumbent staff and students, and when the energy so evident to Willett flagged among the school's fine art staff, the profile of the department reduced, as did its perceived connectedness to the city.

Despite the perennial popularity of the Art School in terms of attracting students, it has to be said that the last forty years have not been an illustrious period in terms of producing 'star' students.

This is notwithstanding the institution's excellent academic attainment record, research achievements and international links, as evidenced by the Research Assessment Exercise review of the period 2001–08. The Art School's most visible connection to the city has been the use of its various galleries to participate in broader events such as the Biennial and additionally its collaborative lecture programme with the Tate. In the 1990s the Centre for Art International Research (CAIR) set up a residency programme, with institutional financial support from the Henry Moore Foundation. CAIR continued to contribute through research fellowships, conferences and public shows – for example at the Bluecoat – with Imran Qreshi (Pakistan), Walid Sadek (Palestine), and UK-based artists Nina Edge, Juginder Lamba and Bill Ming. CAIR was far-sighted in its focus on diversity and exposition of non-G8 perspectives, but it has not received adequate institutional support to enable it to flourish in recent years.

In the last fifteen years Liverpool Hope University has transformed itself from a teacher training college in the suburbs of Liverpool into a university college with a city-centre presence. Cornerstone Gallery at Shaw Street, Everton, has an ongoing programme of exhibitions promoting work by students, staff members and local artists. Hope has an impressive record in the degree to which its staff and former students have shown themselves committed to developing the local arts infrastructure, and have put initiative and energy into organising workshops with an international reach, notably Lin Holland's *Cyfuniad* workshops which have brought artists from around the world to work alongside regional artists, based on the Triangle model established by Robert Loder and Antony Caro.

Liverpool Community College of further education has also made its presence felt in the city through developing a 'flagship' city-centre arts building designed by Austin-Smith: Lord and completed in 2001. The staff includes locally based and outward-looking artists of ambition such as Geoff Molyneux, and they are hungry to develop partnerships and joint initiatives with other organisations, contributing to the sense of a growing infrastructure with international connectedness.

Chapter 1. Individuals and Institutions in Dialogue. Lewis Biggs

Wirral Metropolitan College performs a similarly valuable role both in employing practising artists and nurturing local creativity. And Liverpool Culture Campus, a partnership set up in 2006 between the higher education institutions and visual arts exhibiting organisations, aiming to attract and retain arts graduates, is a welcome forum for interface.

The Civic and the National

Liverpool City Council lost its responsibility for arts during the existence of Merseyside County Council in the 1970s and early 1980s, and the major part of that responsibility was never returned on the abolition of the MCC because the Walker and Liverpool Museums were considered significant enough to merit being put beyond local politics and funded directly by Westminster. This was a tragedy in respect of the effect on local politicians, who henceforth had no responsibility for (and therefore no interest in) the tradition of nurturing visual arts in the municipality through collecting. But it may have averted the potential comedy of giving those responsibilities to particular politicians in the 1980s. The abolition of the metropolitan counties also led to the merger of Merseyside Arts Association with the North West Arts Association, based in Manchester not Liverpool, eventually to become Arts Council England North West.

During the 1990s, the city council's Arts Unit provided grant aid to community organisations in what was essentially a political role, along with very modest revenue to the Bluecoat, Open Eye, Video Positive, Visionfest etc. The process from 2001 of bidding to be European Capital of Culture forced the council to review its relation to the arts, and especially after the bid was won in June 2003. However, the council decided to administer the event itself, despite having no experience or skills in this area. The failure to separate the cultural programme and funding from direct control by elected politicians also made every cultural decision open to political infighting: while maximising the effect of 'culture' on the 17,000 council employees, this decision has probably minimised the potential effect on the other 450,000 citizens of Liverpool.

Yinka Shonibare and Kate Smith's installation, *Discreet Charm*, at Croxteth Hall, curated by Richard Hylton for Visionfest, 1996.
(Photograph courtesy of Visionfest Archive, Liverpool John Moores University)

John Moores 25 Contemporary Painting Prize, 2008, at the Walker Art Gallery, with Richard Kirwan's painting *As Above, So Below*.
(Photograph, Simon Webb, courtesy of NML)

The Walker Art Gallery presented Liverpool's municipal
collection, a repository of civic pride in culture, until it was
taken into the remit of the County of Merseyside in the 1970s
and from 1986 put under the governorship of trustees receiving
funding directly from Westminster as a part of National Museums
Liverpool. For Willett, 'the activity for which [the Walker] has
become most widely known is the holding of the biennial John
Moores competitions, which in the last seven years have …
started drawing the London art critics to Liverpool'.[6] As
compared with the parochial Liverpool Academy, this national
painting competition connected the Walker to broader
movements, national and international, and the reputation of
the gallery soared. At the start of the 1980s, the Walker was still
a national force in contemporary art, with the Peter Moores
Projects (from 1971 to 1977) alternating biennially with the
John Moores painting competition. Timothy Stevens, the
Director, and Marco Livingstone, his assistant, were professionals
with national reputations, introducing artists from this larger
field to Liverpool – for instance Graham Crowley, Stephen
Farthing and Derek Boshier all showed at the Bluecoat after
being introduced by Livingstone, who also organised major
retrospectives of Pop Artists (Peter Philips, Patrick Caulfield) at
the Walker and temporary exhibitions of contemporary art at
Sudley House (including Keith Milow), and initiated the artists'
residency scheme mentioned above.

In 1982, on the initiative of Stevens and reflecting his broader
outlook and desire to strengthen its quality, the annual Liverpool
Academy was replaced by an annual Merseyside Artists
Exhibition. He was supported in the project by John Entwistle, a
local solicitor with an interest in art, who organised a committee
to support Stevens' show and also started his own art gallery in
Cumbria (his sons later started a gallery in London). Another
Liverpudlian, Max Blond, similarly acted to introduce Liverpool
artists to the London market through his gallery, Blond Fine Art.

The amalgamation of the Walker with Liverpool Museum in
1986 effectively demoted its leadership: Stevens and Livingstone
departed, and by the end of the 1980s engagement with

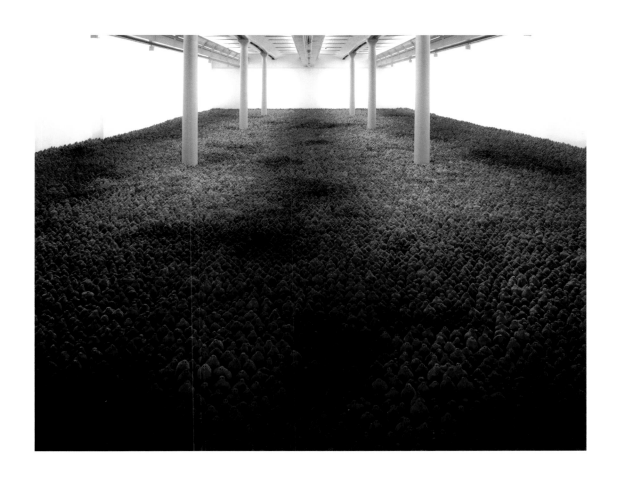

Chapter 1. Individuals and Institutions in Dialogue. Lewis Biggs

contemporary art was left to less senior curators. The artists' residencies stopped, and responsibility for collecting contemporary art, whether by national or regionally based artists, was not considered a priority. It is true that the opening of the Tate may have led the Walker to concentrate on the more distant past rather than the recent past or present, but the effect of this shift in policy on the broader perception of the Walker was certainly damaging. The failure of the Walker to continue to collect or engage with contemporary art, outside the biennial John Moores exhibition, ultimately meant that the remaining local and regional collectors of art became detached from it also.

In the last few years there have been some initiatives, particularly in relation to the Biennial international contemporary art festival, to re-inject a sense of contemporaneity into the Walker's programme. And perhaps more significantly, contemporary art has become a feature of the other sites within National Museums Liverpool – for instance the residency and exhibition by Tony Phillips at the World Museum Liverpool, Paul Clarkson's slavery installation at the Transatlantic Slavery Museum, projects at the Maritime Museum, etc. These are encouraging signs for the connectedness of all Liverpool's institutions in the broader debate about globalisation and inter-culturalism.

Tate Liverpool opened in 1988 with several identity problems. It was the first Tate gallery to be founded since the original one on Millbank in 1898, and as a result, expectations not unnaturally were focused on the Constables and Turners, for which the Tate collection was chiefly celebrated. However, as the largest museum dedicated to modern art in England throughout the 1990s, the Liverpool gallery and its collection were regarded by many as a futuristic spaceship unexpectedly landed in a maritime heritage theme park. Known initially as the Tate of the North, it was widely perceived to exemplify the 'north–south divide', rather than the more proper and ambitious function of reflecting on contemporary culture internationally, including Liverpool's own position as a globally connected city with an inter-cultural history.

Simryn Gill solo exhibition at the Bluecoat, 1999, an OVA touring exhibition.
(Image courtesy of the Bluecoat)

The gallery staff made strenuous attempts to 'ground' it in the city through the work of the outreach and education team; there were six-month artists' residencies funded by the transport firm Momart; and of course local artists found support through employment as information assistants in the gallery, just as Jackson Pollock had worked at the Museum of Modern Art, New York. There were exhibitions that tried to create a context within the gallery programme to include both art made in the region and art produced overseas: *New North* (1990), *Making It* (1996), and the ambitious *Artranspennine98* which treated the M62 corridor as a 'gallery' and attempted to activate and bring it to self-awareness from a contemporary art perspective in both production and consumption. And there were exhibitions that focused on the inter-cultural context: art from Korea (linking Abstract Expressionism with Asian calligraphy); from Japan (inter-cultural technology); two shows of art from Africa (one from sub-Saharan Africa, the other from North Africa). Nevertheless, it must be said that despite all this there was still a lack of any direct interchange between artists based in the city and the artists who visited to exhibit in the gallery, not helped by the topographically isolated situation of the gallery in the 'tourism' area of Albert Dock.

The institutions located more centrally may have fared better in the cross-fertilisation of local and international issues for debate. The Bluecoat's institutional role has been to nurture both creative individuals and audiences, and it has been at the heart of Liverpool's artistic life for a century: as a society of practising artists and their supporters, as a venue for local groups of artists to show their work, and from time to time as a venue for new international developments in the arts, most notably in the early years of the last century and again from the late 1960s onwards.[7]

Despite an always limited exhibition budget, through the 1980s and 90s Bluecoat's Artistic Director Bryan Biggs approached the issue of representing a global and inter-cultural perspective with vigour and success, receiving 'national touring' exhibitions of work by overseas artists (from India, Pakistan, China, Japan), and taking a leading role in organising inter-cultural exhibitions by

UK-based artists from diverse backgrounds (Keith Piper, Eddie Chambers, Sonia Boyce, Gavin Jantjes, Chila Burman, Lubaina Himid and most prominently *Trophies of Empire* organised with Arnolfini, Bristol and Hull Time Based Arts). The Bluecoat programme remained more multi-disciplinary than those of other Liverpool institutions, including 'processional' work (such as Nina Edge's *Sold Down the River*, 1995) music, literature and live art.

As Willett noted, the Bluecoat Society was set up in order to protect the Blue Coat School building from development, and the tug of war between conservationists and modernisers (familiar in many organisations) has been won for the moment by the modernisers, with the building converted by Biq Architecten, opening as a fit for purpose contemporary arts centre in 2008.

Bill Harpe, initially and for many years supported by Wendy Harpe, founded Great Georges Community Cultural Project (The Blackie) in 1968. Its idealistic position – a statement from 1973 mentions 'a collaboration of artists and vandals, toddlers and businessmen, arts lab youngsters and local mothers, students and unemployed, those interested in the arts and those interested in fighting'[8] – has always reflected the spirit of that year. Although energy has sometimes flagged, it has always been ambitious in its educational outlook – publishing books on art education through the Arts Council – while preferring to operate on the most local of levels.

Yellow House was started, and is still run, by George and Gosia McKane, initially in Bootle, more recently in central Liverpool, being an 'institution' that is more a way of life than a building. It is run with passion and understanding as a kind of artistic 'safe house' for young people, where they learn theatre and film skills (George is also a lecturer in film studies while Gosia used to work in the Ministry of Education in Warsaw). Yellow House is 'naturally' international, and an important part of its activity takes place 'on the road' in Europe or while mixing with young people from overseas. Some of the projects, of a very high standard, are exhibited, although as an organisation it can be said to give greater status to production than to consumption.

Photographer Colin Wilkinson founded Open Eye in 1978. It was one of a number of photographic initiatives across the country towards the end of the 1970s, and its social documentary exhibitions in Whitechapel had a national profile during the 1980s, but the organisation, which included a community video and recording studio, was fundamentally practice- and teaching-based. It moved to Bold Street as The Open Eye Gallery, then to Wood Street in the Ropewalks area, and its current Director, Patrick Henry, is planning to move in 2010 to a new dockside site. While it successfully brings lens-based work of a high standard to Liverpool, and occasionally commissions new work, the original impetus of practice and teaching is no longer present.

The most ambitious arts 'institution' to appear in Liverpool since the FACT Centre is housed in three buildings on Greenland Street and administered by A Foundation, the charity set up by James Moores and other family members initially to fund Liverpool Biennial. Greenland Street has made use of its large industrial spaces to commission ambitious new work from UK and overseas artists shown in the context of the Biennial, but moving towards a year-round programme. It looks as if its major contribution will be in providing Liverpool-based and visiting artists a supplement to the Bluecoat in terms of an informal forum for ideas and debate. It is too soon to know whether the work commissioned will sell locally or nationally, or how the programme will engage locally based artists.

Collaborations

Collaboration does not appear to have come easily to Liverpool's arts institutions, which makes the current spirit of co-operation all the more remarkable. A South Liverpool Festival of Art took place in 1960, which Willett notes as 'an apparently successful example of a new kind of collective (or neighbourhood) art therapy … of very practical benefit to the city', while in 1962 and 1963 there were Merseyside Arts Festivals held at Hope Hall. As sometimes happens, the organisers of the 'regional' event appeared much less interested in how many people attend than those of the more parochial one, and despite both being

Chapter 1. Individuals and Institutions in Dialogue. Lewis Biggs

based in Liverpool 8 the organisers of these two festivals never contacted each other.[9]

Adrian Henri was involved with the above festivals, as with almost every art manifestation in the 1960s. So it is interesting that it was his view that the presence of the Tate after 1988, despite its lack of direct engagement with local artists, encouraged a proliferation of artists' studios in Liverpool as well as a growth and diversity of art activity generally.[10] It is even possible that the Tate's 'alien' presence provided the stimulus for local artists at last to collaborate in opposition to it.

One prominent collaboration was Visionfest, held each October from 1992 to 1997. The prime mover was John Brady, a former officer with Merseyside Arts, who succeeded in raising funds from the city council and Arts Council to create a platform for locally based artists and their professional friends and colleagues from around the UK and overseas. A key feature of Visionfest was its ambition to use the energy of many individuals to achieve a critical mass over multiple sites – it grew out of co-ordinated open studios – and it made use of the streetscape as much as the network of galleries and studios. It also set out to be fun, and to demystify the artistic process.

A smaller and more specialist festival predated Visionfest by three years. Merseyside Moviola, an organisation dedicated to teaching, promoting and creating artists' film and video, had been founded by Eddie Berg and two colleagues in 1985. Sensing the opportunity to attract top level overseas artists afforded by the Tate's arrival in Liverpool, in 1989 Berg initiated an international festival, *Video Positive*, across the Bluecoat, the Williamson Art Gallery in Birkenhead and Tate. *Video Positive* became a biennial festival, the sixth and last one taking place in 1999, the same year as the first Liverpool Biennial.

In 1997 Merseyside Moviola was renamed FACT (Foundation for Art & Creative Technology) and the following year, with Liverpool John Moores University and Manchester Metropolitan University, it co-hosted *ISEA98* (International Symposium on Electronic Arts). From 1999 it focused its ambition on creating a building: the FACT Centre in Wood

The FACT Centre entrance announcing the Pipilotti Rist exhibition, 2008.

(Photograph, Alison Ferguson)

47

Street, the first purpose-built arts building in Liverpool since the Philharmonic Hall in the 1930s, opened in the spring of 2003. The FACT Centre has also been invaluable in providing a place for aspiring artists to meet and 'hang out' together, especially during the closure of Bluecoat for rebuilding.

In contrast to gallery-based visual arts organisations, Merseyside Moviola followed an 'agency' model more familiar in film, theatre and live art, and focused on 'production' rather than presentation. It relied heavily on freelancers, on outreach workers and on an event-based approach to exhibition. It was enabled in this approach through its offices being located within the Bluecoat: significant portions of virtually all the Moviola/FACT exhibitions were shown at the Bluecoat and in collaboration with it, making use of Bluecoat's organisational experience and support.

In 1997 the New Contemporaries exhibition was hosted by Tate Liverpool, with the opening coinciding with that of the John Moores painting exhibition. Both exhibitions were financially supported by James Moores, who also hosted a dinner at the Town Hall for both sets of artists. The occasion was hugely positive for art in Liverpool, sowing the seed of Moores' decision to initiate – and fund – a biennial in Liverpool. Liverpool Biennial of Contemporary Art Ltd was founded in 1998, shortly after the reopening of the expanded Tate Liverpool with *Artranspennine98*. This exhibition, organised by Tate Liverpool and the Henry Moore Trust in Leeds, was presented in thirty sites – in galleries and outdoors – in the region served by the Transpennine train system traversing the North of England. In Liverpool it was hosted by the Bluecoat and Tate, and (bearing Visionfest and *Video Positive* in mind) underlined both the collaborative possibilities and the capabilities of the Liverpool infrastructure for hosting a large-scale international biennial exhibition.

Liverpool Biennial's principles of operation include partnership, a preference for working without a dedicated exhibition space, a belief in the importance of newly commissioned work from artists as a process for generating meaning, and a commitment to bringing overseas artists into

direct, and preferably sustained, contact with local people (including artists). Like Merseyside Moviola and Visionfest in the 1990s, it aims to provide work for local artists and to create situations in which they work alongside artists from overseas. It has also organised and facilitated exchange exhibitions between regionally based and overseas artists. From being an organisation devoted solely to the realisation of a biennial festival, it has become an agency working continuously through commissioning new art from artists, and throwing a spotlight on its own and others' programmes through the Biennial festival.

For the first Liverpool Biennial Festival, James Moores was concerned that the international outlook of the Artistic Director (Tony Bond, Senior Curator at the Art Gallery of New South Wales) should be balanced by a vigorous contribution by local artists. He asked Jonathan Swain, an artist who knew Liverpool well, and had been involved in the radical performance group Visual Stress, to animate the 'independent' artists not otherwise catered for, finding temporary spaces and opportunities to show their work. The resulting constellation of exhibitions and events was called *Tracey* (a riposte to Tony Bond's exhibition entitled *Trace*). For the second and third Biennials in 2002 and 2004, Moores again animated this sector through providing funds from A Foundation – and by 2004 he had the use of the buildings in Greenland Street mentioned above. By 2006 he decided to concentrate his resources on a 'curated' programme at Greenland Street, while Arts Council England North West supported local artists through a programme that became known as the Independents Biennial (co-ordinated by the same John Brady who had co-ordinated Visionfest between 1992 and 1997).

Conclusion

If the ecology of art in a city is to be healthy, it needs artists to work alongside each other, providing mutual moral support as well as competition; ambitious commercial galleries selling art to well-informed ambitious collectors; an outward-looking and generous formal learning environment within a vigorous academic framework; an ongoing passionate debate about art

that recognises multiple perspectives; spaces and places in which artists can work or network cheaply; exhibitions that import great examples of art as well as showing great examples of locally produced art; entrepreneurs, impresarios, fundraisers, promoters.

On this measure, a healthy art ecology is about individuals, not institutions – it is they who make institutions work. In 2008 Liverpool's visual arts ecology looks healthier than at any time maybe since the early twentieth century, when it was still 'the second city of Empire', with the wealth and ambition to attract talented individuals. It is currently better developed in terms of exhibition spaces and cheap accommodation for artists than it is in terms of a debating and learning environment, but a significant development is the building of a new Art School by architect Rick Mather, into which all the arts courses taught at Liverpool John Moores University are being gathered. New energy and more informed, confident levels of debate on the visual arts should emerge from this situation when the building opens in 2009. The most obvious lack is that of a market for art, and it is hard at this moment to believe that any positive development is likely in this respect; however, the recent arrival in the city of the Ceri Hand Gallery is a welcome addition here.

[1] John Willett, *Art in a City* (London: Methuen, 1967; repr. Liverpool: Liverpool University Press and the Bluecoat, 2007), pp. 239–40.

[2] Willett, *Art in a City*, p. 65.

[3] Willett, *Art in a City*, p. 66.

[4] Willett, *Art in a City*, p. 78.

[5] Willett, *Art in a City*, p. 121.

[6] Willett, *Art in a City*, p. 76.

[7] The Bluecoat Society of Arts evolved to become the Bluecoat Arts Centre and from 2008 the Bluecoat.

[8] Sam Gathercole, 'Facts & Fictions: Liverpool and the Avant-Garde in the late 1960s and 70s', in Christoph Grunenberg and Robert Knifton (eds), *Centre of the Creative Universe: Liverpool and the Avant-Garde* (Liverpool: Liverpool University Press in association with Tate Liverpool, 2007), p. 141. The venue was re-named The Black-E in 2008.

[9] Willett, *Art in a City*, p. 130.

[10] Bryan Biggs. 'Welcome to the Pleasure Dome: Art in Liverpool 1988–1999', in Grunenberg and Knifton (eds), *Centre of the Creative Universe*, p. 188.

Chapter 2. Liverpool, Art City?[1] Sara Selwood.

One might be excused for thinking that, in Liverpool, the size of aspirations is what counts. Ben Shaw, chair of Liverpool Corporation's Arts Sub-Committee in the 1960s, justified his very considerable ambitions for the arts by observing that: 'If a thing's big, it'll get big support. If it's little we'll just dodder around.'[2] Half a century later, Liverpool Vision, the economic development company, celebrated its contribution to the recent regeneration of the city centre in *Make No Little Plans*. Inspired by Daniel Burnham, Chicago architect and urban planner, its title was indicative of the scale of its goals:

> Make no little plans. They have no magic to stir men's blood and probably themselves will not be realised. Make big plans. Aim high in hope and work.[3]

Willett's own vision was equally grand. In *Art in a City* (1967) he visualised the visual arts as contributing to the transformation of Liverpool. Forty years on, that vision persists. Post-Willett, one of the cultural sector's orthodoxies is that culture drives regeneration and should be 'firmly embedded in regeneration ... not an add-on or an afterthought'.[4] Indeed, according to the Department for Culture, Media and Sport (DCMS), culture is 'at the heart of regeneration'.[5] A report commissioned by Arts Council England (ACE) maintains that there is 'mounting evidence that the visual arts, and particularly their contemporary manifestations, have a distinctive, important and as yet under-realised role to play in delivering access and social inclusion across society'.[6]

Liverpool's successful bid for European Cultural Capital 2008 not only recognised the importance of its visual arts,[7] but identified culture as central to its transformation. It promised a 'new

Taro Chiezo, *Superlambanana*, 1998. Commissioned for the artranspennine98 public art project, Chiezo's sculpture stayed in Liverpool, proliferating as an unofficial symbol of the city. For ten weeks during summer 2008, Go Superlambananas! consisted of 125 versions of the iconic sculpture, decorated by artists and communities across the city.

(Photograph. Angela Mounsey)

Liverpool' characterised by 'its creativity, internationalism and heritage', which would be 'a better place for a new generation to live in, work in, visit and invest in'.[8] The Liverpool Culture Company, which was set up in 2000 to prepare and submit the city's bid to become the UK nomination for European Capital of Culture, is responsible for the strategic direction, coordination and support of its cultural infrastructure. Its work is intended to underpin Liverpool's future position as a premier European destination for culture, tourism and investment and create a legacy for its people, which will include more jobs and a stronger economy.[9]

However, not all Liverpool's agencies are determined to put culture at the centre of their versions of the city's economic recovery – Liverpool Vision is one example. Its mission is to accelerate the city's economic growth and provide strategic leadership on the economy. It regards the European Capital of Culture award as symbolic of how far Liverpool has travelled since being in the 'depths of economic, political and fiscal crisis' twenty years ago.[10] While it acknowledges the value of the city's ambition – something that 'probably could have been endorsed by any city at the time' – Liverpool Vision's focus is on the bigger picture. Its concern is to

> … establish a 21st century economy; improve competitive career prospects; create inclusive communities and a skilled and adaptable workforce; deliver a high quality safe urban environment; exploit the city centre's rich historic character; be a benchmark for the next generation of international city centre regeneration; become a world class tourist destination; become a premier national shopping destination; create a quality lifestyle; provide a welcoming experience; improve Liverpool's European image; create an effective and efficient mechanism to deliver the Vision.[11]

The existence of such different perspectives raises the question – how grounded was Willett's advocacy and that of successive cultural agencies? Did the visual arts prompt Liverpool's renaissance and, if

so, how firmly embedded in it are they? Or, could it have been the other way around? Was the burgeoning of Liverpool's visual arts actually dependent on the city's transformation?

This chapter considers the circumstances of the visual arts in Liverpool in the late 1960s; the scale of Willett's ambition; and, forty years on, the makeover of the city and its visual arts. As far as possible, the definition of the visual arts used here adheres to Willett's implicit understanding of work by artists, art in public and established institutions. Regeneration is understood to refer to the transformation of place – the 'breathing [of] new life and vitality into an ailing community, industry and areas [bringing] sustainable, long term improvements to local quality of life, including economic, social and environmental needs'.[12]

Willett's aspirations

Background: the city

Ten years before the publication of *Art in a City*, the British Prime Minister, Harold Macmillan, famously asserted that the majority of the population had 'never had it so good'.[13] But, by the mid-1960s, things were already looking very different: 14 per cent of the population lived in poverty; over 1.8m dwellings were unfit for human habitation; urban dereliction was a growing problem as industrial restructuring and technological changes led to the abandonment of inner-city industrial premises.[14] Willett's detailed observations of Liverpool reflect this reality. An outsider, he described the city as characterised by 'a burden of poverty' which stemmed from its legacy of Victorian industrialisation – dirt, poverty and slums – and had been reinforced by a history of 'bad planning', extensive post-war dereliction and swathes of undeveloped, municipally owned land.[15]

Nevertheless, at the time he was writing, Liverpool Corporation's new planning unit, regarded as a leader in the field, perceived this as an opportunity to redevelop the city. Indeed, its potential was

... unequalled by any other major city in this country and few in the world. Large areas of comprehensive development are therefore feasible and they, in turn, make the creation of a new and attractive urban environment an early possibility in several parts of the city centre.[16]

Liverpool's *Interim Policy Planning Statement* (1965) was radical for its times. Based on an 'overall conceptual framework', its vision for the city's future integrated economic, social and physical dimensions. As Willett noted, the 1962 City Centre Plan had already proposed making the city 'more beautiful'.[17] There was every reason for him to believe that this would happen. Walter Bor, appointed as Liverpool's first City Planning Officer in 1962, had already encouraged London County Council to install art in the flats and schools that it built in the 1950s. So it was hardly surprising that Willett envisaged a future in which the visual arts contributed to the city's redevelopment and thrived in the context of a new, mutually beneficial relationship.[18]

By the mid-1960s Liverpool, like many other cities, was losing its population: the inner city was left with a disproportionate share of unskilled and semi-skilled workers, of people who were unemployed, of concentrations of immigrant communities, and of overcrowded and inadequate housing. Willett described Liverpool's 750,000 inhabitants as an 'unusually mixed lot', comprising groups of Irish ('this [being] the cheapest crossing to England from Dublin'), Welsh, English, West Indians and Chinese, whose presence was 'more noticeable than their actual numbers would suggest'.[19] He reported the changes in the city's fortunes as having been so overwhelming that its inhabitants could only see their nineteenth-century legacy as a 'terrible and cramping handicap'. Reinforced by the loss of England's position as the world's leading manufacturer, the damage wrought by two world wars, the unemployment of the 1930s, and 'our own century's inability to cope', Liverpool had become 'one of the most vulnerable communities in our ... economy'. Willett also experienced a city centre abandoned by its wealthier citizens and taken over by

immigrants, where the rateable value of properties had fallen, where trees were no longer being planted because of 'general destructiveness', and where those 'who would have supported intelligent evening entertainment and served in local government [had] in many cases gone to live outside'.[20] The fact that power in the city council had continually passed between Labour and the Conservatives since the Second World War presumably contributed to the situation.[21]

Background: the visual arts

Despite this apparent political instability, Willett was convinced that Liverpool provided 'a strong and active structure for the visual arts' – more so than most other English cities.[22] At the time he was writing, the city's institutions principally focused on historic rather than contemporary visual arts. They included:

- the Walker Art Gallery, one of four provincial galleries which the Standing Commission of Museums and Galleries regarded as having 'been built up to a national standard';
- a number of other art galleries in and around Liverpool, which included Sudley House, Lady Lever Art Gallery, the Williamson Art Gallery, Birkenhead, and Bootle Art Gallery;
- the College of Art, the University and the public libraries;
- the Bluecoat and Sandon Studios Society, part of an 'embryo network of arts centres such as the present government, the Arts Council and the Gulbenkian Foundation all in their various ways wish to encourage'; and
- Liverpool Academy and the John Moores exhibitions – the mainstays of local and contemporary arts.

According to Willett the Arts Council's budget for the visual arts for the whole of England (except for the North East) was £55,000 – equivalent to about £720,000 in 2007.[23] It had recently closed its regional offices, having 'largely abandoned the

effort to think [local] initiatives out for itself'. It consequently 'played no real part in the visual arts in Liverpool, apart from the rare despatch of an important exhibition to the Walker Gallery and the still rarer purchase of a local artist's work ... its local influence' was, at best, 'an indirect and intangible one'.[24]

There was virtually no regional arts administration or infrastructure. The first Regional Arts Association, the North East Association for the Arts, was established in 1961, as a joint enterprise by 50 local authorities stretching from Berwick on Tweed to North Riding, Yorkshire. It was supported by 1/8d rate, by private industry, trade unions and working men's clubs. It administered the Arts Council's funding for the region and supported an arts officer funded by the Calouste Gulbenkian Foundation. It was not until 1968 that a regional branch of the Arts Council was set up for Merseyside, which lasted until 1991 when it was absorbed into North West Arts.

Willett does not specify the extent of Liverpool Corporation's funding of the arts. But he mentions that in 1959/60 its Arts Sub-Committee had supported the Walker to the tune of £122,595 (equivalent to about £2,056,000 in 2007) and that £10,000 of municipal funds was devoted to acquisitions (approximately £168,000 in 2007).

The Gulbenkian, not yet ten years old, had already emerged as a major policy irritant and player. Having criticised state patronage for its lack of activity in the provinces, it recommended a policy of establishing high standards, increasing accessibility and allowing more scope for experimentation.[25]

Private support was crucial to Liverpool's visual arts. Willett singled out Granada's Northern Arts and Sciences Foundation and John Moores, the founder of the Littlewoods' pools and department stores.[26] The first biennial John Moores Contemporary Painting Prize was held in 1957, six years after the Walker re-opened after the Second World War. It was intended to enable the Gallery to mount 'an exhibition of painting embracing ... the best and most vital work being done today throughout the country' and to challenge London's increasing domination of the national arts scene. While the

event was open to anyone, by the early 1960s it had come to be regarded as the UK's leading showcase for avant-garde painting. Moores sponsored the prizes and purchased many of the prizewinning works for the Walker's collection.[27]

With the benefit of hindsight, it is possible to see that major national and local changes were on the way. Jennie Lee had been appointed as the country's first Minister for the Arts in 1964. Her White Paper, A Policy for the Arts: The First Steps (1965), recommended a network of regional associations and raised issues about problems of access and education. In 1967 the government extended the charter of the Arts Council of Great Britain to embrace work in the regions; the first urban programme was launched in 1968 to address areas of severe social deprivation; and, in Liverpool itself, plans were afoot to regenerate the Albert Dock – albeit for office development. But, at the time, Willett perceived little that was likely to upset the status quo:

> … there is a sense in which institutions do become established, and that is when they are so generally accepted that they go on running without anybody having a very clear idea what their purpose it. In Liverpool as much as elsewhere there is a reluctance to think clearly about these matters.[28]

Although some independent public art initiatives might, potentially, have changed things, as far as Willett was concerned they were ineffective – suffering from too many clichés, 'out of place' and 'out of scale'.[29]

> The lessons are surely that the commissioning of public art is at present undertaken too amateurishly, without enough sense of site and purpose; that symbolising pious sentiments like the resurgence of Liverpool is merely laughable unless they correspond to a strong public feeling; that the architect needs advice and the artist some awareness of scale and materials if their arts are to combine effectively; above all that once art gets out into

the open the pseudo-philosophising and the display of personal temperament which impresses gallery-goers or magazine readers matter less than a real feeling for the background – the background not only of the building in question but also of the city's climate and architecture and the hopes and needs of the people who live there.[30]

Aspirations

It has to be said that Willett was messianic about contemporary art. He believed it to be 'a great educational force' and envisaged potential new commissions that would become the heritage of the future – something that citizens could be proud of. These would make the city more attractive, and draw qualified employees and new firms to the area.[31] Perhaps even more importantly, he envisaged these new public art commissions as something that the people of Liverpool could enjoy for their own sake.

> If people need art it is not to bolster up their claim to be civilised but because it is an age old human activity, a continual delight to practice, study, or simply sit back and gape at; full of jokes, problems, explosions, sudden breath-taking beauties; something unpredictable that can be set against modern's life's mechanisms and routines.[32]

Ben Shaw had already insisted that quality was paramount – 'Particularly to those who don't know, only the best will do'. This was something that Willett regarded as axiomatic:

> People who are not used to painting and sculpture can still be swept off their feet by the sheer force and quality of something which they do not yet 'understand'. The initiated can afford to be interested in the second- or third-rate artist … The moral should be written out in letters of gold for all those concerned with disseminating and administering the arts.[33]

Willett acknowledged that the majority of people rarely visited galleries, so the incompatibility of 'generalised public taste' with such

institutions' expectations seemed relatively unimportant. But he knew that the situation on the street would be different. If Liverpool was to incorporate public art into its new plans, it had to include 'some that will be outstanding in our time and would bring credit to the city among the ... minority of art lovers throughout the world'. This implied

> ... works of possibly 'extreme' modern art which are bound to cause hot controversy in the city itself ... There is no point in authorities fighting aesthetic battles for the sake of inferior public art: the waverers will not be convinced, and if they were it would mean a lowering of standards.[34]

Willett's most fundamental assumption was that the visual arts could contribute to the city's redevelopment plans by

- humanising and beautifying the reconstruction of the city;
- strengthening its identity, both to its own citizens and to outsiders;
- stimulating a distinctive Liverpool art, particularly among the younger generation, and removing obstacles to visual self-expression;
- breaking down the barriers which isolate art and design as supposed inessentials; and
- creating an exciting atmosphere for persons and institutions concerned with art.[35]

Despite being a member of the *cognoscenti*, Willett was curious about people's awareness of art, their tastes and their grasp of the potential of art to 'embellish the city'.[36] In an early example of arts research, he surveyed samples of visitors to the Walker Art Gallery, children and staff at a comprehensive school and Littlewoods' employees. A relatively high percentage of his 368 respondents already had access to the visual arts and very few expressed any animosity towards it. But if, in theory, they accepted the idea that art was desirable and wanted more of it in their lives, in practice they largely overlooked what was already there. Willett was struck by the fact that people

identified neither the city, nor their own lives, with art.

Despite having no idea how representative his findings were, Willett's survey strengthened his resolve. He believed that he could identify a vote of confidence in a more active public art policy and that many of the resentments and resistances he had encountered could be overcome by generating local pride. According to a somewhat tautological logic, he imagined that acceptance and tolerance of a 'more go-ahead official policy' would only be created when Liverpool feels that she 'can assert herself visually as she has already asserted herself in sound and sport [...] If Liverpool really wants a more public art she will have to strike out on her own.'[37] He recommended that the Bluecoat Society of Arts, which had commissioned his enquiry, and the Corporation together set about realising that potential by:

- appointing a public art advisor, responsible to the Liverpool Corporation, who would commission works – potentially from an outstanding international artist. These could be planned by area of redevelopment and paid for through a percentage of building costs and possibly also supported by various patrons;
- even after the 1960 Coldstream Report, overhauling the entire system of art teaching, making it better co-ordinated, with an eye to encouraging professionalism and breaking down the barriers between design and manufacture, fine art and industrial design;
- facilitating a dealership for modern art;
- establishing a scheme for pictures in hospitals, touring works to factories, talks, loans to schools;
- encouraging a greater awareness of the city's historic and other visual attractions, and establishing a museum of the history of Liverpool.
- publishing a local news sheet concerned with the visual arts.

Forty years on – the visual arts and Liverpool now

> Liverpool is a city in transition. The centre has
> experienced a period of significant investment, £589
> million spent on Liverpool Vision projects alone since
> 2000 and a further £1 billion investment by Grosvenor
> in their Liverpool 1 retail development.[38]

Since the publication of *Art in a City*, Liverpool's social and
economic experiences have been dire: throughout the 1970s and
1980s its unemployment rates were about twice the national
average; the city lost more of its population than any of the
other core cities[39] – with 436,100 residents in 2006, the
population was 60 per cent of what it had been in Willett's time;
and, at one point in the 1970s, the city was blighted by as many
as 750 hectares of vacant and derelict land.[40]

Perhaps one of the greatest changes to have taken place in the
forty years since Willett's book is the rate of employment in the
city and the nature of that employment. Liverpool has shifted
from an industrial to a service economy:[41] in 2006 health and
social work accounted for 17 per cent of employment; education,
13 per cent; retail trade (except for motor vehicles), 10 per cent;
public administration, 10 per cent; hotels and restaurants, 11 per
cent.[42] Liverpool 08's ambitions included reinforcing that trend.

Although evidence of the city's changes and successes,
collected in 2008, indicates dramatic improvements across a
variety of social and economic indicators, Liverpool has still not
caught up with comparable cities and nor does it meet national
averages. According to the government's Index of Multiple
Deprivation it remains one of the most deprived cities in the UK:
in terms of employment deprivation, Liverpool is the second most
deprived area; in terms of income deprivation, it ranks third; in
terms of the proportion of population living in the most deprived
areas in the country, it ranks fourth; and for its overall score,
Liverpool ranks first.[43] Table 1 lists some of the social and
economic indicators used to assess Liverpool's position.

Table 1: Social and economic indicators for Liverpool

		Date	Liverpool	GB average
Education qualifications	Percentage of working age population qualified to NVQ 4+	2006	21.5%	27.4%
	Percentage of working age population with no qualifications	2006	23.2%	13.8%
Employment & unemployment	Unemployment rate	2006	9.1%	5.5%
	Percentage change in total employment	200-2006	14.9%	4.4%
	Employment rate	2006	63.5%	74.3%
Earnings & contribution to the economy	Full time median weekly earnings – workplace based	2007	£440	£459
	Gross Value Added per head	2005	£16,320	
	Percentage change in full-time workers' median weekly earnings – workplace based	2000-2007	24.3%	27.4%
Crime	Violence against the person – recorded crimes per 1,000 residents	2006-2007	27	19 (England & Wales)
	Burglary dwelling offences per 1,000 households	2006-2007	27	13 (England & Wales)
Heath & well-being	Percentage of residents with limiting long-term illness	2001	24.6%	
	Life expectancy	2004-2006	73.8m/78.3f	77.3m/81.6f

Source: M. Hutchins, *Make No Little Plans: The Regeneration of Liverpool City Centre 1999–2008. The Evidence Base* (2008), figs 27, 29, 32, 34, 35, 36, 38, 40, 42, 44, 45, Table 8; http://www.liverpoolvision.co.uk/documents/corporate.asp (accessed 10 July 2008)

Over the past twenty years, however – and, perhaps, contrary to expectations – Liverpool's visual arts have been flourishing. Willett's recommendations to the Bluecoat are now nothing if not a familiar aspect of arts practice. And far from being particular to Liverpool, they are typical of the visual arts and heritage throughout the country.

- Since the early 1980s, the burgeoning of public art, the appointment of public art officers, the creation of public art agencies and percent for art became typical of both urban and rural environments;[44]

- The teaching of art has been transformed as part of the ongoing reconstruction of the higher education system. University-validated degrees generally replaced diplomas from the 1970s, and formerly independent art schools merged with the former polytechnics (subsequently the 'new', or 'post-1992' universities). Courses increasingly reflect the government's emphases on the cultural and creative industries and entrepreneurialism. Whether this encourages greater professionalism across the board is open to question. However, the work of other agencies such as Creative & Cultural Skills and, to a lesser extent, cultural agencies is currently emphasising the development of skills, entrepreneurialism and leadership.[45]

- Since at least the early 1990s, the Arts Council has been conscious of the need to grow the market for contemporary art and encourage the sale of artists' work in a strengthened private sector outside London.[46] It is, for example, currently exploring the feasibility of investing in the development of emergent commercial galleries.[47]

- The Arts Council first introduced education into its agenda in the mid-1970s, appointing its first visual arts Education Liaison Officer in 1978 (with Gulbenkian funding) and creating an education unit in 1980. Museums and galleries were encouraged to undertake outreach and educational work from the mid-1980s onwards, recognising this as the most effective way in which to work with 'hard to reach' audiences.[48] Work around communities started in the late 1970s. By that time, Labour's National Executive (1977) had proposed that the arts could develop a sense of community and that Urban Aid Funding should be made available to local authorities to encourage community-based activities which might contribute to unified neighbourhoods, and help to overcome neglect, alienation and ultimately crime and vandalism.

- From the late 1990s, DCMS has encouraged greater awareness of England's historic attractions.[49] Related initiatives have included Liverpool's 2004 City Heritage Guide, providing 'inside information' for visitors, funded through DCMS's £13m Culture Online programme.[50] ACE is currently also committed to link 'contemporary art with art from the past and heritage'.[51]

In terms of Willett's specifically Liverpudlian objectives:

- His proposal for a museum of the history of Liverpool was realised in the Museum of Liverpool Life. This opened in 1993, closing thirteen years later to enable work on the building of the new Museum of Liverpool to begin. This is under the aegis of National Museums Liverpool (NML), which also incorporates the World Museum Liverpool, the Merseyside Maritime Museum and other museums.
- His proposal for a newssheet about the visual arts has been more than fulfilled by the plethora of online information now available.[52]

Various other of Willett's concerns have persisted: cultural organisations recently referred to wanting to create a distinct cultural identity; the difficulties of attracting sponsorship and, to a lesser degree, support from trusts and foundations; and their lack of capacity to work with international partners[53] – all of which were addressed by Liverpool's European Capital of Culture Year, Liverpool 08.

The visual arts and Liverpool's regeneration

Willett had already identified the potential of the visual arts to contribute to regeneration. By the early 2000s, when the bid for Liverpool 08 was being conceived, it had become standard practice to consider cities and their cultural assets in relation to the prosperity of regions, if not the national economy. Studies showed that those that supported culture generated returns of more investment, business growth and sustainable jobs and that creative people gravitated to cities with a rich and diverse cultural base.[54] 'A strong correlation between good design, quality public realm, investment in iconic buildings, positive image promotion, commerciality mixed with art and heritage and the increasing competitiveness in Europe and beyond' was perceived as constituting a recipe for success.

From the government's perspective, cities came to be regarded as 'economic assets' with 'great capacity to promote community development, social cohesion and civic and cultural identity'.[55] Their performances were measured and compared on the basis of demographic

and employment trends, indicators of social cohesion and economic performance.[56] In some quarters, the growth of cultural industries is taken to be a key indicator of the success of regeneration programmes.[57]

It was within this context that Liverpool's regeneration strategy (as articulated in its bid to become European Capital of Culture) focused on the development of the cultural infrastructure and the delivery of a cultural strategy. Beyond delivering Liverpool 08, the Culture Company's job is to create a sustainable cultural infrastructure, an inclusive and dynamic community, a premier European city and destination for culture, tourism and investment.[58]

The visual art sector is clearly part of that, but has become almost unrecognisable compared to how it was in the mid-1960s. The institutions that Willett was familiar with included

- the Walker Art Gallery, the Lady Lever Art Gallery and Sudley House, all now part of NML, established as the National Museums and Galleries on Merseyside in 1986. This is the only national museums group created in its own right within an English regional city and is one of 12 national museums in England and Wales;
- the Bluecoat, which reopened in 2008; and
- Liverpool School of Art & Design, which is now part of Liverpool John Moores University (formerly Liverpool Polytechnic) and the University of Liverpool's art collection, which was only recently re-housed in the refurbished Victoria Gallery & Museum. With the addition of Liverpool Hope and Edge Hill, the city now has four universities, which run various arts and media courses.

Since Willett's time, Liverpool has gained

- Tate Liverpool, the largest modern art gallery outside London, which opened in 1988 as part of the development of Albert Dock. One of a family of four

art galleries housing the UK's collection of British art from 1500 and international modern art, it was intended to share the Tate collection with the North of England.

- FACT, the Foundation for Art & Creative Technology, which was originally founded in 1985 as Merseyside Moviola. As the UK's leading organisation for the commissioning and presentation of film, video and new media art forms, it opened a new centre in 2003, Liverpool's first purpose-built cultural venue in over sixty years.

- The Liverpool Biennial, which is the UK's largest festival of contemporary visual art. It was established in 1998 with funding from James Moores and the support of his A Foundation. Since its inception, it has commissioned well over 100 new works, many for the streets and public spaces of Liverpool. It also provides an umbrella for Bloomberg New Contemporaries, the Independents Biennial and the John Moores Painting Prize. Willett had called for outstanding international artists to work in the city:[59] recent commissions the Biennial has been involved in include Antony Gormley's *Another Place*, comprising 100 cast-iron sculptures now permanently installed on Crosby Beach, and Richard Wilson's *Turning the Place Over*, which literally turns Cross Keys House, Moorfields, inside-out.[60]

- The A Foundation, which was established by James Moores in 1998 to support the development, production and exhibition of contemporary visual art and focus on the enrichment and regeneration of Liverpool through culture and the arts. It provided the initial support for the Biennial, and funds the New Contemporaries and the John Moores Painting Prize. In 2006 A Foundation opened three gallery spaces in former industrial buildings in Greenland Street, in the heart of Liverpool's old dock warehouse area, where it has an annual programme of major new commissions.

- Open Eye, which continues to present a range of lens-based exhibitions in its current premises in Wood Street, the third space it has occupied since it was established in 1977 as a photography gallery.
- New museums in the NML group, which include the Merseyside Maritime Museum (1986), the National Conservation Centre (1996), World Museum Liverpool (2005), the International Slavery Museum (2007), Museum of Liverpool Life (1993) and its successor institution, the Museum of Liverpool, due to open 2010/11.

Other parts of the wider visual arts infrastructure have also expanded: Arts in Liverpool.com lists 31 'main galleries',[61] Liverpool is reputed to be the third (after London and Manchester) most creative city in the UK,[62] and the creative economy in the North West is said to be second only to London and the South East.[63] The city was home to several of the first attempts to develop the creative industries: the first film office was established in Liverpool in 1989, North West Vision & Media, and the 1990s saw the setting up of the Moving Image Development Agency, the Design Initiative (a specialist regional agency), the International Centre for Digital Content (based at LJMU), which helps businesses and other organisations to understand how digital technology can benefit them,[64] and Merseyside ACME (Arts, Culture and Media Enterprise), which supports the creative industries sector in Merseyside.[65]

Accounting for the difference

But what was it that enabled Liverpool's visual arts sector to grow so much, so fast? The short answer is 'public investment' – albeit investment in cultural education or investment intended to encourage cultural consumption, deepen understanding of existing cultural forms and innovation in new ones, construct new facilities and renovate others, regenerate and strengthen communities and build networks and encourage agglomeration effects or clusters.[66]

Like a number of other English cities currently going through their own urban renaissance, such as Newcastle, Manchester, Birmingham and Leeds, Liverpool's current affluence is the direct result of a combination of national and European policies and the government's support of cities, in particular:

All English cities have done well during the last ten years, even if they have not caught up with the most successful European cities. Liverpool has shared in and benefited from that wider urban recovery … The national economy has boomed. Public expenditure has been high. Public investment in cities has been big. And Liverpool particularly benefited from large amounts of European investment.[67]

Liverpool's visual arts boom reflects that reality. Its origins lie in two projects which were supported, if not initiated, by the Merseyside Development Corporation (1981–88), which was a central government-appointed agency set up to regenerate the Merseyside docks.

● The Liverpool Garden Festival was the first of a series of international, biennial Garden Festivals, which ran from 1984 to 1992. Based on the German post-war *Bundesgartenschau*, they were intended to regenerate large areas of derelict and contaminated land in Britain's industrial districts: in the case of Liverpool, the festival gardens occupied a 950,000 square-metre derelict industrial site south of Herculaneum Dock. The idea of featuring art came from the then Director of the Walker Art Gallery, whose John Moores exhibitions were the focus for contemporary art in Liverpool. He wanted to emulate the 1951 Festival of Britain, and provide a complement to the Victorian and Edwardian sculptures in Sefton Park.[68] The festival was enormously popular: it is reported to have attracted over 3 million visits. The Beatles-inspired *Yellow Submarine*, built by apprentices from Cammell Laird shipyard, is still a city landmark.

● The new Tate of the North, as was, was accommodated
 in a converted warehouse in the Albert Dock in 1988
 – part of a complex of buildings that was registered in
 1952 as the largest group of Grade 1 Listed buildings
 in Britain, but had fallen into near dereliction before
 being closed in 1972. The new gallery was sited
 alongside shops, offices and apartments and the
 Merseyside Maritime Museum, which opened two years
 previously. The Albert Dock is now part of Liverpool's
 'Maritime Mercantile City', which was made a
 UNESCO World Heritage Site in 2004. The site,
 which stretches along the waterfront from Albert Dock
 to the Pier Head and up to Stanley Dock, and up
 through the historic commercial districts and Rope
 Walks to the cultural quarter, has attracted investment
 from English Partnerships, Northwest Regional
 Development Agency (NWDA), and European
 Objective One[69] and is now home to most of the visual
 arts organisations mentioned in this chapter – the
 Walker, the Bluecoat, Tate Liverpool, various NML
 sites and FACT.

But where did subsequent investments for the visual arts
infrastructure come from, and how much did they provide? Some
funding is more easy to account for than others.[70]
 In 1967 Willett referred to Arts Council funding for the
visual arts nationally (with the exclusion of the North East) as
having been £55,000 (equivalent to about £720,000 in 2007). In
2007/08, ACE's annual revenue funding to its regularly funded
visual arts organisations in the North West alone was
£3,992,104.[71] This implies that the value of ACE support to the
region has increased by a factor of 44. Table 2 lists other sources
of organisations' annual revenue and programme funding.

Table 2: The funding of Liverpool's visual arts organisations and museums

Organisation	Project	Funders	Date of award/ completion of project	Amount
National Museums Liverpool[1]	Grant in aid	DCMS	2007/08	£22,000,000
The Bluecoat[2]	Revenue/ programme funding	ACE NW; Liverpool City Council; Liverpool Culture Company; Esmée Fairbairn Foundation	2007/08	£1,070,897
Tate Liverpool[3]	Grant in aid	DCMS	2007/08	£36,000,000
FACT[4]	Revenue funding	ACE; Liverpool City Council	2005–08	£5,300,000
	Programme grants	Arena Housing; ACE; Wellcome Trust; UK Film Council; Liverpool City Council; Liverpool Vision; Liverpool & Sefton Health Partnership; Liverpool Culture Company; Gulbenkian Foundation; First Light; enquire	2005–08	£1,100,000
Liverpool Biennial	Annual revenue/ programme funding[5]	ACE; Liverpool City Council	2006/07	£728,300
	All other income[6] (includes grants, sponsorship, earned income, public art income)	Gulbenkian; NWDA; Mersey Forest; Forestry Commission; Henry Moore Foundation; Objective 1; Ernest Cook Trust; Eleanor Rathbone Charitable Trust; Creative Partnerships; UE Culture Programme; Granada Foundation and others	2006/07	£2,419,847
A Foundation[7]	Funding for A database	ACE	2008/09	£70,000
Open Eye[8]	ACE annual funding	Liverpool City Council; Liverpool Culture Company; trusts & foundations; sponsorship	2007/08	£166,000
			Total	**£68,855,044**

2007 values are calculated with the Bank of England inflation calculator, http://www.bankofengland.co.uk/education/inflation/calculator/flash/index.htm

[1] This figure is for all NML venues and cannot be disaggregated (DCMS, Funding Agreement 2005–2008 NML. Funding Agreement between The National Museum Liverpool and The Department for Culture, Media and Sport [2006], http://www.culture.gov.uk/images/publications/fa_nml.pdf accessed 10 July 2008).

[2] http://www.nwda.co.uk/news--events/press-releases/200801/cultural-secretary-at-bluecoat.aspx (accessed 11 July 2008).

[3] This figure is for all Tate venues and cannot be disaggregated (DCMS, Tate Funding Agreement 2005/06–2007/08 [2006], http://www.culture.gov.uk/images/publications/fa_tate_0506_0607.pdf accessed 10 July 2008).

[4] Correspondence with Mike Stubbs, 4 July 2008.

[5] Correspondence with Lewis Biggs, 30 June 2008. Figures shown are for a year in which the Biennial took place. Figures for 2007/08: ACE and LCC revenue funding £698,275 (ACE gives less in non-Biennial years); all other income was £1,183,605 (including some received against the 08 programme).

[6] http://www.biennial.com/content/Footer/Supporters1.aspx (accessed 11 July 2008). As with some other organisations, the Biennial's annual turnover may vary considerably according to the scale of projects involved in any one year.

[7] http://www.afoundation.org.uk/afoundation/support.php (accessed 11 July 2008).

[8] http://www.openeye.org.uk/history.asp (accessed 11 July 2008).

The majority of the funding sources that visual arts draw on did not exist in 1967. These mainstays of arts funding include the National Lottery, launched in 1994. This was initially intended to support five good causes: the arts, heritage, charities, sport and projects to mark the beginning of the third millennium – each with its own funding distributor. Between 1995 and 2008, £816m worth of lottery grants went to cultural projects (arts, millennium and heritage) in the North West (Table 3).

Table 3: Lottery funding distributed in the North West region – total monetary value and total grants awarded, 1995–2008

	Arts	Heritage	Millennium	Total
£	272,228,427	431,242,806	112,118,181	815,589,414
No of grants	4,501	1,541	297	6,339

Source: A. Gilmore, 'Quality of Life', in NWDA, *Culture & Image.* Evidence Paper 23 (2008), p. 23, http://www.nwriu.co.uk/2489.aspx (accessed 11 August 2008)

Table 4 provides an overview of the total value of funding for specific capital developments. NML's developments are valued in the region of £189m. By comparison (and excluding the Walker Art Gallery's capital development costs which were included in NML's *Into the Future* scheme), visual arts organisations' capital development projects have received the equivalent of about £57m since the late 1980s. Compared to the level of support for the Baltic, Gateshead – a £46m capital development funded by ACE, with an endowment of £7.5m – this seems very little. Moreover, Liverpool's capital funding has been manifestly piecemeal, comprising smaller amounts raised from a larger number of organisations, as the notes to Table 4 reveal. The organisations themselves identified regeneration agencies, the EU and the Lottery as their most important sources of capital funding (Table 5).

Table 4: Funding for visual arts capital development projects

Organisation	Project	Amount	Date of award/ completion of project	2007 value
Museum of Liverpool Life, World Museum, Walker Art Gallery, storage[1]	Into the Future	£44,977,000	2005	£48,403,876
Lady Lever Art Gallery	Improving access & facilities: Phase 1. New entrance[2]	£529,000	2007	£529,000
	Phase 2: new gallery[3]	£451,000	2008	£451,000
World Museum Liverpool	Extension[4]	£35,000,000	2005	£37,666,710
	Egyptian gallery[5]	£600,000	2008	£600,000
International Slavery Museum	New museum[6]	£4,048,000	2007	£4,048,000
National Conservation Centre	New site[7]	£10,160,000	1996	£13,745,683
	New display: ReVeal[8]	£957,000	2006	£998,023.00
Museum of Liverpool[9]	New museum	£71,668,000	2010/11	£71,668,000
Merseyside Maritime Museum	New display[10]	£200,000	2002	£234,499
	New gallery – Seized: revenue & customs uncovered[11]	£913, 000	2008	£913, 000
NML[12]	Capital allocation	£8,500,000	2008–11	£8,500,000
Sudley House[13]	Refurbishment	£1,123,000	2007	£1,123,000
Walker Art Gallery: Children's Gallery[14]	New display	£574,000	2006	£598,605
	Sub total	**£178,787,000**		**£188,566,396**
Tate Liverpool	New museum: Phase 1[15]	£6,500,000	1988	£12,562,248
	New museum: Phase 2[16]	£6,940,000	1998	£8,801,899
FACT[17]	New building	£10,000,000	2003	£11,395,414
Liverpool Biennial	Initial support[18]	£1,300,000	1998–2000	£1,577,106
	Public Art Programme[19]	£1,200,000	2007 & 2008	£1,200,000
The Bluecoat[20]	Refurbishment and new wing	£12,500,000	2008	£12,500,000
Victoria Gallery & Museum[21]	Refurbishment	£8,600,000	2008	£8,600,000
	Sub total	**£47,040,000**		**£56,636,667**
	Total	**£225,827,000**		**£245,203,063**

2007 values are calculated with the Bank of England inflation calculator,
http://www.bankofengland.co.uk/education/inflation/calculator/flash/index.htm

[1] All NML data (unless otherwise specified) was sourced through correspondence with Sue Senar, NML, 22 July 2008 and 11 August 2008. Major funders for this project included HLF, Objective One, NWDA, Littlewoods. Other supporters included: Garfield Weston Foundation; Clore Duffield Foundation; Professor E. Rex Makin, Shirley Makin and family; Esmée Fairbairn Foundation; Friends of National Museums Liverpool; Aldham and Avril Robarts; Professor Phil Redmond and Mrs Alexis Redmond; Lankelly Foundation; PH Holt Charitable Trust; Mersey Television Company Ltd; the late Susan Cotton; MEPC plc; Wolfson Foundation.

[2] DCMS/Wolfson Foundation Museums and Galleries Improvement Fund (£225,000); other (£304,000).

[3] HLF (£275,000); other (£178,000).

[4] HLF (£32m) from the Into the Future Fund; European Objective One Programme for Merseyside (£3.65m) and NWDA (£1.9m). Major donors included Garfield Weston Foundation; Littlewoods plc; Clore Duffield Foundation; Professor Rex and Shirley Makin; Esmée Fairbairn Foundation; Friends of National Museums Liverpool; Granada Foundation; Lankelly Foundation; Oliver Stanley Charitable Trust; Professor Phil Redmond and Mrs Alexis Redmond; Mr and Mrs Aldham Robarts.

[5] DCMS/Wolfson Foundation Museums & Galleries Improvement Fund; Tomlinson Bequest; Sir Richard Foster Memorial Fund.

[6] HLF (£1.65); DCMS (£500,000); NWDA; estate of the late Molly Tomlinson.

[7] City Challenge (£1.438m); ERDF (£2.868m); Department of National Heritage (£3.325m); other (£2.53m). Correspondence with Sue Senar, NML, 13 August 2008.

[8] ReDiscover Fund (Millennium Commission, Wolfson Foundation & Wellcome Trust).

[9] Source: DCMS, 'James Purnell announces extra Arts funding – £50 million by the third year of settlement', media release 11 July 2007 [updated 22 November 2007] http://www.culture.gov.uk/reference_library/media_releases/2233.aspx (accessed 10 July 2008).

[10] Merseyside County Council; Merseyside Development Corporation.

[11] Source: correspondence with Sue Senar, NML, 22 July 2008 and 11 August 2008.

[12] Source: DCMS, 'DCMS sponsored Museums and Galleries in England to get £191 million capital investment over three years', media release 15 February 2007, http://www.culture.gov.uk/reference_library/media_releases/2200.aspx (accessed 10 July 2008).

[13] Source: correspondence with Sue Senar, NML, 22 July 2008 and 11 August 2008.

[14] Source: correspondence with Sue Senar, NML, 22 July 2008 and 11 August 2008.

[15] Merseyside Development Corporation (£4.5m); Office of Arts and Libraries (£0.5m); trusts and foundations, companies and private donors (£1.5m). (Source: correspondence with Helen Watters, 30 June 2008).

[16] HLF (£3.8m); ERDF (£1.5m); trusts and foundations, companies and private donors (£1.64m). (Source: correspondence with Helen Watters, 30 June 2008).

[17] ACE; NWDA; ERDF; Liverpool City Council; English Partnerships; bfi; Granada Foundation; City Screen. (Source: correspondence with Mike Stubbs, 4 July 2008).

[18] James Moores. (Source: correspondence with Lewis Biggs, 30 June 2008).

[19] Liverpool Culture Company. (Source: correspondence with Donna Campbell, 7 July 2008).

[20] ACE; HLF; NWDA; Objective One, and foundations, trusts and private funding. (Source: correspondence with Anna Cassidy, 3 July 2008).

[21] Jenny Rathbone; Estate of the late Marian Thomason; Linbury Trust; Friends of the University of Liverpool; PH Holt Foundation; Pilgrim Trust; Henry Moore Foundation; Professor Drummond and Vivian Bone; Sir Neil and Lady Cossons; Dr and Mrs Michael Potts; Sir Howard and Lady Newby; Stone City Films; University of Liverpool Women's Club. (Source: http://www.liv.ac.uk/vgm/support.htm).

Table 5: Summary of capital funders

		Walker Art Gallery	Lady Lever Art Gallery	The Bluecoat	Victoria Gallery & Museum	Tate Liverpool: Phase 1	Tate Liverpool: Phase 2	FACT	Liverpool Biennial	A Foundation
	Public sector									
Local authority	Liverpool City Council							■		
DCMS	DCMS/OAL					■				
	DCMS/Wolfson =		■							
Lottery	ACE/ACE Lottery			■				■		
	HLF	■	■					■		
EU	ERDF						■	■		
	Objective One	■		■						
Regeneration	English Partnerships							■		
	Merseyside Development Corporation					■				
	NWDA	■		■				■		
Other	BFI							■		
	Trusts & Foundations									
	A Foundation/ James Moores								■	■
	Granada Foundation							■		
	Corporate									
	Littlewoods	■								
	City Screen							■		

Regeneration funding for specific projects and programmes has also been of major importance to the sector. This is nothing new: back in 1987, a report to the Office of Arts & Libraries revealed that the Manpower Services Commission's funding of arts projects in Merseyside exceeded that of Merseyside Arts and Liverpool City Council combined.[72]

The NWDA leads the economic development and regeneration of the region, developing business competitiveness and improving the skills base. A government-sponsored public body, set up in 1999, its priorities include business, skills and education, people

and jobs, infrastructure and quality of life. Quite apart from its capital funding for Liverpool's visual arts organisations (Table 6), it will have invested some £4.6m in direct commissions, enhancement of proposed programmes and grants between 2007 and 2008. As the director of the Liverpool Biennial put it, such funds – which are so important a part of the visual arts' income – are tied to particular developmental functions:

> The spending of funds from local, regional and national sources are still – in 2008 – being assessed against instrumentalist criteria that relate to policy objectives for tourism and other parts of the economy, for social inclusion, for education and even for health. We are looking forward to seeing the Ministerial statements of the past three years (to the effect that art is good in itself) reaching down to the level of accountability, and maybe Brian McMaster's report, which recommends peer review of excellence as the only criterion for evaluation, may be the mechanism to deliver.[73]

Table 6: NWDA funding of the visual arts, 2007–2009

Public Art Programme (Biennial)	£1,200,000	2007 & 2008
Enhancement of Cultural Partners programmes (FACT, The Bluecoat, Open Eye, etc.)	£1,735,000	2007 & 2008
Direct commissions	£574,000	2007 & 2008
Film	£200,000	2007 & 2008
Arts & Cultural Grants	£110,674	2007–2009
ACE Regularly Funded Organisations	£734,064	2008–2009
Total	£4,553,738	

Source: Correspondence from Donna Campbell, 7 July 2008

A major factor in visual arts organisations being able to access such funding is their increasing compliance with instrumentalist policy agendas. Eight leading arts institutions in Liverpool – the Bluecoat, FACT, Liverpool Biennial, Tate Liverpool, NML, the Liverpool Everyman and Playhouse, Royal Liverpool Philharmonic and the Unity Theatre – have established a

partnership to ensure that cultural organisations play a key role in the regeneration of Merseyside. LARC (Liverpool Arts Regeneration Consortium) contributes to the city's regeneration by 'releasing the creativity and aspirations of the people of Merseyside. Its aim is to enable people of all ages to fulfil their own potential and to play a full role in the social and economic renewal of Merseyside.' The partnership is currently involved in two major publicly-funded projects: one, backed by £1.34m from ACE's *Thrive* programme, will enable it to test a new model 'for embedding the arts and cultural sectors in the processes of social and economic renewal';[74] the other involves one of the ten pilots for the government's £25m *Find your Talent* programme, intended to give young people the chance to encounter a range of high-quality cultural experiences for five hours a week both in and outside school (DCMS/DCSF, 2008). At the time of writing, the planning budget was around £3.9m (60% of which is likely to be government funding).[75]

● Tables 4 and 5 suggest that European funding, in particular ERDF (European Regional Development Fund) and Objective One, have been crucial to several of Liverpool's visual arts' capital developments. Access to such funds is dependent on the state of the regional economy: the ERDF is intended to stimulate economic development in the less prosperous regions of the EU and to help to redress regional imbalances; Objective One funding (1994–2000 and 2000–2006) is intended to help regions to improve their economic performance. It is targeted at the most deprived areas of Europe and focuses on developing business, people, locations and communities. To be eligible, a region had to be 'under-performing' against the EU average (i.e. below 75 per cent of the average performance, as measured by Gross Domestic Product per head of population).[76] The total cost of projects funded under Merseyside's Objective One programme for 2000–2006, (including other public, voluntary and private sector contributions) is over £2.3 billion.

- The Liverpool Culture Company, which was set up in 2000, constitutes another new source of funding. Between 2005 and 2008, its budget was £94.9m and its plans were to increase revenue spending on culture by £22.5m by 2008, budgeting £22.6m for 2007 and 2008.[77]

Delivering on expectations

It is standard practice in the subsidised cultural sector to look for positive proof of the arts and cultural sector's environmental, economic or social impact – from the perspective of both public funding and corporate social responsibility. Evans and Shaw, for instance, described deliberately searching for evidence 'of culture as a driver, a catalyst or at least a key player in the process of regeneration of renewal' for DCMS.[78] The requirement for reporting those is often driven by advocacy – justifying support already received or supporting requests for future funding.

In the event, not all projects deliver what might have been expected. Nowhere is this more conspicuous than in the visible legacies of major regeneration projects – the Millennium Dome being the most obvious. The Liverpool Garden Festival was intended to create a unique riverside parkland gifted to the city 'for all to share'. After it closed, the site changed hands several times and, in the event, only half was used for residential housing. Twenty-five years on, the development of the rest of the site remains a matter of contention. Despite the fact that it has returned to dereliction and attracts vandalism and other anti-social behaviour, campaigners from Save the Festival Gardens have protested about the detrimental impact that a £250m plan to build more than 1,300 houses would have on the local wildlife and the Mersey promenade.[79]

The benefits of generations' worth of regeneration investment in Liverpool, more generally, have been much debated. A National Audit report of 1988 reviewed the difficulties of the Merseyside Development Corporation's various schemes.[80] Post-millennium, a leading American urban commentator observed that the city still had 'a lot to do, but a lot to do it with' – highlighting the dilemma of the

relationship between the city's problems, its potential and the effective management of its resources.[81] Nevertheless, it has been proposed that, despite continuing to be regarded as 'our most troubled provincial city', Liverpool was beginning

> ... to pick itself up from its self-made disasters of the 1980s. Its Labour Party is changing its spots. The local private sector, at least, is beginning to face up to its responsibilities. Civic leaders complain less and shoot themselves in the foot less. They co-operate with, rather than rail against, government policy. Ten years ago, under the Hattonistas, the political talk was of riots, revolt and no surrender – now it is of European programmes and partnerships. A less compelling news story. But better politics. And many things in the city have got better. The waterfront has been transformed with the best skyline in this country – and many others. The culture, tourism and leisure industries are flourishing. The technology park is successful. Higher education is booming. Brussels insists that Merseyside's innovative social programmes are a model for the rest of Europe. The population loss is being staunched and people are moving back into the city centre to live. Shopping is improving and the city is even getting its first four-star hotel. The thriving club scene means Liverpool is almost as busy at four o'clock on Saturday morning as it is on Saturday afternoon. Hardly a miracle – but far from a disaster zone.[82]

If 'better politics' – the attitudes of local politicians, the local authority's relationship to central government and the city's relationship with Europe – are vital to a city's potential successes, it follows that they may also be crucial to the development of its visual arts. It is unclear whether the anecdote about NML being created in 1986 in order to protect the collections from any potential action by Militant Tendency has any truth in it: the official line is about the 'outstanding quality of the city's collections'.[83] But it is certainly the case that, since the late-1980s, the city's museums and galleries have received increased government support, if not favoured status. Table 7 highlights the number of DCMS projects that Liverpool has been associated with in recent years. Indeed,

the former Secretary of State for Culture, Media and Sport touted Liverpool as an example of 'the "new" economy. An economy in which culture pays'[84] and promoted Liverpool 08 as an exemplar for the Olympics: 'We'll learn from what you are doing here in Liverpool. And after 2008, the road leads to 2012.'[85]

Table 7: Liverpool's contribution to DCMS projects

Year	Organisation	Project/purpose	Value	Total funding available
2002	City of Liverpool[1]	Department's Space for Sport and Arts programme to modernise or build new multi-use halls, new music and arts studios and other facilities	£3,500,000	
2003	Liverpool City Council and Liverpool Culture Company	Wins UK's nomination for European Capital of Culture, 2008		
2004	Liverpool City Council and Liverpool Culture Company[2]	One-off boost for Capital of Culture programme	£5,000,000	
2004		Funding set aside to facilitate links between Liverpool's plans for 2008 and programmes of other ECOC cities[3]		£200,000
2004		Funding to assist with securing EU ratification of Liverpool's nomination for Capital of Culture[4]	£100,000	
2004/06		Liverpool eligible to bid for Urban Cultural Programme funded by ACE and Millennium Commission[5]	£1,200,000	
2004		Publishes City Heritage Guide, providing 'inside information' for visitors, funded though Culture Online[6]		£13,000,000
2005	Central Library and Archive[7]	Transformation of Liverpool's Central Library and Archive, cultural quarter improvement of access and services to the public	£47,900,000	
2005	Liverpool City Council and Liverpool Culture Company[8]	Chosen to host Cultural Pathfinders projects, showing how culture can help deliver government priorities across public life. 'It's Not OK' was aimed at changing young people's attitudes towards violence and reducing alcohol-related violence and harm		
2008	The Bluecoat, FACT, Liverpool Biennial, NML, Tate Liverpool[9]	Committed to delivering on the government's creative apprenticeships		
2008	LARC[10]	Find your Talent	to be agreed	

[1] DCMS, 'Huge Boost to Primary School Sports and Arts Facilities in England', media release, June 2002, http://www.culture.gov.uk/reference_library/media_releases/2830.aspx (accessed 10 July 2008).

[2] DCMS, 'Spending Review 2004 – Tessa Jowell Heralds "Record Rise" for Museums and Galleries Funding in England', media release, 16 April 2004, http://www.culture.gov.uk/reference_library/media_releases/2430.aspx (accessed 10 July 2008).

[3] DCMS, 'Culture Secretary welcomes £15 million lottery grant to support European Capital of Culture legacy', media release, 1 August 2004, http://www.culture.gov.uk/reference_library/media_releases/2340.aspx (accessed 10 July 2008).

[4] DCMS, 'Culture Secretary welcomes £15 million lottery grant to support European Capital of Culture legacy', media release, 1 August 2004, http://www.culture.gov.uk/reference_library/media_releases/2340.aspx (accessed 10 July 2008).

[5] http://www.culture.gov.uk/reference_library/publications/3687.aspx (accessed 11 July 2008).

[6] DCMS, 'City Heritage Guides launched in ten cities across England', media release, 11 May 2004, http://www.culture.gov.uk/reference_library/media_releases/2329.aspx (accessed 20 November 2008).

[7] DCMS, 'Tessa Jowell Announces £130 Million Boost for Library and Sports Projects under Private Finance Initiative', media release, 11 March 2005, http://www.culture.gov.uk/reference_library/media_releases/3057.aspx (accessed 10 July 2008).

[8] DCMS, 'Thirteen Local Authorities in England to become Cultural Pathfinders', media release, 2 May 2005, http://www.culture.gov.uk/reference_library/media_releases/3068.aspx (accessed 10 July 2008).

[9] DCMS/BERR/DIUS, 'From the Margins to the Mainstream – Government unveils new action plan for the creative industries', joint press release, 1 July 2008, http://www.culture.gov.uk/reference_library/media_releases/2132.aspx (accessed 10 July 2008).

[10] DCMS/DCSF, 'Five hour "find your talent scheme" moves a step closer with ten pilot areas named', media release, 4 July 2008, http://www.culture.gov.uk/reference_library/media_releases/5149.aspx (accessed 10 July 2008); correspondence with Belinda Kidd, 9 July 2008.

DCMS's expectations are, however, not exclusively fixated on Liverpool 08. While its aims may not be as explicitly instrumental as those of the development agencies, the department is nevertheless committed to improving the quality of life for all through cultural activities and championing the tourism, creative and leisure industries alongside supporting the pursuit of excellence.[86] Interestingly, its *Culture at the Heart of Regeneration*[87] chimed with many of Willett's recommendations, even though its emphasis was conspicuously on people and community, rather than art and artists:

- community consultation and participation are vital – leading to pride in public arts and design;
- the revitalisation of the historic environment contributes to successful regeneration because people want to live in an interesting and attractive place;
- mixed-use developments, which are a feature of many vibrant, regenerated areas, extend the appeal to a wider range of people;
- better design and planning encourage usage of local public services, such as libraries, healthcare, education and transport; and
- participation in cultural activities delivers a sense of belonging, trust and civic engagement, bringing far-reaching benefits including improvement in education and health, and reduction of crime and anti-social behaviour.

Liverpool's bid to be European Cultural Capital was nothing if not strategic: it emphasised the fact that the city mirrored the EU's aspirations, challenges and concerns around regeneration, unemployment, new technologies and cultural identity,[88] and it promised to deliver on a dozen local, regional, national European and worldwide objectives. In terms of Liverpool, for example, it anticipated

- increasing community participation in cultural activity – 300,000 people (75 per cent of the city's population);
- securing an extra 1.7 million visits by 2012, through new projects and the Capital of Culture 'legacy effect';

- creating city-wide investment of over £2bn by public and private sector partners up to 2008;[89] and
- creating 14,000 jobs in Liverpool's cultural sector (defined as tourism, sports, heritage and the creative industries) by 2012 based on trend growth, new cultural investments and a successful European Capital of Culture 2008.[90]

The visual arts

Even if the exact scale of investment in its visual arts is uncertain, within the context of what has been referred to as the 'new accountability' one might ask what they are contributing to the 'new' Liverpool. How has the investment paid off?

In terms of Liverpool 08, the visual arts only constitute one element of the city's cultural activities. Like those, they are 'perceived as contributing to the image, perceptions, attractiveness and quality of life in the region for visitors, residents and inwards investment and providing the economic impact from enterprise and in relation to major events'.[91] One of the intended outcomes of Liverpool 08 is to re-position the city's national image[92] and artists are regarded as having a potentially large contribution to make to this: 'Urban renewal is often about changing the perception of an area – artists have a potentially large role here as they can get to the essence, the heart, the soul of an area'. [93]

Much has been said about Liverpool, in its capacity as European Capital of Culture, 'breaking the spiral of decline', creating 'a sense of pride', and giving 'confidence to people who would never have thought of investing in the city to do so'.[94] An analysis of the city's press coverage between 1996 and 2005, leading up to the 12-month celebration of European Capital of Culture, showed a dramatic increase in stories about culture and the arts, with art galleries and the visual arts being one of the dominant sub-themes attracting positive coverage.[95]

Despite much discussion in DCMS about the value of the arts residing in their support of instrumentalist agendas or promoting excellence,[96] how to identify, understand and measure the benefits of cultural investment – particularly the intangibles

– remains problematic. In assessing success, the default has often been to classical economics, perhaps because profits, losses and economic impact can be calculated (albeit accurately or not), articulated in quantitative terms, and understood, and because it is most likely to speak to the Treasury. DCMS has recently reinforced that by commissioning an economics consultancy to design a framework for evaluating cultural policy[97] and it proposes that education and skills development and the creation of new products can be measured in terms of economic benefit.

Doubtless, this convention accounts for the very considerable emphasis on the visual arts' capacity to generate large numbers of visits and create economic impact. The last few years, for example, have seen museums and galleries commissioning impact studies, for advocacy purposes as much as anything else.

- The study *National Museums Liverpool. Its Impact on Liverpool and the North West*[98] revealed that more than 1.5m visits are made to the seven venues that make up NML, more than twice the number in the late 1990s; that the museums' combined expenditure was £25m; their annual turnover in 2004/05 was £30.2m and expected to hold. NML's economic impact was estimated to be between £69.9m and £74.6m.[99]
- NWDA reported that visitor numbers to Liverpool Biennial rose from 100,000 in 2001, and 350,000 in 2004, to 400,000 in 2006 and that its economic impact increased from £11m in 2004 to £13m in 2006.[100]
- Tate Liverpool's *Economic Impact Study of the Turner Prize 2007* estimated that the exhibition generated over £10m to Liverpool in terms of visitor spend. It received 72,000 visits (54% of which were by people residing outside Merseyside and a further 10% by overseas visitors). In return for every £1 of public money granted to the Turner Prize, over £4 was generated for the city in economic benefit, and in return for every £1 of public money granted to the exhibition, over £32 was generated for the city in positive PR.[101]

Even the benefits of individual projects are evaluated in terms of attracting increased partnership funding and/or generating more activities and outputs per £.[102]

But, however many visits the visual arts generate, and however many outputs they deliver, questions inevitably hang over their future. Despite, if not because of, the successful creation of a visual arts infrastructure in Liverpool over the past twenty years, sustainability is an issue. The visual arts sector, in general, is heavily reliant on subsidies: according to ACE's own data, of all the art forms that it supports, the visual arts are the least likely to generate income and are the most dependent on public subsidies.[103] Boris Johnson famously criticised Liverpool, among other things, for an 'excessive predilection for welfarism'.[104] The juxtaposition of the two observations might imply that the visual arts in Liverpool are extraordinarily vulnerable. It is not so much a prediction as a foregone conclusion that during the next ten years 'things will not be the same. The economy will be less buoyant. There will be much less government money for cities. European funding will virtually dry up.'[105] The 2012 Olympics are already taking their toll on HLF funding. The question is, how will Liverpool retain its position as 'Art City'?

[1] I am grateful to Bryan Biggs, Artistic Director, the Bluecoat, for inviting me to write this chapter and for his considerable patience while I did so. I would like to thank Abigail Gilmore, Director, Northwest Culture Observatory; Andrew Lambert, Web Content Assistant, National Audit Office; Helen Watters, Directors' Office, Tate Liverpool; Lewis Biggs, Director, Liverpool Biennial; Anna Cassidy, Development Manager, the Bluecoat; Mike Stubbs, Director, FACT; Sue Senar, Financial Information Services, National Museums Liverpool; Donna Campbell, Executive Producers' Assistant, Liverpool Culture Company; Belinda Kidd, Programme Director, LARC; Ruth Melville, Programme Manager, Impacts 08 – The Liverpool Model, European Capital of Culture Research Programme; Athina Mermiri, Researcher & Evaluator, A&B; Roger Beaton, Public Information & Enquiries Group, Bank of England – all of whom have generously answered my questions and provided me with information.

[2] John Willett, *Art in a City* (London: Methuen, 1967; repr. Liverpool: Liverpool University Press and the Bluecoat, 2007), p. 11.

[3] Burnham cited in M. Parkinson, *Make No Little Plans. The Regeneration of Liverpool City Centre 1999–2008* (Liverpool: Liverpool Vision, 2008), frontispiece.

[4] Department for Culture, Media and Sport, '"Places to live must be living places" – Tessa Jowell sets out vision for successful cultural regeneration', media release 8 March 2004, http://www.culture.gov.uk/reference_library/media_releases/2419.aspx (accessed 10 July 2008)

[5] Department for Culture, Media and Sport, *Culture at the Heart of Regeneration* (London: Department for Culture, Media and Sport, 2004).

[6] Prevista Ltd, 'The Impact of Contemporary Visual Arts in the Public Realm', unpublished document prepared for ACE (2005), p. 1.

[7] One of the objectives of its bid was to 'Reposition with cultural image focusing on strengths, especially in visual arts and popular culture', ERM Economics, 'European City of Culture 2008. Socio-Economic Impact Assessment of Liverpool's Bid', paper for Liverpool City Council (2003), p. 11, http://image.guardian.co.uk/sys-files/Society/documents/2003/06/10/finalreport.pdf (accessed 10 July 2008).

[8] Liverpool Culture Company, 'Executive Summary of Liverpool's Bid for European Capital of Culture 2008' (2002), Q8, http://www.liverpool08.com/Images/tcm21-32519_tcm79-56880_tcm146-122188.pdf (accessed 10 July 2008).

[9] Liverpool Culture Company, *Strategic Business Plan 2005–2009* (2005), pp. 6–7, http://www.liverpool08.com/Images/BisPlan2-sect-1-3_tcm79-48110_tcm146-122184.pdf (accessed 10 July 2008).

[10] Parkinson, *Make No Little Plans*, p. 11.

[11] Parkinson, *Make No Little Plans*, p. 19.

[12] LGA, *A Change of Scene. The Challenge of Tourism in Regeneration* (London: Local Government Association/Department for Culture, Media and Sport, 2000), cited by G. Evans and P. Shaw, *The Contribution of Culture to Regeneration in the UK: A Review of Evidence* (London: Department for Culture, Media and Sport, 2004), p. 4.

[13] Harold Macmillan, speech at a Conservative Party rally in Bedford, 20 July 1957, http://news.bbc.co.uk/onthisday/hi/dates/stories/july/20/newsid_3728000/3728225.stm (accessed 10 July 2008).

[14] C. Couch, *City of Change and Challenge. Urban Planning and Regeneration in Liverpool* (Aldershot: Ashgate, 2003), p. 72.

[15] Willett, *Art in a City*, p. 11.

[16] Willett, *Art in a City*, p. 15.

[17] Willett, *Art in a City*, p. 103.

[18] Willett, *Art in a City*, p. 2.

[19] Willett, *Art in a City*, p. 4.

[20] Willett, *Art in a City*, pp. 8–10.

[21] Willett, *Art in a City*, p. 4.

[22] Willett, *Art in a City*, p. 67.

[23] The comparative costs of public funding and grants can be calculated by using either a GDP (Gross Domestic Product) deflator or the RPI (Retail Price Index). The calculations used in this chapter have been based on the Bank of England inflation calculator, http://www.bankofengland.co.uk/education/inflation/calculator/flash/index.htm (accessed 10 July 2008).

[24] Willett, *Art in a City*, pp. 198–99.

[25] Willett, *Art in a City*, p. 199.

[26] Willett, *Art in a City*, pp. 200–01.

[27] http://www.liverpoolmuseums.org.uk/walker/johnmoores/history.asp (accessed 10 July 2008).

[28] Willett, *Art in a City*, p. 85.

[29] Willett, *Art in a City*, pp. 111–13.

[30] Willett, *Art in a City*, pp. 112–13.

[31] Willett, *Art in a City*, p. 234.

[32] Willett, *Art in a City*, p. 239.

[33] Willett, *Art in a City*, p. 238.

[34] Willett, *Art in a City*, pp. 240–41.

[35] Willett, *Art in a City*, p. 242.

[36] Willett, *Art in a City*, pp. 130ff.

[37] Willett, *Art in a City*, p. 138.

[38] M. Hutchins, 'Make No Little Plans: The Regeneration of Liverpool City Centre 1999–2008. The Evidence Base' (2008), p. 1 http://www.liverpoolvision.co.uk/documents/corporate.asp (accessed 10 July 2008).

[39] 'The Core Cities group is a network of England's major regional cities: Birmingham, Bristol, Leeds, Liverpool, Manchester, Newcastle, Nottingham and Sheffield. They form the economic and urban cores of wider surrounding territories, the city regions and are the economic drivers of their regions. The umbrella theme for the joint activity of the Core Cities Group is economic development'. http://www.corecities.com/ (accessed 10 July 2008).

[40] Couch, *City of Change and Challenge*, p. 189.

[41] Bell defines these as comprising trade, finance, transport, health, recreation, education and government. D. Bell, *The Coming of Post-industrial Society: A Venture in Social Forecasting* (Harmondsworth: Penguin, 1976).

[42] Hutchins, 'Make No Little Plans', p. 12.

[43] Hutchins, 'Make No Little Plans', p. 15.

[44] S. Selwood, *The Benefits of Public Art. The Polemics of Permanent Art in Public Places* (London: Policy Studies Institute, 1995).

[45] See, for example, ACE, *Ambitions into Actions* (London: Arts Council England, 2004).

[46] See ACGB and G. Morris, 'Selling the Contemporary Visual Arts', unpublished report prepared for Arts Council of Great Britain (1991); Morris Hargreaves MacIntyre, *The Feasibility of a National Art Purchase Plan* (London: Arts Council England, 2003); Morris Hargreaves McIntyre, *Taste Buds. How to Cultivate the Art Market* (London: Arts Council England, 2004); and ACE, *Turning Point, Arts Council England: A Strategy for the Contemporary Visual Arts in England* (London: Arts Council England, 2006).

[47] S. Selwood, 'Towards Developing a Strategy for Contemporary Visual Arts Collections in the English Regions', unpublished paper for ACE.

[48] ACGB, *Glory of the Garden. The Development of the Arts in England, A Strategy for a Decade* (London: Arts Council of Great Britain, 1984); S. Selwood, S. Clive and D. Irving, *Cabinets of Curiosity? Art Gallery Education* (London: Arts Council of England and Calouste Gulbenkian Foundation, 1994).

[49] The funding agreement between DCMS, Department for Communities and Local Government (DCLG), the Department for Environment, Food and Rural Affairs (Defra) and English Heritage (EH), for example, specifies that EH should 'Help people develop their understanding of the historic environment', 'Help local communities to care for their historic environment' and 'Stimulate and harness enthusiasm for England's historic environment'. 'Funding Agreement between the Department for Culture, Media and Sport (DCMS), Department for Communities and Local Government (DCLG), Department for Environment, Food and Rural Affairs (Defra) and English Heritage 2005/6-2007/8', http://www.culture.gov.uk/images/publications/EHFundingAgreement06_08.pdf (accessed 10 July 2008).

[50] DCMS, 'City Heritage Guides launched in ten cities across England', media release 11 May 2004, http://www.culture.gov.uk/reference_library/media_releases/2329.aspx

[51] House of Commons Culture, Media and Sport Committee, *Caring for our Collections. Sixth Report of Session 2006-07* (HC176-1) (London: The Stationery Office, 2007), Ev 260.

[52] See, for instance, http://www.24hourmuseum.org.uk/nwh_gfx_en/ART51002.html; http://www.visitliverpool.com/site/welcome-to-liverpool/european-capital-of-culture-2008/visual-arts; http://www.artinliverpool.com/ (accessed 10 July 2008).

[53] BOP in partnership with Experian Business Strategies, 'Review of the Presentation of Contemporary Visual Arts. North West Case Study. Manchester, Liverpool & Cumbria', unpublished report prepared for Arts Council England (2005), pp. 4ff.

[54] ERM Economics, 'European City of Culture 2008', pp. 1–2.

[55] Office of the Deputy Prime Minister, *State of the English Cities*. Urban Research Summary 21 (London: Office of the Deputy Prime Minister, 2006), p. 1.

[56] M. Parkinson, M. Hutchins, J. Simmie, G. Clark and H. Verdonk, *Competitive European Cities: Where do the Core Cities Stand?* (London: Office of the Deputy Prime Minister, 2004); Morris Hargreaves McIntyre, *A Literature Review of the Social, Economic and Environmental Impact of Architecture and Design* (Edinburgh: Scottish Executive, 2006).

[57] ERM Economics, 'European City of Culture 2008', pp. 1–3.

[58] Liverpool Culture Company, *Strategic Business Plan*, pp. 6–7.

[59] Willett, *Art in a City*, p. 243.

[60] http://www.biennial.com/index.aspx (accessed 10 July 2008).

[61] http://www.artinliverpool.com/index.php/maingalleries (accessed 10 July 2008).

[62] Future Laboratory, *The Sharpie Index UK Top Creative Towns* (London: The Future Laboratory, 2007) cited in A. Gilmore, 'Quality of Life', in NWDA, *Culture & Image*. Evidence Paper 23 (2008), http://www.nwriu.co.uk/2489.aspx (accessed 11 August 2008), p. 30. 'The Sharpie creativity index … uses criteria such as residents employed in creative industries, creative award short lists, arts and creative funding (ACE and National Lottery grants); creative consumption of the people who live there (number of festivals and fairs, percentage of residents who attended a local gallery/museum), and measures for sub-cultural values, including fair-trade and graffitti policies'.

[63] Culture North West, *A Snapshot of the Creative Industries in England's North West* (London: DCMS, 2004).

[64] It also hosts the Open Culture project inspired by Liverpool's status as European Capital of Culture 2008 – 'an attempt to allow anyone to engage in and create culture' http://www.icdc.org.uk/Portfolio.aspx?projectID=338 (accessed 10 July 2008).

[65] BOP and Experian, 'Review of the Presentation of Contemporary Visual Arts. North West Case Study', p. 3.

[66] M. Ridge, D. O' Flaherty, A. Caldwell-Nichols, R. Bradley, and C. Howell for Frontier Economics, 'A framework for evaluating cultural policy investment' (2007), http://www.culture.gov.uk/images/research/Aframeworkforevaluatingculturalpolicyinvestmentmainreport.pdf (accessed 11 July 2008).

[67] Parkinson, *Make No Little Plans*, p. 11.

[68] T. Cavanagh, *Public Sculpture of Liverpool* (Liverpool: Liverpool University Press, 1997), pp. 56ff; see also A. C. Theokas, *Grounds for Review: The Garden Festival in Urban Planning and Design* (Liverpool: Liverpool University Press, 2004).

[69] http://www.liverpoolworldheritage.com/ (accessed 10 July 2008).

[70] There are a number of reasons for this:

- Despite being publicly funded and publicly accountable, arts organisations are often reluctant to disclose precise details of their income.

- Culture is not a funding category. While NWDA is reported to have prioritised the contemporary visual arts (BOP and Experian, 'Review of the Presentation of Contemporary Visual Arts. North West Case Study', p. 3), unlike education or employment, culture is not a regeneration category, nor is it an output (as would be the number of people attaining particular education qualifications or finding employment), but is treated as a conduit for these.

- Ambiguities often lead to double counting.

- Reporting on cultural activities is often at regional, rather than city, level. Data for activities taking place in Liverpool is often included in aggregated figures for the North West, Liverpool City Region or Merseyside (e.g. S. Craig for Leisure Futures, *Urban Cultural Programme, Full Evaluation Report*, http://www.culture.gov.uk/SearchResults.aspx?_SRH_SearchString=urban%20cultural%20programme [accessed 10 July 2008]; Gilmore, 'Quality of Life').

- Definitions of the 'visual arts' and 'culture' vary. Since 1998, DCMS's policies have been generic, encouraging the tendency to refer to collective cultural activities rather than individual art forms (DCMS, *A New Cultural Framework* [London: Department for Culture, Media and Sport, 1998]). The 'creative industries', which DCMS committed to supporting in 1997, are often under the heading of 'culture'. Confusion about what cultural activities comprise has been compounded by the government's encouragement to local authorities to produce Local Cultural Strategies (DCMS, *Creating Opportunities Guidance for Local Authorities in England on Local Cultural Strategies* [2000], http://www.culture.gov.uk/reference_library/publications/4678.aspx [accessed 10 July 2008]), which were expected to cover the arts, libraries, museums, heritage, tourism, parks and sport. Liverpool's bid to become European Capital of Culture embraced a combination of tourism, creative industries, sports, heritage – 'everything from arts and entertainment to music and sport' (ERM Economics, 'European City of Culture 2008', p. 15). Consequently, spending on the visual arts is not necessarily always easily disaggregated from what has been spent on 'culture'. This is made all the more complex by cross-sectoral collaborations.

- The total costs of projects may involve several funding sources.

[71] Selwood, 'Towards Developing a Strategy'.

[72] P. Collard, 'Arts in Inner Cities', unpublished report prepared for the Office of Arts & Libraries (1988), p. 12.

[73] Correspondence with Lewis Biggs, 15 July 2008.

[74] LARC, *Business Case for Arts Council England Thrive! Programme 2008 to 2010. Executive Summary* (Liverpool: Liverpool Arts & Regeneration Campaign, 2008); LARC, 'External Communications Statement', mimeo (2008).

[75] Correspondence with Belinda Kidd, 11 July 2008.

[76] http://www.erdf.communities.gov.uk/ERDFFundedAreas/NorthWest/NorthWestObjective1 (accessed 11 July 2008)

[77] Liverpool Culture Company, 'Executive Summary', Q7; Liverpool Culture Company, *Strategic Business Plan*, p. 29.

[78] Evans and Shaw, *Contribution of Culture*, p. 4.

[79] *Liverpool Daily Post*, 2008

[80] NAO, *Department of the Environment: Urban Development Corporations* (London: HMSO, 1988).

[81] H. Russell, 'A lot to do but a lot to do it with'. Parliamentary Brief, July 2001, http://www.ljmu.ac.uk/EIUA/67773.htm (accessed 11 July 2008).

[82] M. Parkinson, 'The Quality of Mersey', *The Observer Comment* (2007), http://www.ljmu.ac.uk/EIUA/EIUA_Docs/The_Quality_of_Mersey.pdf (accessed 10 July 2008), p. 1.

[83] http://www.liverpoolmuseums.org.uk/about/ (accessed 10 July 2008). Militant was a revolutionary socialist movement associated with the then deputy leader of Liverpool City Council, Derek Hatton, who had clashed with the Conservative government over its budget and the abolition of the metropolitan authorities. From a national perspective, Labour's triumph over Militant arguably opened the way for a reformed New Labour and its 1997 election victory after eighteen years in opposition and, more specifically, the modernisation of local government. http://news.bbc.co.uk/onthisday/hi/dates/stories/november/27/newsid_2528000/2528725.stm (accessed 10 July 2008).

[84] T. Jowell, 'Transcript of Secretary of State Tessa Jowell's speech to the Financial Times Business of Sport Conference' (2003), http://www.culture.gov.uk/reference_library/minister_speeches/2111.aspx (accessed 10 July 2008).

[85] T. Jowell, 'Speech by Tessa Jowell – Culture and the Olympic Ideal' (2007), http://www.culture.gov.uk/reference_library/minister_speeches/2075.aspx (accessed 10 July 2008).

[86] DCMS's strategic objectives for 2008–2011 include creating opportunity – encouraging more widespread enjoyment of culture, media and sport; excellence – supporting talent and excellence in culture, media and sport and economic impact – realising the economic benefits of the Department's sectors. http://www.culture.gov.uk/our_priorities.aspx (accessed 10 July 2008).

[87] DCMS, *Culture at the Heart of Regeneration* (London: Department for Culture, Media and Sport, 2004).

[88] Liverpool Culture Company, 'Executive Summary', Q2. Liverpool 08's central theme was initially 'The World in One City', underpinned by three supporting themes – Create, Participate and Regenerate – to be explored through three lenses – Yesterday, Today and Tomorrow (Liverpool Culture Company, 'Executive Summary', Q3). It was to be delivered through what is effectively a seven-year programme: 2003, Celebrating Learning; 2004, Faiths and Community Service; 2005, Celebrating the Arts; 2006, Year of Sport; 2007, Celebrating Heritage; 2008, The World in One City; 2009, Celebrating the Environment; and 2010, Celebrating Innovation (ERM Economics, 'European City of Culture 2008', p. 7).

[89] Capital of Culture 2008 is expected to generate £100m to the regional economy and £50m to Merseyside alone (Gilmore, 'Quality of Life', p. 27).

[90] Liverpool Culture Company, *Strategic Business Plan*, pp. 34–35.

[91] Gilmore, 'Quality of Life', p. 1.

[92] ERM Economics, 'European City of Culture 2008', p. 11.

[93] David McCall, cited in BOP and Experian, 'Review of the Presentation of Contemporary Visual Arts. North West Case Study', title page.

[94] Council Leader Warren Bradley, cited in D. Cavendish, 'Liverpool 08 the story so far', *New Statesman* (20 February 2008), http://www.newstatesman.com/life-and-society/2008/02/liverpool-culture-capital-city (accessed 11 July 2008).

[95] B. Garcia, 'Press Impact Analysis (1996, 2003, 2005). A Retrospective Study: UK National Press Coverage on Liverpool, before, during and after bidding for European Capital of Culture status' (2006), http://www.impacts08.net/ (accessed 10 July 2008).

[96] T. Jowell, *Government and the Value of Culture* (London: Department for Culture, Media and Sport, 2004); B. McMaster, *Supporting Excellence in the Arts. From Measurement to Judgement* (London: Department for Culture, Media and Sport, 2008).

[97] Frontier Economics, 2007

[98] T. Travers, J. Wakefield and S. Glaister for London School of Economics, *National Museums Liverpool. Its Impact on Liverpool and the North West* (2005), http://www.liverpoolmuseums.org.uk/about/corporate/documents/EconomicImpactAug05.pdf (accessed 11 July 2008).

[99] Travers et al., *National Museums Liverpool*, cited in Gilmore, 'Quality of Life', p. 15.

[100] Gilmore, 'Quality of Life', p. 27.

[101] Gilmore, 'Quality of Life', p. 28 citing Tate Liverpool, *Economic Impact Study of the Turner Prize 2007* (Liverpool: Tate Liverpool, 2008), p. 4.

[102] Liverpool's Urban Cultural Programme was co-ordinated by Liverpool City Council and the Liverpool Culture Company. A grant of £1.2m from the Millennium Commission and ACE, contributed to a total of £6.6m (made up of local authority partnership funding of £264,000, private sector funding of £2.1m and £3.1 from other sources). Of all the 19 national schemes, Liverpool's included the lowest percentage of Urban Cultural Programme funding (18%) and the highest percentage of private sector support (32%) (Craig, *Urban Cultural Programme, Full Evaluation Report*, p. 15). It also attracted 1.5m audience and 50,639 participants; created 10,708 days' employment for 4,324 artists; resulted in 2,423 performances and exhibitions, 1,145 new commissions/works and 8,829 workshops (Craig, *Urban Cultural Programme, Full Evaluation Report*, p. 27).

[103] ACE, *Regularly Funded Organisations: key data from the 2005/06 annual submission* (London: Arts Council England, 2007); ACE, 'Visual Arts 2006/07' from *Regularly Funded Organisations: the 2006/07 annual submission* (London: Arts Council England, 2008).

[104] B. Johnson, 'The Leader: Bigley's fate', *The Spectator* (16 September 2004), http://www.spectator.co.uk/archive/the-week/12691/bigleys-fate.thtml (accessed 11 July 2008).

[105] Parkinson, *Make No Little Plans*, p. 11.

Chapter 3. Culture at the Heart of Regeneration?
Pam Meecham.

> For the truth is that art has nowhere to go unless it
> travels in the company of the people with whom it is
> trying to communicate. The transformation of society,
> and the grave lesson of recent history is that artists
> eventually cease functioning on any meaningful level if
> they do not keep this reciprocal relationship at the
> forefront of their ambitions.[1]

Mandy Romero,
'Queen of Culture', in
Liverpool One during
its construction, 2007.
(Photograph, Leila Romaya)

In 'A Plan of Campaign', the final chapter of *Art in a City*,
Willett was clear about two things: art should relate in some way
to the city that accommodates it and it must do more than be
spuriously attached to the reforming zeal of the great and the
good. Willett was rightly cautious of the role of public art if
'stifled and distorted [by] the art conscious minority [appearing]
in the guise of Lady Bountiful, patronizing the artists and
improving the public mind'.[2] With great prescience considering
today's climate of accountability and instrumentalism he
declared 'What the public would ... appreciate is to see art
associated with the drive for better living: to see it as a hope
rather than an implied reproach. For this reason in a city like
Liverpool it should above all be linked firmly to the great
schemes for re-planning and development.'[3] However, Willett's
concern that art be relevant to society rather than 'set apart'[4]
was constrained by a different set of considerations to the
current charge that art courts the risk of irrelevance if it is not
socially engaged. Presently, art's ability to be morally, spiritually

Detail of Allen Jones' *The Tango*, at the Liverpool International Garden Festival, 1984. The steel plate sculpture is now sited in Concert Square in the city centre.

(Photograph, Angela Mounsey)

or visually improving, the thrust of much nineteenth- and twentieth-century rhetoric, has been superseded, at least in the political imagination, by art's presumed ability to generate worthy citizens and pump-prime economic regeneration through increased tourism. The civic and public tone of Willett's rhetoric is telling: he could not have foreseen the unstoppable rise of corporate culture and its role in both the patronage of art and city regeneration. 'To humanize and beautify the reconstruction of the city' at the same time as 'strengthening its identity' and 'stimulate a distinctive Liverpool art',[5] Willett's mantra for the arts, still resonates today as art is used to humanise the 42 acres of Liverpool One. However, the landscape for the arts has significantly changed and regeneration projects between Willett's 1960s and the 2008 enterprise, Capital of Culture, should give us cause for reflection and caution. If for Willett the role of art in humanising and adding local distinction to the city seemed achievable through the creation of adequate structures to deliver such laudable ambitions, our contemporary artistic climate complicates the process.

Since Willett wrote *Art in a City* we have witnessed a change in the conceptualisation and pathology of the artist: the rise of the relational, socially engaged artist. Once the preserve of community arts, the participatory artist is now ubiquitous and an officially sanctioned part of community redevelopment, empowerment-led education programmes and regeneration schemes. If in the 1970s the distinction between art and politics was clear, post-punk the distinction was less secure, and culture and politics are now increasingly interconnected, with the old romantic antagonisms between artist and establishment, if not over, at least held in mutual abeyance. The interdisciplinary nature of today's social activities means that these are no longer separate spheres of activity but, rather, overlapping. In the new order, artists have had to concede some of their outsider privileges as the blurred distinctions between jealously guarded distinct roles have opened up. As Andrea Fraser, writing about the radicality of the strategy of artists' interventions, points out, 'It's not a question of being against the institution: We are the

institution. It's a question of what kind of institution we are, what kind of values we institutionalize, what forms of practice we reward, and what kinds of rewards we aspire to.'[6] Less easy then to make art that marched hand in hand with socialism, evident in Adrian Henri's painting *The Entry of Christ into Liverpool* (1964), reproduced on the nostalgia-laden cover of the *Art in a City* reprint.

It has been argued by Miwon Kwon in relation to the itinerant artist that 'the yoking together of the myth of the artist as a privileged source of originality with the customary belief in places as ready reservoirs of unique identity belies the compensatory nature of such a move'.[7] In essence Kwon maintains that increasing institutional interest in site-oriented artists' practice has mobilised both the site (often a gallery or city) and the artist (usually freelance) to create works that through their criticality (artists as interventionists) contribute to a dynamic, place-based individualism. It also contributes to an aesthetic that has the artist performing a service such that, through artistic narration, 'values like originality, authenticity, and singularity are also reworked in site-oriented art – evacuated from the art work and attributed to the site – reinforcing a general cultural valorization of places as the locus of authentic experience and coherent sense of historical and personal identity'.[8] It seems to me that some of the concerns expressed about the role of artists in compensating for an increasing homogenisation of our cities (and Liverpool is no exception) lie at the centre of the debate around culture at the heart of regeneration. It has to be argued that civic identity through its buildings (for all their nineteenth-century allegiance to the gothic and the classical) has in recent years been eroded in preference for 'other media more intimate with marketing and advertising'.[9] Further, given that artists are used to forging connections with repressed histories, minority cultures, and offering a unique sense of place, then we need to ask what kind of place Liverpool is or wishes to be beyond the desire for an artistic gloss that ameliorates the burgeoning corporate identities so evident in the new cityscape.

Much that Willett had to say about art's relevance to local needs still chimes with today's regeneration projects as Liverpool rejects 'managed decline' and relocation to the South East for Willett's 'drive for better living'.[10] This chapter reiterates the premise that, in Liverpool, projects that use the arts should engage sections of the community with their own regeneration, and therefore that what works best should not be a blueprint developed centrally, standardised and disseminated to other regions and urban centres. Genuine, sustainable transformation, however, has not always been achieved in Liverpool: the arts are often a casualty of poorly managed projects. This chapter looks back at other attempts at renewal to see what might be learned from the local and international. The other telling item to be gleaned from Willett was the urgent need to build infrastructures to support the arts: such structures have taken time to develop and have not been without regressions.

Although culture was absent from the Community Development Projects (CDPs) of the1970s, by the 1980s it had become central to political debates and to questions of renewal. During the 1980s and following a period of political and social unrest, popularly referred to as the Toxteth riots, an International Garden Festival was mooted as one way of regenerating Liverpool in general and in particular this part of the Riverside constituency, known locally as the Cast Iron Shore (or the Cazzie).[11] Building on Michael Heseltine's enthusiasm for what we might now call the greening of Liverpool came the aspiration to turn a municipal rubbish tip into a garden festival with an afterlife: private housing, science-based industry, an arena, festival hall and theatre, and a public park. The festival hall was built so it could be converted into a swimming pool and sports hall. In 1984 the Liverpool International Garden Festival opened to general acclaim. It was, according to Holden, 'a success, politically, socially and economically. A total of 100 hectares of derelict land was reclaimed, 3 million m³ of material were moved and the problems of methane and toxicity dealt with. About 45 hectares were developed as a garden festival site, and while it was open

Chapter 3. Culture at the Heart of Regeneration? Pam Meecham

from May to October 1984, 3.5 million people visited it.'[12] The celebratory tone of most pundits, however, could not mask the underlying tensions between Merseyside Development Corporation (a government quango) and Liverpool City Council. The MDC's planned handover to Liverpool City Council, not without trauma, is not the subject of this chapter, but it is important to note that the intention was for a pub, the Britannia Inn, to remain in the park and for the Marine Esplanade to be part of a continuous riverside path between Otterspool Promenade and the Pier Head. However, it is the use of art in that particular regeneration package that is the focus of this chapter. In defiance of received horticultural traditions and the experience of the Dutch, who liked a ten-year-long run up to building an international garden, Liverpool's challenging site was developed and opened in two and half years: Holden refers to the development as 'a lash up'. With just two years of growth the planting looked immature and the structure of the festival site, nineteenth-century serpentine, seemed conservatively and inadequately designed. What many will remember, however, are the commissioned, borrowed and purchased sculptures that gave the site focus and solidity: they totalled over sixty in number. Richard Cork, writing in the official *Festival Sculpture* guide, observed, 'Those who argue that commissioning sculpture is a disgraceful irrelevance, at a time when re-housing and industrial renewal should be real priorities are in danger of allying themselves with the attitudes which produced the heartless functionalism of so many post-war city-scapes'.[13] The commissioned works selected by Sue Grayson Ford were to be left on the site for the people of Merseyside when it became a public park. The sculptures embraced the unashamed populism of John Clinch's *Wish You Were Here* (1983/84), with figures based on Rockfist Rogan of the *Hotspur* comic, Allen Jones' *The Tango*, Dhruva Mistry's magisterial, brilliant red concrete Indian sacred bull, *Sitting Bull* (1984), a modern Nandi of Hindu legend, and the organic forms of Stephen Cox's peperino stone *Palanzana* (1983/84). Tracing the fate of the peripatetic sculptures from the 1990s requires tenacity. Without the

Stephen Cox, *Palanzana*, (detail) 1983/84, Peperino stone, shown at the Liverpool International Garden Festival, now sited on Byrom Street.
(Photograph, Angela Mounsey)

institutional frameworks that are needed to support art, these works were often treated as part of the celebration of the festival, with little thought to their post-festival life. Some sculptures were built into the site and conceptualised as part of the fabric of the public park that was to follow. Graham Ashton's *Dry Dock* (1983/84), for instance, was envisioned by the artist as reaching maturity in ten or fifteen years after interaction with the public. It was one of the few locally relevant commissions done during the artist's residency at the Walker Art Gallery and Bridewell Studios. The concrete and painted steel sculpture within a sunken pit was also a children's playground, containing a light buoy, a torpedo, a lifebelt, a sinking ship, and a compass and sundial fixed at the time of the sinking of Liverpool's RMS *Lusitania*. *Dry Dock* commemorates and mourns a moment in Merseyside's maritime history but, without a playful audience, it stands as a reproach and lament, as uncertain commercial operations and theme parks have haunted the festival since 1986. By 1991 some of the commissioned pieces such as Alain Ayres' *The Kissing Gate* (1984) were found battered in the festival hall. On an immaculately kept site to which few had access, some sculptures such as David Kemp's *Flight of Rooks* (1984) were still in situ but in need of renovation and repair.

Currently the subject of further controversy, there are plans to regenerate the regeneration project and even renovate some of the internationally renowned gardens. The beneficiaries of the derelict site have been the wildlife and birds thriving in the overgrown gardens, making reconstruction even more complex. Recent plans to regenerate the site have encountered difficulties. In rejecting one plan the Commission for Architecture and the Built Environment noted, 'In terms of social sustainability, we think that there is greater scope for community involvement in the park, for other types of private and semi-private gardens, and for the promotion of interaction between people from neighbouring housing areas in the park'.[14] The growing recognition that sustainability needs local and diverse community involvement can be extended to regeneration on Merseyside more generally.

The themed international gardens now look as clichéd and dated as national art pavilions, but the reservations about regeneration expressed in the 1980s and 1990s resonate today. Long-term planning is crucial if short-termism is to be avoided. The fate of the sculptures can be seen as a metaphor for many regeneration projects. Art works do not always benefit from permanence: some, like Richard Wilson's *Turning the Place Over* (2007–8),[15] have mutability built into them, but others require longitudinal stability and where possible community ownership with a stake in conservation.

Regeneration is defined as 'the positive transformation of a place – whether residential, commercial or open space that has previously displayed symptoms of physical, social and/or economic decline'.[16] Neighbourhood renewal, however, is not necessarily achieved by the imposition of a gallery designed by an international guru, and one of the notable successes in the past twenty years in Liverpool has been the regeneration of the Albert Dock buildings into a range of museums and galleries. The authors of DCMS's *Culture at the Heart of Regeneration* are aware of the problems of gentrification and alienated local cultures, displaced by rising house prices when iconic art galleries are used as tools of economic and social regeneration. The arrival of the Guggenheim Museum in Bilbao provides a salient example: after the hype was over, surveys of local residents in Bilbao, 'whilst recognising the economic impact and value for the middle class minority, found little value attached to the museum in terms of quality of life, social cohesion, regional identity or governance. After an initial boom, visitor numbers amongst locals are declining.'[17] Barcelona's experience of renewal through culture may provide an example more relevant to Liverpool. First, in stark contrast to Bilbao's acquisition of an iconic, large-scale cultural facility, Barcelona's cultural programmes emphasised 'the characteristics of each of its districts and attempt[ed] to continually refresh its offering to both visitors and inhabitants'.[18] The two approaches taken in Spain might alert us to the potential pitfalls and benefits underlying strategies for regeneration that make naturalised assumptions about what

and who make up communities and, crucially, what constitutes *legitimate* culture. The rampant commodification of culture should not be allowed to blind us to counter-cultural activity, or the reality that culture is diverse and pluralistic, not readily counted or coerced into a target-setting ethos. It would be expected therefore that the arts would at least acknowledge, or even better reflect, a lack of consensus in what cultural activity can be. It is also the case that the collapse of distinctions between high and low culture makes redundant many of the assumptions about regeneration through particular established beacons of cultural practice. It is noteworthy that, while lip-service is paid to culture as being at the heart of regeneration, the examples often touted are likely to be recognisable names and 'products'. A recent *Guardian* publication emphasising 'back street culture' claimed that, unlike other cities given over to bland cosmopolitan commercialism, 'Liverpool knows exactly who it is and keeps a gritty sense of spirit peppered with a genuine warmth flowing through its urban veins'.[19] Wide-ranging small-scale projects such as the *Four Corners* reminiscence and *Streetwaves: Cities on the Edge* give credence to the hype. It is to be hoped that Liverpool's distinction will be to build structures that support the illegitimate as well as the legitimate, the tangible and intangible. Public consultation is not enough if it is simply used as a means to buttress the status quo.

Lewis Biggs, writing in 1996, stated, 'It is ... clear to me that a community that has suffered trauma requires the recreation of culture to bring about renewal'.[20] He was concerned to make the relationship between welfare and culture explicit. 'When Tate Gallery Liverpool opened in May 1988 there was an astonishing volume of press coverage, but little of it was concerned with the Gallery's objective (introducing people to the Tate's collection of modern art). The press focused instead on the apparently controversial issue of using art for the regeneration of a city. The surprise is that anyone could find anything controversial about linking culture and renewal.[21] Ten years or so later the linking of culture and renewal is less surprising, having become a plank of global economic growth: a

Chapter 3. Culture at the Heart of Regeneration? Pam Meecham

signature style 'great shape' museum, a Gehry, a Koolhaus, a Foster or a Liebeskind – not just a signifier of internationalism but of reconciliation. However, the presumed axiomatic relationship between culture and renewal is problematic. The 1990s left us with a Blairite vision of community: it sought to systematise the most dynamic, fluid and intangible qualities of successful community organisations, and to link them to the most general objectives of a government for society – dignity, activity, wealth and progress. Blair's vision challenged some highly cherished principles about equity, risk management and democratic accountability. The use of the arts as a benign panacea for social ills was part of that vision but, as we have seen, such a process has been problematic in the past, as has the linking of regeneration with tourism. Tourism is the precondition for regeneration in DCMS's *Understanding The Future: Museums and 21st Century Life, The Value of Museums* (2005): 'They [museums and galleries] act as a powerful engine for regeneration, and are a primary reason why overseas visitors come to this country'.[22] The same coupling was foregrounded in *Culture at the Heart of Regeneration*, citing Liverpool as an example. It was foreseen that its role in the European Capital of Culture initiative, heralded as 'A Catalyst For Regeneration', would reinforce Liverpool's role as a regional shopping centre, its role as a UK and European tourism destination and promote awareness of its cultural heritage'. The economic figures presented in *Culture at the Heart of Regeneration* are compelling, with Tate Modern, the Eden Project and the Lowry demonstrating increased jobs, investment and millions of visitors. The competing demands of tourism and local identities are, however, often difficult to reconcile and artists may be one group who can skilfully open up debate, brokering between local communities and the international tourists.

Looking for the authentic may be a fugitive enterprise but seeking a distinctive Liverpool art requires a reconciliation of the contradictions between local and global cosmopolitanism, tourism and diverse, ever-changing local identities. Sustainable regeneration therefore will only be achieved if it involves

103

[greater forms of popular participation and diverse cultural activities that dismantle the old cultural hierarchies.] Centralised systems of control will also need to hand over decision-making to the local.

Liverpool's contribution to the regeneration debate can be to demonstrate the management of long-term regeneration and counter the 'implied reproach' in proliferating regeneration projects. The eco-museums or community museums that have sprung up globally are an indication of a seismic shift in the role of museums and galleries in the formation of our cultural identities, and a demonstration that regional development is not just about the economic and social. Through the arts, both tangible and intangible and rooted in a dynamic, constantly changing culture, it is possible to regenerate beyond the economic, important though that is. Courting large-scale tourism that will generate cash is only a partial answer to regeneration. Willett was correct in arguing for the development of a distinct Liverpool art that includes the embrace of international work,[23] not just to bring tourists to the city but as part of social change, so that communities can express their aspirations in the language of a living, diverse, pluralistic culture distinct from the culture consensus so easily disseminated by dominant institutions. [Culture, particularly in Liverpool, is often deeply subversive, perverse and uncomfortable.] It is not destined to act merely as a glue to rebuild communities or create worthy citizens – and it is all the better for that.

[1] Richard Cork, *Art for Whom?* (London: Arts Council of Great Britain and Serpentine Gallery, 1978), p. 10.

[2] John Willett, *Art in a City* (London: Methuen, 1967; repr. Liverpool: Liverpool University Press and the Bluecoat, 2007), p. 239.

[3] Willett, *Art in a City*, p. 239.

[4] Willett, *Art in a City*, p. 240.

[5] Willett, *Art in a City*, p. 242.

[6] Andrea Fraser, 'From the Critique of Institutions to an Institution of Critique', in Noah Horowitz and Brian Sholis (eds), *The Uncertain States of America Reader* (New York and Berlin: Sternberg Press, Astrup Fearnley Museum of Modern Art and Serpentine Gallery, 2006), pp. 32–39 (p. 38).

[7] Miwon Kwon, 'Itinerant Artists', in Horowitz and Sholis (eds), *The Uncertain States of America Reader*, pp. 45–51 (p. 49).

[8] Kwon, 'Itinerant Artists', p. 48.

[9] Kwon, 'Itinerant Artists', p. 48.

[10] Policy Exchange's Dr Oliver Marc Hartwich, author of *Cities Unlimited* (2008), has argued, using GVA (gross value added) cash figures showing the per-capita contribution that people make to the economy, that personal income and employment in towns that are receiving large amounts of urban policy funding are not converging to the UK average but are 18 per cent behind it. He proffered the option of moving to the South East as a solution. The Department of Communities and Local Government responsible for funding, including neighbourhood renewal projects, totally rejected the report's claims and solutions.

[11] The term's origins possibly lie with the introduction of cast iron into buildings designed for Saint Michael-in-the-Hamlet by Thomas Rickman, although it may have earlier origins.

[12] Robert Holden, 'Landscape Revisits: Liverpool Garden Festival', *Architects' Journal*, 22 January 1986, pp. 68–72, p. 67.

[13] Richard Cork, *Festival Sculpture* guide (1984).

[14] Commission for Architecture and the Built Environment, *Design Review: Former International Garden Festival Site* (2007).

[15] Richard Wilson's *Turning the Place Over* is literally part of the fabric of a building, a former Yates's Wine Lodge scheduled for demolition.

[16] DCMS, *Culture at the Heart of Regeneration* (London: Department for Culture, Media and Sport, 2004), p. 8.

[17] DCMS, *Culture at the Heart of Regeneration*, p. 13.

[18] DCMS, *Culture at the Heart of Regeneration*, p. 14.

[19] *The Guardian* in association with Liverpool 08 – European Capital of Culture and England's Northwest, *Finger on the Cultural Pulse* (2008), p. 3.

[20] Lewis Biggs, 'Museums and Welfare: Shared Space', in Pedro Lorente (ed.), *The Role of Museums and the Arts in the Urban Regeneration of Liverpool* (Leicester: Centre For Urban History, University of Leicester, 1996), p. 70.

[21] Biggs, 'Museums and Welfare', p. 61.

[22] DCMS, *Understanding The Future: Museums and 21st Century Life, The Value of Museums* (2005), p. 6.

[23] The community involvement in the purchase of Antony Gormley's *Another Place*, sited on Crosby Beach, is evidence of internationalism at a local level.

Chapter 4. Liverpool Glocal. Sean Cubitt.

In 1914 German firms held the controlling share of the world's chemical industry. At the outbreak of the First World War, at the request of the Lloyd George government, the Hoechst and BASF dye factories at Ellesmere Port and Birkenhead were taken over by British firms. The biggest requirement was for dyes for soldiers' uniforms, but it was already clear that many dyestuffs also had important medical applications.[1] By 1956 the UK was producing 90 per cent of its own dyes, firms like Glaxo (originally founded in 1873 in Wellington, New Zealand) were in a position to become world leaders, and the Mersey was coloured by run-off from the dye works. But from the 1980s onwards, competition from India and China was so intense that even with a round of amalgamations and reverse take-overs, the Merseyside chemical business was in rapid decline. The April 2003 toluene explosion at Shell Chemicals and the September 2007 acid spill from a Shell tanker that closed the M53 motorway tell us that the legacy of industrial chemistry is still alive and well. It is not only the docks that connect Liverpool to the world and that in many, sometimes unfortunate, ways bring the world into the Mersey.

The city's fortunes have been implicated in the processes of globalisation since the nineteenth century – one reason why the statue of Christopher Columbus in Sefton Park still bears the motto 'The Discoverer of America was the Maker of Liverpool'. It's a sad irony that Sefton Park was also one of the first places in England to be blighted with Dutch Elm disease, a beetle-born fungus fatal to elms that appears to have travelled from central Asia, probably through a transport network set up in the timber trade. The history of globalisation stretches back for millennia,

The BBC Big Screen, Liverpool city centre: live broadcast of Yoko Ono's performance at the Bluecoat, 2008.

(Image courtesy of the Bluecoat)

to the Silk Road, and before that to the coastal trade that linked the civilisations built on the great rivers: Yangtse, Indus, Euphrates, Nile. It is a material history of the spread of plagues as much as of religions and trade.[2] The abrupt acceleration of the globalisation process might be traced back to the 1865 meeting of the first International Telegraph Convention, twenty-one years after Morse's invention. The foundation of what would become the International Telecommunications Union was significant in two key ways: it recognised that communication is the essential infrastructure of global commerce, and it established the world's first international regulatory body, the first inkling of a new kind of international politics. To indicate how complex the issue of governance has become, the ITU is one of fourteen intergovernmental and non-state organisations named in the Internet Governance Project's final report (2004): but individual governments, and many of the 2,350 non-governmental organisations with UN 'ECOSOC' status, also have a hand in decision-making; while at the UN's Tunis World Summit of the Information Society, an immensely powerful bloc of commercial operators also showed their muscle. From the days when pilgrims, horse-traders and mercenaries swapped tales round the camp fire, to the earth summit in Bali, the shape of the world has changed.

The great debates about the new world order centre on three big ideas. The first is that the globalisation of capitalism and the end of the Soviet bloc has thrown the world into the hands of mega-corporations who drive the globalisation process.[3] The second argues for the continuing role of nations in controlling the worst effects of pure competition.[4] The third suggests that the intersection of these two powers occurs not at the level of global networks and institutions like the World Trade Organisation, nor in the international politics of treaties and the UN, but in cities.[5] According to the UN Population Fund, 2008 is the year when, for the first time, more than half the world's population will live in cities. We are talking here not only of traditional cities, even of massive cities like London and New York, but of megacities, with in excess of 25 and in many cases

more than 50 million people. This is what Mike Davis calls the Planet of Slums.[6] But it is also the planet of the cosmopolitan elite, who travel in isolation from the squalor and degradation, moving from corporate headquarters to premium hotels across time zones and through borders that lesser folk find closed to them. The city is the new frontier, Sassen argues. It is where the strategic decisions are made, where the future is designed, where the management of populations is planned and implemented. But it is also the place where the marginalised meet the powerful in close proximity, where increasingly privatised and commercialised public spaces are disputed and fought for, where a new mode of informal politics is beginning to emerge.[7]

This is what is at stake in the relationship between any city and the new movements in globalisation. It has always been clear that there is a direct relationship between the global and the local. No one knew they were local until they began to understand the nature of the global: 'local' was simply *here*. It is a similar disjuncture to the early one dividing tradition from modernity: only as we became modern did we learn that we had been traditional. Until then we had simply lived. The new dialectic of local and global is rather different in one sense: it is not an either/or matter, but a both/and one. With our shoes from China and our Korean mobile phones manufactured in the Philippines, our Asian-built computers using US software and our East German clothes, with our Costa Rican coffee in Portuguese cups, we are woven into the web of the world. But we experience these things in one place, and tailor them for our deeply local wants and needs. Sometimes the global is invisible and unconscious: it was perhaps only during the UK dock strike (September 1995–January 1998) that we became intensely aware of the containerised maritime transport that brings bananas to the breakfast table. Sometimes, however, it is passionately obvious, and celebrated or attacked with verve and invention. Sometimes the local is so familiar we no longer sense it; and sometimes it is the site of riotous pride or righteous anger. The city is where these powerful forces meet.

According to the Capital of Culture website, Liverpool

attracted over a million people in the first two months of 2008. Culture is a buzzword for city economies. Creative industries are the road out of poverty. But what this means in reality is strange indeed. Cultural activities have to do more, much more, than simply be good enough. They have to be economically viable, either in themselves, or in attracting people into the city to spend their money on more tangible things such as food, drink and hotel rooms. Economic viability is a central platform of the neo-liberal Washington Consensus that governs global trade,[8] but its ramifications touch the minutiae of urban life. Then cultural activities have to prove their value to those elements of life that have been marginalised by the same neo-liberalism that requires the arts to be financially sound. Arts and culture increasingly have to demonstrate that they are good at providing the educational opportunities that have been destroyed by reductions in state spending. They have to show how they will provide alternatives to crime, drugs and vandalism among the young abandoned in the rush to efficiency. And on top of all that they have to exhibit the kind of quality that the opera-going elite will approve of. This 'expediency of culture'[9] places demands on cultural workers that might stifle even the strongest constitution. What solutions are there?

The Liverpool Big Screen is one of the new generation of cultural artefacts which are increasingly networked across the world (the inaugural conference of the International Federation of Large Screen Operators took place in Melbourne in 2008 with representatives from four continents). With a programme stretching from the Cup Final to ballet, celebrations of the city's life in film to interactive gaming competitions with other cities, the Big Screen articulates the centre of Liverpool with other city centres with a potentially global reach. It creates a public space where people can gather to mourn a death or to celebrate a sporting victory. It provides a platform for the diversity of cultures that now characterises the global city. It opens itself up to contributions from anyone who cares to offer them, and its guidelines are exclusively to do with copyright, potential offence (swearing, nudity) and protection of children: there is no

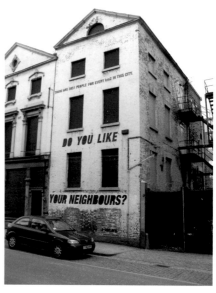

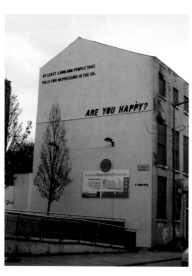

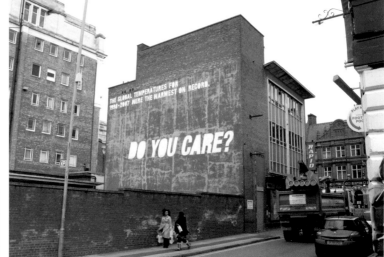

apparent ban on political works so long as they abide by guidelines designed for continuous, rotating programming in a popular shopping street. But perhaps its greatest achievement is in changing the nature of the street itself, previously entirely dominated by shopfronts, now open to a huge range of other kinds of content and activity. The shops no doubt benefit from the extra crowds. In the partitioned world of twenty-first-century zoning and housing, gathering together is no longer the familiar activity it once was. The reinvention of the crowd in public space is itself a cultural work of immense value.

The crowd is so important because it is a living, breathing and randomising assembly. Towards the end of his life Michel Foucault established a historical typology of state control. In the old days there was the sovereign, with the power of life and death. In the wake of the eighteenth-century enlightenment there arose a disciplined society, founded on the interiorisation of norms of behaviour in each individual. But from the later nineteenth century onwards a new biopolitical regime begins. Based on the new sciences of statistics, and informed by other emerging sciences such as epidemiology, biopolitics is no longer about individuals but about populations. It concerns itself with improving the average figures for health, wealth, education and mortality rather than the disciplining of individuals. It wants to lower teenage pregnancy rates rather than criminalise teenage sexuality. It is pragmatic, and it deals in the largest scales. So a-ape's *Visual Virals* project (taking place in Liverpool in 2008), which paints statistical data and questions on buildings and intervenes in weighing machines, also deploys very visible public screens, and is like the Big Screen in addressing people not as the traditional individual viewer of art but in the mass. In older art, we expect an individual experience of depth, emotional and intellectual, a deeply personal experience. In these new public forms, the art takes over (and perhaps implicitly critiques) the massified management of crowd behaviour we might expect from advertising. How can you tell if a public service ad campaign works? By the reduction in drink-driving statistics. The same for commercial products. What behaviours might public screens

produce on a similar scale? Not deep, not personal, but shallow and broad effects: as if everyone in Liverpool walked with their heads turned slightly towards the screen …

The crowd, despite the mass and anonymity that so frightened witnesses of its formation in the early twentieth century, is an intensely local phenomenon. It takes the shape of the streets it moves through or occupies, as river water fills the outline of the banks. Perhaps it is the individual who is genuinely global, and the crowd that is especially local. This is a genuine difficulty for the curators of biennials, not least in Liverpool. Thierry de Duve opens a critical article on biennial culture with a list of 37 cities boasting a biennial, from Athens to Zagreb by way of Luanda, Kwanju and Sharjah. He moves into his conclusions with the following reflection:

> The philosophical question raised by the glocalisation of the art world via the proliferation of art biennials … has to do with the difference we ought to make between works of art and cultural goods presented under the umbrella of art, if we attach a value to the word art other than its economic or its entertainment value.[10]

De Duve concentrates on the word 'ought', bringing it into contact with the ethics of duty in Kant, reversing his argument that communities create the concept of art by suggesting that the duty of recognising art is what creates the community. Before we look at that, though, it is worth pausing on the question of whether 'we' do actually value art beyond economics and entertainment. Certainly there is the expectation that art will provide moral guidance and educational opportunities as well as economic and entertainment outcomes. But how are we to define art? The question has baffled generations, and has only become more difficult when, as de Duve has written elsewhere, art today can be made out of anything whatever. It might have been easy enough to say art was made up of painting and sculpture back in the nineteenth century when the façade of the Tate at Millbank was built with the muses of those two arts in its architrave. But

Keith Piper, *Balance of Trade*, at Merseyside Maritime Museum, 1992, commissioned for Trophies of Empire.

(Images courtesy of the Bluecoat)

after Beuys' fat and felt, and even before them, after Kurt Schwitters' Merzbau and Duchamp, materials and technique no longer distinguish art. Rather than define it by what it is, why not, after all, define it by where it turns up: in art institutions and the art economy? Is it time to admit that art has become just another sector of the global economy, an import/export market whose trade fairs are the biennials?

De Duve cuts this Gordian knot by suggesting that we must distinguish between the elite community of taste that runs the art world and the common sense constructed by an increasingly global community. The former is *glocal*: it moves between city-based institutions and the global art scene, debating, making and breaking reputations, selecting the works that will fly best in each local event. The latter is more truly global: the public addressed by art, who answer the question 'what is art', or move towards answering it. To make this more concrete, a quick look at today's offering of films on the FACT screens shows Fatih Akin's German/Turkish *Edge of Heaven*, a Cannes prize-winner; two films from the States, *Juno* and *There Will be Blood*; and one from France, *The Diving Bell and the Butterfly*, the latter with the artistic signature of Julian Schnabel; plus Michel Gondry's new feature film. As I write in the immediate aftermath of the awards season, the presence of three Oscar-nominated films is no surprise. Oscars translate actively into extended runs and increased interest in the successful films. FACT would be rash not to programme them. Clearly it is as important to respond to the wisdom of the global market in film distribution as it is to include internationally renowned artists such as Orlan, Stelarc and Eduardo Kac in FACT's concurrent exhibition of bio-art, *sk-interfaces*.

In the increasingly competitive world of biennials much the same tenet holds good. Biennials strive to obtain works from the hottest talents, judged as those that have the best coverage in the art press, the biggest stands at the biggest exhibitions, the best profile in the news media. Local audiences expect nothing less. They want the evidence that their biennial is the equal of any other, as global in reach, as innovative in style, as controversial and as surprising. But as in the world of cinema, so

in the art world: there is no formula for success, and every artwork and every event is a prototype. Every biennial also needs to innovate, to find new artists, and to do so must make sure that the event attracts the big names which in turn attract the big audiences so that the new names get some limelight to walk in. This is the glocal in operation, the *realpolitik* of matching aspirations with realities, local drive to global imperative.

Liverpool is now and has been for a century a geographical oddity. With its back turned to the rest of the country, Liverpool looks out to the Celtic fringes and beyond them across the Atlantic to the New World. But it is also in some ways typical of a remarkable feature of the British art scene. Victorian city fathers established art galleries like the Walker across the country in an extravaganza of civic pride, with more than an admixture of cultural legitimation and aristocratic aspiration.[11] In more recent years, a network of such galleries and their modern and contemporary art siblings has grown up beyond the immediate reach of the London scene. The anomalous position of London, as a world city in a relatively small country, makes it on the one hand the hegemonic power in the construction of taste, but on the other remote from its own hinterland. So, for example, the exchanges between the Bluecoat in Liverpool, Hull Time Based Arts and the Arnolfini in Bristol in 1991/92 during the quincentenary of Columbus's 'discovery' of the Americas could occur without the blessing and equally without the interference of London tastemakers. A certain independence, a certain ability to respond to change, became the hallmark of the regional galleries in the 1960s and has remained a hallmark subsequently. Art that could not get a toe-hold in the capital – media arts, for example, and international art from beyond the dominant Berlin–Paris–London–New York axis – was far more likely to find curators and audiences in the UK regions. Here Liverpool, with its long history of interconnection with the world and its old-established Black British and British Chinese communities, was a leading light in exhibiting work that found London impenetrable. Such too was the basis of the success of FACT, from its beginnings as Merseyside Moviola in the 1980s. Video art had fallen between

the stools of the art and film establishments. Far from their immediate governance, FACT could become a national centre for the new media arts. And like the Bluecoat – for example in its special connections with Cologne or Dakar – FACT was also able to bypass the capital and make its own international connections.

A particular characteristic of the Liverpool art scene has been its long history of engaging communities in its major events. Not only has there been an interchange with the Liverpool Art School in its various manifestations, and a powerful tradition of community arts around institutions such as the Blackie and Open Eye; not only has the Bluecoat housed artists and educational projects, and FACT hosted a resource base and projects like the *tennantspin* collaboration with Superflex and the tenants of social landlord Arena Housing; but the Biennial has opened up from its first iteration to its fringe. The result has been the remarkable fondness many exhibiting artists show towards putting on their work in the city. More than one visiting artist at the *Video Positive* festivals commented on the knowledgeable critiques they got from Liverpool audiences, who often enough would drag them along to see their own installations in the community programme. The intense local quality of these initiatives and many more like them belies their truly glocal nature. Collaborations between *tenantspin* and the Hindu Cultural Organisation, or Bill Harpe's (2001) Blackie-produced book of global games,[12] or Rajni Shah's Mr *Quiver* live art installation at the Bluecoat's re-opening demonstrate a keen awareness of the inter-relationships of place and migration. Of all UK cities Liverpool, as the gateway to the sea, has more reason than any to recognise that its geography and history are entirely bound up in the movement of populations.

From the global branding of Liverpool FC to the intricate networks of trade and invention that stitch the Mersey's petrochemical industries into webs of wealth, power and war, it is as a city that Liverpool weaves itself into the fabric of the world. Not that national policy doesn't matter: but even the much delayed EU Objective One status awarded in 1994 under John Major (after years of grudging refusal by Mrs Thatcher) indicates that national government is also constrained by its regional

partnerships and treaties, while cities live their own lives within but apart from the structures of the state. The informal politics that have emerged through Liverpool's art and culture scenes, from Thomas Mapfumo playing the Trades Union Centre to Rigoberta Menchu addressing the crowds in Sefton Park, show a living thread running through the city that makes it less part of the topdown globalising hegemony of the Washington Consensus, and more a part of the bottom-up transnations of hip-hop and electronic beats, literary and cultural translations, passages from people to people rather than the intergovernmental or business-to-business models that otherwise dominate planetary affairs. It may well be unfair to demand of art and culture that they produce so many results in so many areas, but in this at least Thierry de Duve's more optimistic vision breaks in. There may be a way to create a new global public, and if so, it will come from exchange and collaboration local to local, locale to locale. After the exchange of things that made world trade the driver of globalisation from the top, there comes the exchange of people to drive a new globalisation from the bottom.

Although, in common with so many others, John Willett served in the Middle East during the Second World War, he remained fundamentally a European. His language belongs to his era: 'the wealthier citizens have moved away from the city centre, leaving the once elegant terraces to be invaded by a different kind of tenant, Irish, Chinese, coloured, with their children and their clubs and their various street debris'.[13] The term 'invaded' says it all. When it comes to ideas about art, art education and what we would now call cultural policy, his sources and comparisons come almost exclusively from the Netherlands, Italy, Germany and France (Spain and Portugal still being dictatorships at the time, and as the 'invasion' theme suggests, Ireland was not considered part of civilised Europe). The multicultural Liverpool of the 2000s, for all its inequality, for all the residual racism, not only finds expression in the art scene: it is in many respects a product of it. It is a truism of globalisation studies that the new global polity is unthinkable without global communications. Equally neither the new global

cultures vividly evident in the music, performance and biennial art worlds, nor the new local, with its intense understanding of how locality is formed in and responds to the global, are thinkable without the reinvention of old and innovation of new channels for communication within and across communities. Willett was the intellectual captive of his generation, but found a way to be visionary in that grim post-war reconstruction that was still incomplete in the 1960s. Our challenge is to escape our own intellectual prisons, and see further and with clearer eyes.

[1] Simon Garfield, *Mauve: How One Man Invented a Colour That Changed the World* (London: Faber and Faber, 2000).

[2] William McNeill, *Plagues and Peoples* (Garden City, NY: Anchor Doubleday, 1976); Richard C. Foltz, *Religions of the Silk Road: Overland Trade and Cultural Exchange from Antiquity to the Fifteenth Century* (New York: St Martin's Press, 1999); Philip D. Curtin, *Cross-Cultural Trade in World History* (Cambridge: Cambridge University Press, 1984).

[3] Kenichi Ohmae, *The Borderless World: Power and Strategy in the Interlinked Economy* (New York: Collins, rev. edn, 1999).

[4] Paul du Gay, *The Values of Bureaucracy* (Oxford: Oxford University Press, 2005).

[5] Saskia Sassen, *Cities in a Global Economy* (Thousand Oaks, CA: Pine Forge, 2nd edn, 2000).

[6] Mike Davis, *Planet of Slums* (London: Verso, 2006).

[7] Saskia Sassen, 'Cities as Frontier Zones: Making Informal Politics', in *16beaver*, 13 September, 2007, New York, http://www.16beavergroup.org/mtarchive/archives/002282.php (accessed 2 March 2008).

[8] Joseph Stiglitz, *Globalization and its Discontents* (London: Penguin, 2002).

[9] George Yudicé, *The Expediency of Culture: Uses of Culture in the Global Era* (Durham, NC: Duke University Press, 2003).

[10] Thierry de Duve, 'The Glocal and the Singuniversal: Reflections on Art and Culture in the Global World', *Third Text*, 21(6), November, 2007, pp. 681–88 (p. 687).

[11] Janet Wolff and John Steed (eds), *The Culture of Capital: Art, Power and the Nineteenth-Century Middle Class* (Manchester: Manchester University Press, 1988).

[12] Bill Harpe, *Games For The New Years – A DIY Guide to Games for the 21st Century* (Liverpool: The Blackie, 2001).

[13] John Willett, *Art in a City* (London: Methuen, 1967; repr. Liverpool: Liverpool University Press and the Bluecoat, 2007), p. 8.

Chapter 5. The Liverpool Artists' Sessions. Robert Knifton.

Since the mid-1960s, Liverpool has altered immeasurably – physically through the regenerating of the urban fabric, but also through its shifting cultural positioning. A cursory glance towards the artistic endeavours that have thrived in the city in recent years attests to this. From Open Eye Gallery, through *Visionfest* and *Video Positive*, *8 Days A Week*, Static, Black Diamond, Museum Man, *Further Up In The Air*, to the A Foundation and Liverpool Biennial, there has been a rich, varied flowering of visual arts creativity.

Yet many of John Willett's concerns for the city's artistic community remain pressing topics: the quality and style of arts education, the scarcity of patronage and exhibition sites, and perhaps most vitally, the specifics of place – how the Liverpool of perception compounds upon its reality, how this impacts on an artist's creative work – and further, the very spaces artists are able to inhabit in the city.

In the winter of 2007/08 I met and interviewed a range of artists based in Liverpool. They all relate to this city in their work, directly or obliquely, through their negotiation of its history and memory, the spaces of the city and notion of place. By portraying this small snapshot of practices, just a fraction of the current vibrant Liverpool art scene, this chapter will question what it means to be a Liverpool-based artist in 2008. How have contemporary artists conceptualised their city? How have its processes of regeneration affected their relationship with its spaces? And how can its particular character and identity fit into the globalised contemporary art world?

Alan Dunn, *The Ballad of Ray+Julie*, 2005 (10th Anniversary of original *Ray+Julie* sculpture), 20 x 10ft billboard, Seel Street / Slater Street, Liverpool.
(Photograph, Alan Dunn)

'It's like planting seeds across the city' – Alan Dunn

Alan Dunn moved to Liverpool from Glasgow in 1994. His work addresses the urban fabric across multiple artistic media, from sculpture, sound art and video, to his ambitious billboard project, and internet work with *tenantspin*. Glasgow shaped Dunn's approach to the city. In 1990 he organised *Bellgrove*, an Arts Council funded project during Glasgow's City of Culture. *Bellgrove* ran for twelve months, bringing in a wide range of artists and writers such as James Kelman, Douglas Gordon, Thomas Lawson and Grennan & Sperandio to exhibit on a billboard in the railway station. As in later Liverpool works, the liminal nature of this space was vital for Dunn, acting upon movement through the city:

> Bellgrove was an amazing space, the Victorian arches coming into the station, leaving the city centre through the tunnel, leaving thoughts of the city centre behind. The site was in the heart of the East End, near Parkhead, all my aunts, uncles and nans would see it. I recently did a similar project about Bold Street as a threshold; being the start of going to the cinema or to a shop. The city isn't just about the city centre; it's the moments before, the build-up to cultural spaces. This city is fantastic for that.

Dunn's first work after moving to Liverpool was the sculptural installation, *Ray+Julie*, a collaboration with Brigitte Jurack. Dunn explains how the piece came about:

> I was commissioned by *Visionfest*, just as I moved into Liverpool. Having *Visionfest* running every autumn was fantastic: all the artists came out of the woodwork and made work for it, pre-Biennial, pre-Capital of Culture. Because there were no formal galleries involved we used a lot of unusual spaces. The London Road commission was for a temporary sculpture on a spot of land between the Furniture Resource Centre and the Lord Warden pub. We

pitched two Rennie Mackintosh style uncomfortable chairs facing each other called *Ray+Julie* after the graffiti at the back of the site. We wanted poetically to give the sense that maybe these people once inhabited the site, and here were their chairs left behind. This was December 1995 and they're still there. They've embedded themselves in the fabric and become a symbol of the unchanging state of London Road. London Road has almost gone downhill since then whilst other parts of the city have moved on.

Dunn recently revisited *Ray+Julie* in a billboard work:

I did a ten-year anniversary, invited some artists to respond to the chairs. That was to do with the civic idea of anniversaries, like the 800 year anniversary of the city, 40 years since Sergeant Pepper. I felt we'd done quite well to reach 10, let's celebrate this! Those billboards appeared over on Seel Street. It's another underlying idea in my work, taking one part of the city, photographing, painting it and putting it in another part. There is something quite shocking about an image of London Road in Seel Street. It's an image of my walking through the city.

The Liverpool Billboard Project has seen Dunn organise artworks throughout the city for many years by artists including Fiona Banner, Felix Gonzales-Torres, Erwin Wurm, Scanner, Robert Pollard and Alma Tischler-Wood. The works are startling: presented without the reassuring contextualisation that surrounds works in galleries, they instead disrupt our relation with the city, placing memories or leaving traces that defy the regenerated cityscape:

It's like planting seeds across the city, scattering seeds, and maybe a few years later something might come to fruition. I never do launches or private views; I enjoy the slow reaction that might come a few years later through memory.

I recently found an Everton website talking now about the [footballer Wayne] Rooney billboard I did four years ago, for example. I enjoy when the billboards are removed, as if there's no need there any more for images. There's a little row of houses on Park Road where some Liverpool Billboard Project works once stood – David Jacques, Langlands & Bell, Sue Leask, Pavel Büchler amongst others. I'm sure people only remember these works (albeit fleetingly) when the billboards have gone.

As co-ordinator for *tenantspin* at FACT, Dunn helped pioneer a new form of community art:

It wasn't a geographical community, but based on age and high-rise across the city, in different flats, dealing with these communities in their own spaces. *tenantspin* was an extraordinary journey; it found a way of communicating between artists, curators and residents. *tenantspin* pioneered a flexible working process – collaborating for an hour or a month. It was unique in terms of the project being held back by technology – it quickly moved beyond what was possible, so we worked on performance pieces and gallery presentations. At New York's MOCA the first challenge was how to represent such a project in a gallery, so we decided to take a selection of the high-rise tenants over to New York. Similar things happened in Sweden, Germany, Denmark.

The global reach of *tenantspin*, and of Dunn's billboard project, is for the artist part of negotiating Liverpool's position in the wider world:

I see myself as making work about and principally for Liverpool. It's about bringing in a global perspective on the local. I try to bring in artists in such a way that creates links. In my latest billboard project it was all by emails, no-one came to Liverpool physically. I'm developing strategies

away from studio space, working in the spaces travelled through the city, creating space in a broken-up art world, structuring around different daily everyday realities. There's the concept of cities on the edge, Marseille, Istanbul etc., but I try to go beyond that, I try to get artists who reflect the chaotic element of Liverpool.

'Liverpool is a bit like Jimmy Savile' – Leo Fitzmaurice

Leo Fitzmaurice's work delves into the everyday detritus of urban lives, retrieving miniature miracles of modernist semiotics from the overlooked: cigarette packets, takeaway menus, shop catalogues. He first came to Liverpool to study in 1989, and has lived and worked in the city ever since. Alongside Neville Gabie he organised the renowned *Further Up In The Air* residency, where a wide range of international artists and writers produced work based on their experiences of living in a Liverpool tower block scheduled for demolition. Like this tower block, many of Fitzmaurice's working spaces have been outside art contexts, from prisons to a disused mental asylum:

I don't know if there is such a thing as neutral studio space, so I think it's better to be clear about space. In the situations where I've worked you can't ignore the fact of where you are. It's part of various people's everyday lives. It's quite important not to be in an ivory tower, just be in mundane situations where people live. I don't know if it's particularly healthy to separate yourself off. I'd then have to transport bits of what I consider the real world into another space to consider them!

Fitzmaurice is fascinated by our relation to the visual world built up through commerce, packaging and advertising:

We're living in the most intense visual period ever. If the Impressionists were still alive they wouldn't be going out into fields looking at poppies, they'd be looking at the

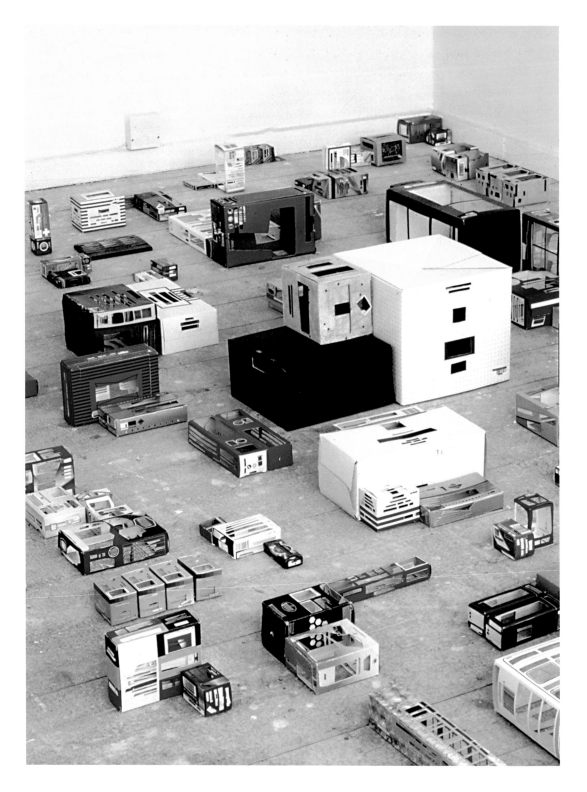

amazing visual environment we're building up. That intensity is heightened in packaging and advertising. By taking it apart I want to just move it slightly askew of its target and enjoy that amazing energy for its own sake. I like that it is all around, I can pick it up, feel it, touch it. I've got a copy of Artforum – it's like a piece of beef! The weight of it, and the way it flops forward. Things like the Argos catalogue are incredibly physical things; I've got this love–hate relationship with them. A lot of it is blather, but if you can rework it in some way, it's incredible.

Working on the thirteenth floor of a Sheil Park tower block for *Further Up In The Air*, Fitzmaurice's art addressed the surrounding architecture, building a tension between modernist ideas and contemporary consumer realities, with packaging stripped of its use-value and meaning being read instead as failed skeletal cityscapes:

Any design is filtered through mass consumerism; everyone is part of the selection of what is good or bad design – an immediate feedback loop. If Wittgenstein was asking, what is red? Well Coke red is red because people have chosen it. That's what happens with design, but I'm not sure if that's possible with architecture. There was a level of irony that packaging is where modernism has most influence. People are going back to mock Victorian bungalows and all we've benefited from those beautiful modernist ideas is this packaging, and we don't even want it! We chuck it away to get at the toothpaste or whatever. On the 13th floor of a tower block that is about to be demolished, these moves I was making were generating a myriad of different ways of thinking about that situation.

Further Up In The Air successfully fostered dialogues between global art practice and the everyday specifics of Liverpool locality by bringing a high calibre of creative talent, including

Leo Fitzmaurice, *Boxwork Cityscape*, 2003, de-texted packaging, produced during Further up in the Air.

(Image courtesy of the artist)

129

Julian Stallabrass, Anna Fox, Gary Perkins, Jordan Baseman, George Shaw and Will Self, into contact with the residents of Kensington, a Liverpool suburb:

> I got connections with artists, writers and curators and started to get a feel for the breadth of the art world. It gave me confidence to think, I can pick any parts of how these people work, but also have the confidence to work my way, be my own person as well. The residents were very important as well – they were complete people, unlike artists who are always trying to fill in lots of gaps. I went from being an incredibly naïve, cut-off character in a provincial town, to feeling the parameters of the art world.

For Fitzmaurice, Liverpool is an ideal place to create art, allowing a balance between the local and global:

> In your own space you can make mistakes, try out things, and when you feel things are starting to work then you can promote them. So a place like Liverpool, it's not so much out of the public eye – because regularly it does become the centre of the art world – but it does allow you a great freedom to do your own thing. If you want a big international audience you can get one, but if you want a month to get on with your work, without worrying about what's the latest fashion, Liverpool lets you.

Fitzmaurice's practice is predominantly urban, but he has recently examined the similarities between urban and rural, explaining countryside spaces as constructed, city space as pastoral. Sign works at two stately homes and a rural sculpture park developed this theme:

> I think there's a great peace in incredibly busy places. In a shopping centre when everyone is doing the same thing I feel as if I might as well be in a corn field. Sometimes the most densely populated places are perversely the most

peaceful. Whereas Westernburg, Harewood House and Yorkshire Sculpture Park are all built environment, built to look like an ideal of the countryside. At Harewood my signs were placed in an Arboretum, with trees brought back from around the world. They're not indigenous, so even the trees are engineered. The rural/urban – I don't necessarily split them along those lines. I almost think the opposite: the shopping centre you can feel as a natural presence, the people's movement around it, whilst the rural is incredibly constructed.

In 2008 Fitzmaurice is working on a book with fellow artist Paul Rooney called *Wrongteous*, which will offer a flipside to the Capital of Culture:

I think the selections will be quite dark; it'll be a counterpoint to '08. It'll steer away from the clichés and uncover what's beneath. I need to psychoanalyse the city – Liverpool is a bit like Jimmy Savile, a performer, but when Savile was on Louis Theroux's programme, under analysis – it was really tense!

'Liverpool: the beginning and end of the world' – Nina Edge

Nina Edge moved to Liverpool in 1993 to take up the Henry Moore Sculpture Fellowship at Liverpool John Moores University. In her practice she has 'used visual art and performance as a magnifying mirror designed to stimulate critical debate around cultural, political, scientific and social order'. This is most visible when addressing the plight of the Welsh Streets, the area of Liverpool where her home and studio are based, currently designated a demolition zone. Edge has used art strategies to discuss the merits of the houses and alternative approaches to regeneration.

When demolition of the Welsh Streets was suggested I had previous experience of being restricted by

regeneration, an activity perhaps more accurately defined by Jonathan Meades as 're-branding'. Cardiff had gone through a very similar process when I lived there. I arrived in Liverpool in 1993 to find it looking suspiciously like Cardiff did when I arrived there in 1981. It was relatively easy for artists to find spaces, the cost of living was relatively low, there was a lot of sharing of facilities, and historic buildings both domestic and industrial. I had seen many losses through regeneration, especially in Cardiff Docks area, where they famously suggested dyeing the brown dock water turquoise, to make it look more like the architect's drawings in which Butetown was relaunched as Cardiff Bay.

What I witnessed in Cardiff gave an insight of the potential of regeneration schemes to deliver disaster, as well as benefit to Liverpool. The city is a place of outstanding architecture and people. Little did I know the reframing of the city would include a proposal to effectively dye my street turquoise.

Receiving a threat to my home and studio by regeneration was not a new experience – I'd been regenerated out of two studios in Cardiff and one studio in Liverpool. Liverpool's Arena Studios on Duke Street became unaffordable after the Ropewalks was rebranded as an 'Arts Quarter'. It's a common global narrative. Artists invigorate neglected areas, property developers follow, and the creatives are priced out of the district. The resulting 'regeneration refugees' are not just artists – but anyone with insufficient resources to pay the new rents and taxes. My work has always been communicative and investigative. It became inevitable that these existing skills would be exploited to encourage audiences to examine regeneration processes and outcomes.

One of the artworks in which Edge dealt with the Welsh Streets was *Nothing is Private*, an installation that used a net curtain to investigate public and private space:

The net curtain hung in the bay window – a web-like veil produced on an antique schiffli machine at Manchester Metropolitan University. There was a light operated by a passive infra-red security system. When people walked past the house their presence threw a light on inside the living room. Whoever and whatever was in the room became an illuminated tableau. Because of conventions surrounding net curtains, the person outside was often taken aback – embarrassed that the room was being revealed to them. The work was shown as an Independents Biennial work for 3 months and effectively moderated the behaviour of the room's occupants.

Like a home the work was fragile and delicate, its design format very like a traditional net curtain. On close inspection it reveals its secrets; the street's three storey terrace, the front door, a 'recycle the houses' logo and a 'no bulldozers' symbol. The future of a community hanging on a thread.

Edge's work engages with global as well as local politics, as in the billboard *Nothing is Fireproof*:

It was made in September 2002, the first anniversary of the attack on the Twin Towers, as part of the Liverpool Biennial Independents programme. A key hovers over a landscape of cash enclosed by text (Nothing is Fireproof) in Arabic, Hebrew and Farsi, and English. The English text was dominant, double-bold Helvetica, believe-me text. Use of Middle Eastern letter forms stimulated interest, surprise, delight and suspicion in the audience. It was made before the invasion of Iraq, looking directly at the inevitable abyss. The work speaks of humans using fire when words fail them, whether bombs, bullets or petrol-soaked rags. The 7/7 London bombs demonstrate what the billboard work predicts, Nothing Is Fireproof. Those who play with fire can expect to get burned.

Edge's own identity as an artist has influenced her views of space and place:

> Liverpool launched its bid to be European Capital of Culture with the slogan 'The World In One City'. If this is the case then Toxteth as a district is the centre of this city. It has been the centre of my time in Liverpool – a remarkable place to continue a practice which considers global concerns. Since I have ancestors from outside Europe I am irreversibly positioned in the broader worldscape as well as wherever I reside. The stresses of both poverties and regenerations on a place can produce negative responses to incomers. Every place can allege that new arrivals do not belong, despite globalisation unfolding a drama which suggests everybody and everything belongs everywhere. In a sense Liverpool has fallen from the role of eighteenth- and nineteenth-century 'Global City' to twentieth- and twenty-first-century 'Provincial Pauper'. If it is to regain a position on global spreadsheets, attitudes regarding incomers and belonging will need revision.
>
> Work in English and Arabic has continued in collaboration with a group of women from Liverpool Arabic Centre. In 2007 we performed a live intervention in Guantanamo Orange suits bearing the script 'Habeas Corpus'. Thus Liverpool natives and incomers discussed King John, his relationship to Liverpool and to personal freedom globally.
>
> The city, like the weather, has been as benevolent as it has been hostile. It remains to be seen if Liverpool will own its regeneration, or if regeneration will own Liverpool.

'Youse not a Scouser' – Pete Clarke

Born in Burnley and raised in Nelson, Clarke comes from a very different version of the North West to Liverpool. He came to teach in the city in 1978, and helped establish the Liverpool

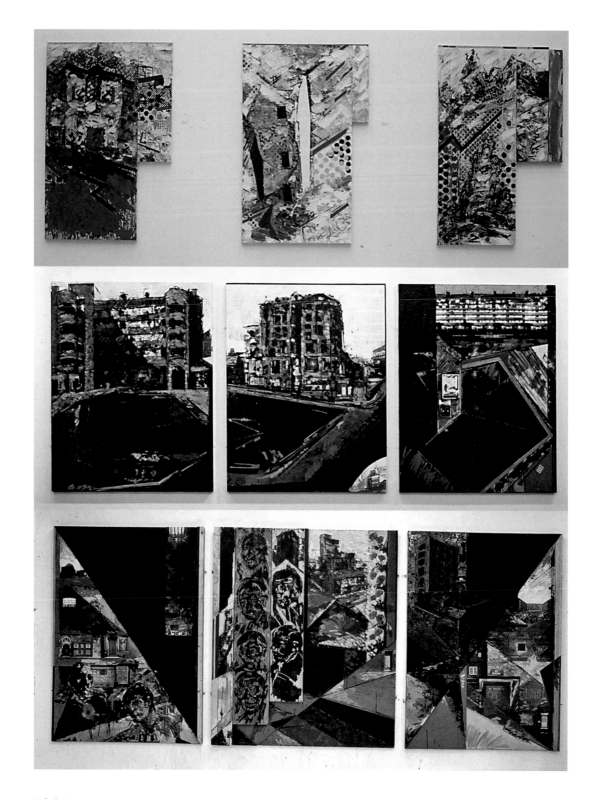

Chapter 5. The Liverpool Artists' Sessions. Robert Knifton

Artists' Workshop, a crucible of new creative talent in the 1980s. He was also an important figure in the development of *8 Days A Week*, the artist exchange programme between Liverpool and Cologne. Clarke's own practice as a painter often addresses city space, layering constructed views, like palimpsests of a city on the boundary between rising forth and collapsing in on itself. His early paintings have a distinctive political element linked to cityscapes, especially the 'Gardens' council tenement blocks:

> I was quite active in the Labour Party and I used to do a lot of knocking on doors, so I knew all of those tenements. I thought that coming from a working class background nothing would shock me, but I was quite shocked by the fact that it was really poor housing. They were all award-winning flats in the 1920s and 30s, Myrtle Gardens, Caryl Gardens. There was something rather ironic in calling them gardens when there was barely a leaf or grass anywhere within half a mile.

Clarke produced contextual paintings such as *Constructed View, Liverpool Garden*, which also had a strong formalist underpinning:

> I was thinking about dialectical painting and the experience of building, like a cubist idea. There's almost an invisible line on the floor where you stand to look at a painting – I'm interested in rupturing that line, so they were constructed over text or photographs. It was a metaphor for engagement: you had to view things close to in order to get a sense of the context, stand back to get a sense of the bigger picture.

In the early 1980s Clarke helped establish the Liverpool Artists' Workshop:

> When I was at the Poly, there were a few students and myself who took over a space next door to the Phil Pub. People like Dave Campbell, who taught Paul Rooney at

Pete Clarke, *Letters to language*, 1998, mixed media painting.

Pete Clarke, *Liverpool Garden Triptych*, 1982, mixed media painting.

Pete Clarke, *Poppies & Roses*, 1983, mixed media painting.

Southport and was involved in Common Culture. We had the workshop there from '81 till about '86/7. My reason for getting involved was the sense of discussion and dialogue. Both me and Dave Campbell had fingers in various leftie pies! It was art in a social context. We once organised a May Day March, with floats, and built a Tatlin's Tower on the back of a TGWU lorry – it was a complete disaster because within two minutes of setting off, it broke and fell over!

Liverpool's character has been important for Clarke:

I like the positioning of Liverpool: I wouldn't say I'm a professional northerner, but I'm not so far off! I've always been attracted to the cultural and social conditions of Liverpool. Because pubs shut at 10.30 there grew up this amazing diverse club culture – we used to go to the Silver Sands or the Somali – Liverpool was incredibly international. Though the art scene felt very claustrophobic in one sense, it was this Beatles, heavy Liverpool thing and nobody seemed to be able to do anything because of this history. I suppose we were a bit rude with a lot of those people. Adrian Henri, Roger McGough were seen as the establishment in Liverpool at the time, and punk was the new thing. About Liverpool in general, however, it's a cliché but I think it's true: a bit like Cologne (in relation to Germany) it doesn't feel typical or representative of England or the UK and I've always found that quite attractive and felt quite at home in that.

Cologne was the city Liverpool built up artistic connections with through 8 *Days A Week*, and Clarke recalls how some of those connections manifested themselves:

Cologne was the place to be, with the Arts Fair, Polke, Kiefer, and so on. Jürgen Kisters came from Cologne for a Bluecoat discussion. I took Jürgen out for a Saturday

night out in Liverpool, he couldn't believe everyone going round half naked, and there was a fight on Mathew St, he thought it was fantastic! We were interested in high art from Cologne and they were interested in culture of Liverpool – Jürgen always said he learnt English through listening to the Beatles.

As part of 8 *Days A Week*, Clarke collaborated with German artist Georg Gartz:

When 8 *Days A Week* was working well, it was always based on friendship between artists, through dialogue over breakfast, chatting about ideas. Georg came from art school in Cologne; he always saw himself as an abstract painter, whereas I was always seen as a social realist painter. We discussed the notion of art being about decision-making: what's important is that you make a decision, regardless of whether it is right or wrong. The themes were images of the city, with a tension between my stuff and his. Working together, we picked up each other's language and vocabulary. Although we didn't always see eye to eye – once I was drawing a bridge, Liverpool doesn't have any, Cologne has loads. I was really pleased with this bridge, I left it and when I came back, Georg had poured a bucket of white paint all over it!

Clarke's work situates the city in dialogues of modernity, and through that develops his own artistic identity:

The city is the metaphor for modernity. I've always liked that notion, something about the local which has that global association. There is a strange indigenous population that you get in Liverpool that's not dissimilar from Cologne, the cosmopolitanism. I like the idea of an imagined community. The worst thing about Liverpool is that it can be very parochial and provincial: I went to a John Belchem history book

Paul Rooney, *Dust (Room 302)*, 2006-2007, video still from sound work with video, 9 mins.

(Image courtesy of the artist)

launch. When it got round to questions, someone accused him: 'Youse not a Scouser'. It started the debate, what is Scouse, and what is the city? The city is a representation and like an imagined community. As an artist you have to have that community, some sort of imaginary audience to sustain the practice. When I first taught on Foundation here in Liverpool, I was giving my introduction and I suddenly heard from the back, this spotty kid pipe up, 'Fucking hell he's a woolly!' Because if you're not from Liverpool you're a woolly-back! Where does Liverpool stop? This city is all-embracing and also excluding.

'Granada-land is my local definition' – Paul Rooney

Paul Rooney grew up in Liverpool. He worked as Common Culture alongside Dave Campbell and Mark Durden, before developing his own highly successful practice, active in the UK and further abroad: first as a musician with his band Rooney – John Peel favourites – and later through critically acclaimed video works that have addressed locations such as Australia, or in the work *No Sad Tomorrow*, Cuba. Rooney's art often utilises pop cultural language to address the forgotten or marginalised in society – narratives of cloakroom attendants, hotel maids, or *Big Issue* sellers. Through music, narrative and image his art works on our own remembrances. Even when his works are based in Liverpool, they often refer to wider global contexts, as with the sound work *Dust (Room 302)*:

Dust (Room 302) refers to Liverpool, although it came out of my Melbourne residency. It refers to a particular piece of Australian history, the Tampa Affair, when some Afghan refugees were picked up by a Norwegian freighter off of Christmas Island in 2001. The ship was not allowed to berth in Australian territory, so it had to sail around offshore for weeks in the glare of the media. The piece arose from that; I was also interested in the Brecht song

'Pirate Jenny' from *The Threepenny Opera* – it has this image of a hotel maid, she works in a hotel on the harbour, and she looks out to sea and imagines a ship that appears offshore, its guns pointed at her city. I used that image of ships offshore, an allegorical image of fear and exclusion, throughout the piece. As Liverpool is a port it was logical to find a hotel here that looked out to sea and to talk to hotel maids who work there.

In *Dust*, Rooney adroitly links the everyday life of a maid cleaning a hotel room to a wider sense of remembrance:

Dust is formed around the leap of imagination when the hotel maid looks out the window. The dust particles that become visible to her when sunlight enters the room in a way stand in for any act of remembrance, for historical moments that can become present in any situation.

Music is vital in many of Rooney's works:

It is about the emotional complexity of these fluid moments of remembrance. With music I'm trying to give a sense of that instability. I was interested in the way the music unsettled expectations. The descriptive material looks quite bland written down, but when sung it took on this comedy, or sadness. Because of the unpredictability of the emotional content of the music it unsettles how you read the content of the work. I'm trying to create a parallel for the emotional power of some of those everyday moments. When I was doing the Rooney music, for two years I just produced albums and did gigs with the band, treating it seriously as its own thing, not necessarily needing an art context. I was interested in communicating in that way. A lot of that early stuff was quite funny – if you're singing about cleaning, or a cloakroom at a club it just becomes funny, it's like John Shuttleworth's songs about tubs of margarine. Later on I

started thinking about how maybe that also links to a local sensibility that I can't really define.

Rooney recently returned to a pure music format, releasing the record *Lucy over Lancashire*:

Lucy over Lancashire is the first record release I've done since the Rooney material. I'm interested in the way northern popular culture stories and myths have been articulated through pop music. Liverpool does want to separate itself from Lancashire, but Granada-land is my local definition. *Lucy over Lancashire* is to do with pre-industrial stories; Lancashire was seen as almost beyond the pale, a dark corner of the land. Witchcraft was really strong in the north west as well as Catholicism: the perception was of Lancashire as being able to absorb these ritualistic, slightly irrational ideas. There are modern mythologies too – the A666 runs from Manchester up to Blackburn – there are all sorts of stories of these weird things happening there! Even now these superstitions percolate through into the modern day. A lot of culture now is globalised and fairly smoothed-off, and art can be like that as well, quite internationalised and easily translatable, but I think there is something interesting about local particularity and specific myths, the character of particular places.

There is often a strong narrative thread to Rooney's films, a fictionalising fabrication by the artist:

The motivation for introducing fiction into my work was because the work I was doing was seen to be almost like documentary work, for example *On This Pitch*, where I wrote a song with a *Big Issue* seller's words which was sung by a choir on his pitch, or *Lights Go On* with the cloakroom attendant, again with a choral setting. But the motivation for those works wasn't the idea of neutral

documentation; the whole way they were represented was meant to question that, to reinforce the artifice of the art work itself and the art making process. The idea of some 'authentic' voice which is allowed to 'express itself' through the work is a questionable one. So I started to really try to push it and intentionally fictionalise elements of an interview with somebody. There may still be a monologue in those works but it is fractured and is literally made up of different voices. This is also appropriate because individual identity, particularly in relation to the city, is often fragmentary.

There is a political aspect to Rooney's work, particularly in the marginalised figures he chooses to create his odes to, something which chimes with the Liverpool context:

The cloakroom attendant, the *Big Issue* seller and the gallery attendant, those works were about being marginalised but also being very visible. Often, the more front of house you are, the less power you have. There's maybe a link also with mobility: people would assume that being mobile, like a *Big Issue* seller moving from pitch to pitch, you have a freedom, but often you can have a lack of real mobility in a political sense. Those works are quite political – there's an interest in stories that wouldn't be viewed, occupations that are totally crucial and not given a value. Having said that, this can go across social classes, some of the recent work I've done such as the Stoke Chapel piece, *A Pox in Your Guts*, the voice in that is more ambiguous, he has a thick working-class accent but talks about driving his new Toyota, so it could be a 'new money' or middle-class context, and this is deliberately not made clear. I think there are lots of different experiences of disillusionment or powerlessness, of unrealised potential, it isn't just those in menial occupations that have the option on this.

'Sometimes Scouse is spoken like French' – Imogen Stidworthy

Language and communication are vital for Stidworthy. Her art often deals with how language describes and defines spaces. Also crucial are myth and memory: her work on the Scotland Road area of Liverpool outlines an absent city space mentally preserved by former residents. From her studio at Static, Stidworthy maps out her global practice – exhibitions for 2008 included Vienna, Amsterdam and Antwerp. The artist recalls her first impressions of Liverpool:

> I was very happy to be moving to a city I didn't know much about. I had visited once before, when my son was four days old, to set up an installation at the Open Eye Gallery. It was over the weekend, so we were hit by the sight of Saturday night in Liverpool. I remember coming down in the hotel lift, which was packed with people coming up on their drugs. They were looking at us as if we were complete aliens. It was a baptism of fire into this extraordinary bacchanalian scene of total excess.

A year after arriving in Liverpool, Stidworthy was commissioned by *Shrinking Cities* to produce a new video work about Scotland Road. Stidworthy drew on the physical, mental and emotional remnants of a community disbanded by social housing policies and regeneration. By examining the remains of community, the project assembles recurring narratives, which reveal both the unity and the contradictions of the site:

> With Scotland Road I started engaging with Liverpool as an artist. It was very interesting for me to find that my thinking around language and identity in earlier work, which tends to focus on individual subjects, could help me in my thinking about this dense community. Nearly all of 'Scottie Road' is now dispersed and demolished, but it is still very present in the minds of the people who used to live there. The history of the industrial

revolution created conditions in the UK that didn't exist anywhere else in Europe; Liverpool was at the centre of that. The docks were massive, the main employer in Scotland Road. Together with the Catholic Church they created incredibly deprived and exploitative conditions which had a profound effect on people's relationship to authority and with each other. Making that piece was a concentrated immersion into that history.

I noticed that certain tropes were coming up again and again in my conversations with people. I began to list these key stories which took on the role of myths; stories about poverty, proximity and power … all sorts of stories, usually about oppression or about finding wily ways of resistance – like the trick of putting potato skins into the collection bag when they didn't have money for the priest. The other thing that struck me was how their nostalgia seems to have become part of the fabric of the city. In these narratives the closing down of the docks seems to be where the story stops as though nothing has come to replace them. The closure was a defining moment for the city, just as Scotland Road is still a defining space for the people that lived there.

*Imogen Stidworthy,
Anyone who had a
Heart, 2003, video still.*
(Image courtesy of the artist)

Myths that develop in city spaces are important to Stidworthy, such as the tale of 'Buckethead':

They're shortcuts to a shared point of recognition and communicate that community to an outsider like me. Someone like 'Buckethead' reflects so many different aspects of the community. There were almost no black people in Scotland Road, they were in the South End, yet he managed to live there, to marry an Irish girl and become a respected figure in the community. Buckethead, whose real name was James Clarke, embodies something about the conditions and contradictions of his position as a black man in a white community – and of the community as a whole.

147

Children liked to swim in the canal, attracted by the effluent of the Tate & Lyle factory because it was warm, and they often got into trouble, or drowned. Buckethead would be called to rescue the child or to recover the body, he'd go in there with his bucket over his head to give him a little stock of oxygen and feel his way round underwater for the body. He also educated people – he ran an annual swimming gala. He invented a beautiful game called 'Me and my Shadow' where he would swim underneath a white swimmer and synchronize his body movements, so that he became his shadow – he was both master and shadow at the same time.

In the sound work *Get Here*, Stidworthy addresses the Scouse dialect directly:

Being a stranger when I was first in Liverpool, I was very aware of the sound of the Scouse accent. I noticed the phrase 'get here', which is usually spoken by women addressing their kids, and I was fascinated by how the demeanour of someone's speech could suddenly transform from calm dialogue to this sonic yanking of the child back through the voice. In general but perhaps especially in Britain, there is a strong relationship between the voice and the geographical, economic and even cultural position of the speaker. The voice expresses but we are also positioned by our voice. With *Get Here* I wanted to address these determining aspects of the dialect; to fragment such fixed identities. In fact 'Scouse' covers a wide range of accents. Sometimes it's spoken like French, delicately in the front of the mouth, sometimes it's very guttural – and depending on how it's spoken, it can mean many different things. *Get Here* was about going into those differences so that the possibility of thinking there is such a thing as a singular Scouse identity disappears. If you listen to the work you are addressed repeatedly by this simple phrase, but with hundreds of different nuances and meanings – in this sense you are constituted and positioned in many

different ways. There are people from all over the world in Liverpool but it's not an international city – people immediately notice if you aren't local. I wanted to make this spectrum audible, from 'local' women to recent Somali immigrants to actresses from LIPA learning to perfect an 'authentic' Scouse accent – each of them inhabiting or wearing their 'Scouse' differently.

Stidworthy exhibited in Liverpool in 2008, although as she explains most of her work is focused away from her home city:

I'm involved in the Liverpool Art Prize: it's the first time I've been identified as a Liverpool artist! A lot of my work goes on outside Liverpool and I enjoy these differences between the places I'm located. I don't feel local. I'm not sure what local means now. On the other hand I'm quite immersed here – we share the same language and that feels very different to living in Holland or Germany, and hearing a language I only partly understand. But even in your own language sometimes what you are listening to slips, and the focus and the understanding shifts away from the linguistic and onto other things. 'You're always a stranger within your own tongue.'

Conclusion

A number of strong recurrent themes appeared over the course of these interviews with six highly individual artists. The impact of regeneration on artists' working spaces and practices in the city, a desire to reach beyond the local and connect with global ideas, a questioning of history and memory as tied up with identity and place, and the multiplicity of identities bound up in Liverpool today. The six highlighted here are all highly diverse, yet they share something in common. They each demonstrate a successful way to reach beyond Liverpool's boundaries, to communicate with a globalised art community, while keeping true to the spirit of Liverpool: an independent, inquisitive, outsider, creative soul.

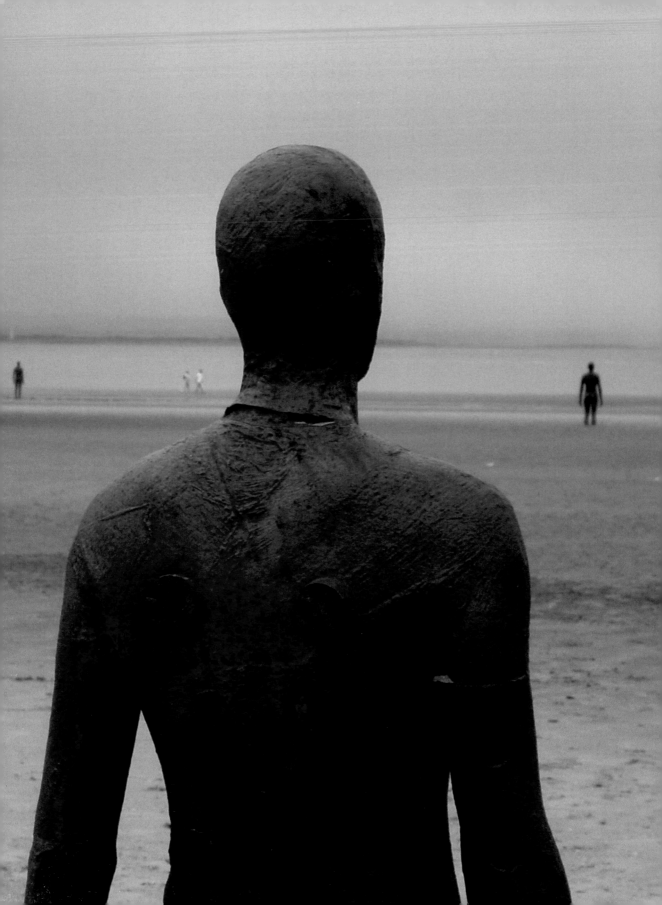

Chapter 6. Of Place and of People. Mary Jane Jacob.

I know Liverpool firsthand from seeking out works of art in public spaces, and this began by trekking to see Tate Liverpool soon after its opening in 1988. Later, biennials brought me there. On the last occasion I saw Antony Gormley's *Another Place*. Of course, I didn't just happen upon this work. You wouldn't unless, perhaps, you lived there. Instead I went specifically, seeking it out, and this time bringing along six other arts professionals whom I had detoured from London, urging them this was a trip worth taking. The poetry of this otherwise-not-so-poetic place resonated fully: drawing us to look out to sea, with longings and dreamings; conjuring histories of trade then and now from traces of industry and toxic imaginings; feeling the presence of new residencies and occasional recreation. Maybe even deeper still was the sense of interiority, of the human mind facing all eternity as symbolised by the vast sea of life and death, and of a kind of collective isolation – being with others yet always alone in our body and with our own thoughts.

In some ways this is an unusual contemporary work of art. Figurative work had been pretty much wiped off the international scene by the 1970s as not new, downright retarditaire. It had certainly been expunged from public art circles (as we would call such outdoor work in the US) for being too closely aligned with monuments of men – all those statues seen to be littering parks and cityscapes, deemed irrelevant and outside contemporary consciousness. Yet, here, at Crosby Beach, these figures made sense – they had to be – and they claimed our attention in spite of, or maybe because of, being no one in particular, because they are us. What I recall is that the experience of this work was not so much of art as of place. Yet I

Antony Gormley, *Another Place* (detail), 2005. The sculpture was brought to Crosby Beach by Liverpool Biennial in partnership with South Sefton Partnership, and later acquired by Sefton Metropolitan Borough Council, with the support of The Northern Way, to remain permanently on the beach.

(Photograph, Steve White)

know I would not have had this experience of the place without art's presence. These figures were of this place (though the artist had employed like figures in other places and in other waters) and, amazingly, they stood more steadfast in the rushing water and slipping sand than if they were on a pedestal in a square.

What was also memorable about this experience was the conversation with the cabbie who brought us there and then accompanied us, not waiting in the parking area but making the pilgrimage, too, walking on wet and dry land to be with these sculptures. This wasn't his first time visiting here, and as we walked together I learned that he sensed that this work should be there, that it had a rightness in this place. His belief in this work was not as an art-goer but as a local citizen. Yet it wasn't so much about civic pride, being proud of this local attraction (though there was some of that, too); it was about his sense of the environment in which he lives and which he shares with others, and a way in which this silent collective brought all that into play.

Why detour to other places and travel outside London, or from wherever you are, to see art? The discourse of place has swept the landscape of contemporary art since John Willett's writing on art and Liverpool. It has resulted in a vast compendium of site-specific and installation works, a genre that I think Willett might well have supported. Art in public space, with direct connection to local histories and everyday concerns or issues, has increasingly flourished over these past four decades. Their references, no matter how particular and rooted in a place, at their best have echoes elsewhere – and herein lies their potential for meaning and their power as art.

Willett understood the relationship of art and location in essential ways. He saw place as both a mechanism for the making and for the receiving of art. A deep resonance occurs when we go to a place to see art, leaving behind our life for a while, when we spend time with one work, as I did Gormley's – so different an experience from walking the halls of a museum among many works – and when the mind has time to follow a path to other places and then find its way back home, back to the place we thought we left behind when we set off to travel. Connecting places, art can also

bring the insider and outsider into a dialogue, as my conversation with the cabbie with whom I walked along Crosby Beach, or into a communion not verbalised. Art in the public sphere draws its concept and physical disposition from such contexts, and when it does not, as Willett observed, it fails. Even when a locality is not the direct subject or inspiration, place plays a role in the artist's process of creation and then in the act of 're-creation' by the viewer, and because places are dynamic, so too, is our experience of a work. It changes over time.

Public art found an opportune moment of expansion and revival with urban regeneration in the late 1960s. Willet saw this writing in 1967. At exactly that time, a parallel effort in the US, termed urban renewal, was given a boost with the first federal funding in 1968. Likewise, it was born in the face of poverty, social disenfranchisement and a desperate need to beautify and clean up dying cities. Art as an antidote, however, was destined for criticism, especially when employing the outdoor modern art collection approach. Such abstract work conformed to the artist's signature style, though made on a colossal scale; it carried with it validation by virtue of its art pedigree but it seemed so *out of place* and was out of touch with public perceptions. Willett saw the failure of this scheme as a result of modernism's reliance on studio practice and personal expression, disregarding a setting's defining physical, cultural and historical terms, as well as collective psychological energy.

By the late 1970s in the US funding directives sought to restore a fusion of art and architecture practices, but these remained mired in professional power struggles. Moreover, artists were educated to protect their mode of expression and the originality of their ideas, and this meant that they kept their distance from the public so that aesthetic standards would not be influenced or subverted by public taste. The result was a 'disconnect': works remained irrelevant to people's everyday life and, so, unsupported by local populations. Upon unveiling, public art administrators saw their job as one of providing art education or just waiting it out until people came to like or got used to the new art.

Attuning art to its surroundings is not just a matter of a well-placed work. It is not about art *in* place but *of* place, so that it might be a part of the people in that place. In the years following Willett's study, several factors came together, making public art a focus for progressive artistic practice. One development was the 1970s explosion of an alternative art scene. At a time of social change and alternative lifestyles, artists assumed a new sense of agency expressed in the formation of artist-run spaces, exerting their own autonomy even if with lesser resources, departing from the public museum or commercial gallery system. This was enabled by the decline of cities that also led to governmental regeneration and urban renewal strategies. So, for example, in New York the erosion of small industries left SoHo vacant for artists' occupation. While this move was initially expedient and proved to be a challenge to the mainstream art-world system, the access to a near-abandoned neighbourhood led artists to take their work out of the studio and into public places and social actions. Temporary meant provisional and experimental – and possible – now! Not intended to be permanent and, given its medium or siting often not possible to endure, these works were not preoccupied with the collector class.

The possibility of art being temporary brought art making into the realm of the performative, with actions that ranged from theatrical to relational, and included other ephemeral arts (such as mail art and artist-produced brochures, fliers, newspapers and other handouts, take-alongs, and ultimately throw-aways). As a corollary, artists also made works in multiple, notably artist's books, a practice that aimed to subvert the economics of the gallery system but became an area of collecting in its own right. Still making an artwork available to more than one person extended ownership and offered a wider range of persons the chance to live with art.

Temporary projects also included interventions on an architectural scale. Outside, in the world, artists (with the help of organisers, collaborators and others) could do what they otherwise could not. Working in the desert or derelict buildings, these impressive works could capture public attention and became events. Even in less visible places, they incisively

cut into situations and touched invested constituencies there, opening up perspectives, shifting thought, and seeking at times to make change. I have found that even though a work may be temporary – or maybe because of its fleetingness – it can live on long after in the memories and imaginations of the public near and far.

In writing that, 'People who are not used to painting and sculpture can still be swept off their feet by the sheer force and quality of something which they do not yet "understand"',[1] Willett pointed to the inherent power of the object and its essential relation to human experience. Thinking of experiences with contextual, site-specific art that I have had or witnessed, however, I would say that understanding can *precede* knowledge. Even though the audience may be outside the art world, they can understand a work that enters their environment – and profoundly so – in ways not even imagined by the artist. They can contribute to the meaning of work in public space and, as we have seen with recent collaborative practices, they can also contribute to its making. Thus, contemporary site practices have advanced Willett's idea, linking his sense of the value of art to people's lives with the value people bring from their own lives to the experience of a work of art.

Recognising the potential role of the public, of the content and perceptions they can bring to a work, and of their experiences that can enhance art's meaning, artists began to operate quite differently in public space starting around the mid-1980s. They became visible to the public, sharing the process and soliciting the involvement of others in the conception and execution of works. This also meant that artists had to put to the test the discourses of authorship, cultural rights and public and private space. This led to the development of new public practices, including the emergence of artists' collectives and collaborations between artists and non-artists, whether they be experts in other fields, community members or more casual passersby. Importantly, it resulted in an enlarged role for the public as maker, informer, participant, as well as spectator.

By the late 1980s developments in public space brought focus

Jorge Pardo, *Penelope* (detail), 2002, Wolstenholme Square.
(Image courtesy of Liverpool Biennial)

Tony Cragg, *Raleigh*, 1986, metal and stone. Purchased by the Tate in 1987, it is located close to Tate Liverpool at the Albert Dock.
(Photograph, Angela Mounsey)

back to museums and an interrogation of the role they play. Damned as elitist, museums were seen to subscribe to hierarchies emanating from colonial or imperial times, evident in their modes of display and systems of representation. Removed from daily life, they seemed to disregard their immediate multicultural populations and a global worldview, along with the critical concerns that mattered to these peoples now. Any accelerated attendance was written off as the success of mindless entertainment and tourism at work. Meanwhile education in museums, which throughout the twentieth century had aimed to cultivate art appreciation through art history knowledge and to improve public taste according to singular standards of quality, required rethinking, too. There was a need to arrive at participatory modes and allow for a more open critical inquiry by the public.

In observing a gulf emerge between the public and modern art, Willett advocated everyday access to art and the cultivation of a sense of normalcy for art to be a part of daily life. Implicit was the idea that art is of value to life on a broad social spectrum, so he put great stock in turning around public education. I would, too, having benefited from the value of art at work in the New York public school system in the late 1960s and 1970s. But by the 1980s in the US, schools had been hijacked by Republican agendas that found contemporary art offensive and frivolous, not of use. In this expulsion of art instruction from the public school system, a new role emerged for museums and, though at times bemoaning this mandate for popular art education as not theirs, this shift presented museums with the opportunity to repair their relationship with the public. By the 1990s many museums were actively exploring new avenues of access and cultivating ways to be relevant to the lives of the visitors they desired to have inside their doors. Here artists came to their aid with site-specific and constituent-specific projects, proving to be able partners in mediating and negotiating ideas with the public, while engendering a new conversation between curators and educators.

Reaching out to the public through art and education was part of the impulse, too, at the origin of Tate Liverpool. So while the website today locates its history in a building conversion as

part of urban regeneration, we also read that it was 'dedicated to showing modern art and encouraging a new younger audience through an active education programme'. When in 1988 I saw Tate Liverpool's inaugural exhibition of Surrealism, I was actually most struck by its corollary offering of works created by the public: people's surreal visions in the form of collages, paintings and sculpture; dreamlike, whimsical and bizarre images. It left a lasting impression. It seemed a kind of public art. It seemed to affirm public ownership of this new institution. It was not patronising and, in my recollection, seemed as large as the masterpiece collection survey. It was endlessly engrossing and it had an impact on my view of the renowned artists in the adjacent show, on the ethos of this new institution, and on my experience of this place new to me – Liverpool.

'The notion that art itself could have a relevance to the community's hopes and ideals, to its work and its leisure, seems to have gone with the Victorian age', Willett said, speaking of a perceived vitality or agreement on an arts agenda, at least among the city movers and shakers if not the populace, in times gone by.[2] But, interestingly, Willett foresaw, too, that '… the sense of individual self-expression and collective self-expression might turn out to be linked'.[3] Maybe it took the self-critical times of the 1980s to realise this potential. Postcolonial discourse led to the expansion of the art world, allowing for the full and viable participation of artists living and working outside the so-called modern art world centres of Paris, New York, London and the like. It led to recognition of multiple centres of art and the creation of a global art scene, giving increased focus to places like Liverpool. These 'other art centres' were promoted and developed in large part through the biennials that placed them on the art map.

Yet, maybe most importantly here, the postcolonial discourses altered the subjects of art, bringing other histories and cultures to bear, and with this, they changed the ways art was made in relation to the public that embodied those histories, leading to art of consensus and collaboration. Public evidences of colonial history offered artists the opportunity to show another point of view and allow for multiple and even conflicted

meanings to emerge. The artist's individual self-expressions
became a collective self-expression as everyone could be part of
the equation: coloniser and colonised, powerful and powerless,
male and female, black and white. Moreover, artists trained in
theory and sensitive to the discourses of centre versus margin
cracked open social dichotomies, probing in their research, their
work, their speaking and their writing the complexities that
went beyond dualistic paradigms. Given the public siting of their
work, the public itself could become part of contemporary art's
conversation. With public participation in artists' projects 'the
notion that art itself could have a relevance to the community's
hopes and ideals' took on new and greater meaning.[4]

When Tatsurou Bashi challenged textbook histories and
connected the present to the past, he challenged, too, the
tradition of the colonial public monuments that are found in
many cities the world over that claim to represent the people. In
Liverpool his work *Villa Victoria* literally re-engaged the
commemorative figurative sculptural tradition and repositioned
it in our own time by resituating Queen Victoria in a mock hotel
room. He added to without taking away what already exists. The
audience got access, literally, to rise atop a massive monument in
Derby Square where they could see the queen close up and in a
new way. Humour, too, became a vehicle to aid in this
translation. Like Gormley's work, the pedestal was gone, though
here encased, so that we could be on the same level as the figure
– history levelled and re-contextualised, and brought closer to us
and into our own times.

Places comprise and are signified by public spaces and
monuments, but part of the reason that Liverpool has been a
fertile setting for new art is not just because of major triumphs in
history but also because of people's way of life. So artists have
looked to the 'monuments' in Liverpool made by industry. Like
statues and civic buildings, industrial complexes and their giant
equipment are commanding; we have the eyes to see them
aesthetically and sentimentally after a century of rising and
waning production. To those of us outside direct experience, they
can be awe-inspiring. To those inside, who knew them as a place

Tatsurou Bashi, *Villa Victoria*, 2002, commissioned for the Liverpool Biennial. This is the interior of the installation incorporating the Victoria Monument; see the Timeline for an image of the exterior.
(Image courtesy of Liverpool Biennial)

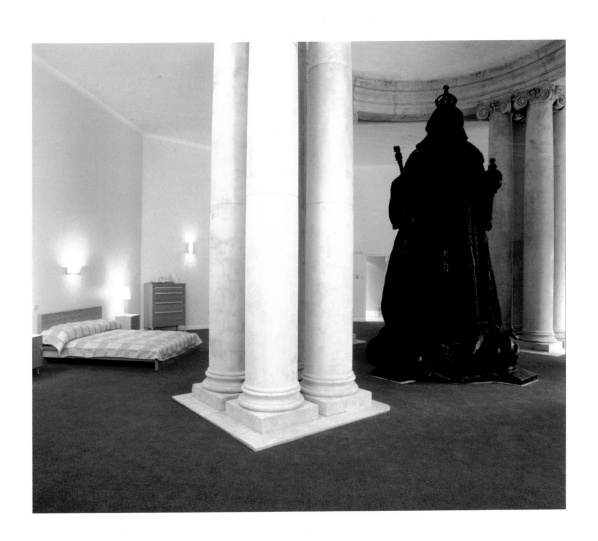

Chapter 6. Of Place and of People. Mary Jane Jacob

of work, they are familiar, old habits, a livelihood; they may have been sources of affliction as well as objects of affection.

Regrettably I didn't experience Richard Wilson's *Turning the Place Over*, but it is a work, at its point of inspiration and in its mode of execution, that acknowledges industry and engineering know-how. That work came in the year following my visit to Crosby Beach. As a scholar of Gordon Matta-Clark, I appreciate it as homage artist-to-artist. Having seen Wilson's work at Matt's Gallery, I felt I could sense even from afar the scale and spatial manipulation he commanded. Then there is that edge of humour provided unexpectedly through photo documentation, as I perceive the work second-hand, watching pedestrians watching the piece and seeing street workers cutting their own hole in the pavement. Wilson's project partakes of that amazingly inventive way in which art and the everyday endlessly enjoy a dialogue and we, through art, have our senses and sense of place disrupted and adjusted.

Works of art can evoke the meaning of a place or of a people. But places, and the people who live there, can also add meaning to art. These meanings given and accrued can live on in a place even if the works are temporary and don't remain there. The art experience is remembered and the place is forever changed. I dare say that if *Another Place* was dismantled, for many people Crosby Beach would be such a changed place. People and places are tied together, and for art to find a place, it needs to be both of place and of people.

Richard Wilson, *Turning the Place Over*, 2007, at Cross Keys House, Moorfields. Co-commissioned by the Liverpool Culture Company and Liverpool Biennial, co-funded by the Northwest Regional Development Agency and The Northern Way, and facilitated by Liverpool Vision.

(Photograph, Alexandra Wolkowicz)

[1] John Willett, *Art in a City* (London: Methuen, 1967; repr. Liverpool: Liverpool University Press and the Bluecoat, 2007), p. 238.

[2] Willett, *Art in a City*, p. 23.

[3] Willett, *Art in a City*, p. 138.

[4] In 1991 in Charleston, South Carolina, I carried out an engaged critique between artists and audiences. Like Liverpool, Charleston is a colonial city, a former great economic power and a global port in a time before 'globalism' was coined, and a key point on the map of the triangular transatlantic slave trade. Like Liverpool, it has uniquely inspired works of art and some of these have been among the first contemporary utterances of another history. That story continues there with artists' projects re-initiated beginning in 2001 to the present. Today they engage contemporary issues of and conflicts around land ownership in the face of rapid development with impact on the built and natural environment. They touch on daily concerns which, while inflected in different ways along racial and economic lines, are shared. Thus, these art projects have become a common meeting ground and, while Charleston-specific in the details, they evoke places the world over.

Chapter 7. Learning and Interpretation. Julie Sheldon.

Since John Willett first arranged his thoughts on art education in Liverpool in 1967 its provisions in the city's museums and galleries, schools and colleges and universities have been informed by a number of shifts in pedagogic theory, cultural policy and creative practice. In several crucial respects the parlance of art education has shifted since 1967, signalled most tellingly by Willett's chapter title 'educating the eye'. Today, the concept of 'educating the eye' is problematic across the sector, where there is a linguistic resistance to the term 'education' in the taxonomy of its operations – reinvigorated by terms such as 'learning', 'inclusivity', 'participation', 'interpretation' and 'access'.

One example of the shifts in educational thinking since 1967 is amply represented in the area of art education in museums and galleries.[1] Willett does not deal explicitly with art education in the gallery and there are valid reasons for his apparent oversight. Until relatively recently, gallery education called to mind schoolchildren and art students dispatched to galleries to sketch the exhibits. This is not to say that museums and galleries in the 1960s did not have an educational remit. On the contrary, the philanthropic impulse for founding provincial art museums was motored by ideas of educational improvement. The point is that there were fewer active opportunities to enable education to take place in the art museum beyond a nebulous equation between the act of seeing and the facility for improving. Willett's only observations on gallery education are references to the lectures at the Walker Art Gallery organised in collaboration with the University of Liverpool where he lists some of the eminent speakers attracted to the city by this programme. Willett also notes the appointment of a Schools Officer at the

Our House, Four Corners, 2007. The house was a temporary exhibition space housing art work created by people from five Liverpool neighbourhood areas, working with Arts in Regeneration, the Bluecoat, Encounters, ICDC and Liverpool Everyman and Playhouse. Created by Mark Storor, Artistic Director of *Four Corners* 2007, it was inspired by an artistic idea by Jane Forster. (Image courtesy of Liverpool Culture Company)

Walker in 1957 but his remarks on the plans for a specially designated children's room that had never materialised are perhaps illustrative of the limited visible presence of art education at the Walker in 1967.

The present descendant of the Schools Officer at the Walker holds the title of Director of Learning and presides over education across the various sites comprising National Museums Liverpool.[2] The vision of the Schools Officer at the Walker in 1957 has finally been realised and, upon entering the Walker, to the visitor's immediate left there is a 'children's gallery', a zoned space cheerfully marked by large coloured tumbling letters reading 'BIG ART', where young people participate in learning activities. Art education then is no longer seen as an ancillary part of the gallery's operations. In fact educational programmes at National Museums Liverpool are often highly visible to the visitor, where, for example, one may be required to circumnavigate activity tables and children's drawing equipment to get to the collections at the Liverpool World Museum.

The post-war Britain that Willett's subjects inhabited in the 1960s had inherited a nineteenth-century idea of gallery education. Its most cherished and long-held belief was that art had the power to improve and to civilise society. Critical pedagogies emerging since the 1960s share the same assumptions; but the mechanisms for social improvement and the presumptions under which educators once operated are largely and irrevocably altered. Recent and contemporary museum and gallery practices have rendered Willett's untroubled use of the word 'education' problematic, and the term now has connotations of stridency with the presumption that the process entails a one-way channelling of information. The semantics are often neatly elided by the substitution of the word 'learning' or 'interpretation' for 'education' in the job descriptions of staff in galleries and museums across Britain. Learning is a term that places the onus on the learner rather than the educator; and interpretation acknowledges that there might be multiple responses to museum experience. In this semantic shift the responsibility for learning resides with the learner, and the gallery's responsibility is to

provide an appropriate learning environment, 'that is life-sustaining and mind-expanding, a place of liberating mutuality where teacher and student work together in partnership'.[3] For instance, at National Museums Liverpool, 'learning' is deployed across the eight sites through 'activities' that typically include talks, hands-on sessions and workshops.

Education programmes in Liverpool's museums and galleries are exercises in facilitation, as opposed to formal taught sessions, relying on a context of mutuality and shared knowledge between stakeholders. Liverpool's museums and galleries have initiated or presided over several innovations in learning over the last twenty years. When it opened in 1988 Tate Liverpool pioneered a particular kind of education, exemplified by its concept of the educator-curator. By pairing individuals from the curatorial team with a member of the education department all exhibitions and displays[4] were devised and project managed in combination. One successful outcome of the design of exhibitions in tandem with education has been the development of teaching and learning resources alongside exhibitions. Tate Liverpool has led with its educational resource packs since 1988 promoting learning within the gallery and through 'follow up work' in the classroom. *Working with Modern British Art* (2000), for example, was a resource pack produced in collaboration with Liverpool John Moores University that suggests rather than prescribes activities and approaches to the works on display from Tate's collection.[5]

The onus upon interpretation in gallery education is frequently grounded in the liberatory pedagogies of the late twentieth century; that is, teaching concerned with audiences who traditionally have been marginalised in schools or educational systems. Progressive educators see the emancipatory potential of art education as a key constituent of learning, where the disempowered are given a voice, inequalities are redressed and individual freedoms are promoted. In this respect Tate Liverpool's outreach work with local communities has been pioneering. Education staff at Tate hold the title of 'Curators of Learning', recalling the original sense of the word 'curator', meaning 'custodian'. A strong commitment to outreach work in

organisations such as Tate is forged on the basis that educational scenarios arising from gallery collections and displays can have beneficial impacts on social groups and local communities. For example, a scheme called 'Young Tate', which has been running since 1994, pioneered peer-led workshops: 'Workshops across all programmes focus on discussion mediated through direct engagement with artists' work, with the aim of encouraging young people to connect in the gallery with their own interests and experiences.'[6]

In addition to the initiatives at Tate Liverpool, the city has hosted other innovative or imaginative programmes that involve communities in the activities of its galleries and arts organisations. In 1999 the Bluecoat set up *Connect*, an arts participation scheme, creating opportunities for a wider constituency (communities of young people in formal and informal educational contexts, disabled people and people from Liverpool's diverse communities) to gain access to contemporary arts, dance, music, writing, live art and visual art. Establishing longer-term relationships with its participants, sometimes over several years, the Bluecoat's participation ethos is further expressed in its recent refurbishment, where there is a dedicated space used by different groups on a regular basis, for instance by adults with learning disabilities, a scheme set up in collaboration with the local authority as an alternative to daycare provision.

A comparable scheme to *Connect* is run as part of FACT's long-established Collaboration Programme, called *tenantspin*, a pioneering community webcasting programme that brings people in Liverpool and artists together in new media projects. During and in between festivals Liverpool Biennial runs an ongoing Learning and Inclusion Programme that operates alongside the festival and various commissions. The team creates and develops a wide range of projects for schools, colleges, universities and community groups.

In the city's primary and secondary education sector there have been significant shifts in the context in which schools are obliged to operate. External shifts, such as the impact of globalisation, growing centralisation, multiculturalism, as well

as internal shifts and reactions to more process-oriented forms of pedagogy, have served to make some of the teaching Willett describes outdated. The 1960s pedagogical assumptions of Willett's phrase 'educating the eye', with its implications of a sensory intelligence, represented the notion that aesthetic qualities or values could be cultivated in the viewer. In one sense, Willett's formulation that art has the power to intellectually, emotionally and morally inspire and transform individuals stands up to current critical pedagogies. Willett was certainly a progressive educator and a counterpoint to the formalist mid-twentieth-century concept that viewing art represents a unique 'aesthetic experience' that renders the appreciation of art as an innate, rather than an acquired ability. But then in another sense, Willett's idea of a sensory intelligence falls short of recent child-centred pedagogies that incline to the view that looking at art is essentially a cognitive activity. To see, young people have also to name, to appreciate, to relate and to draw upon an array of information that will extend beyond what they merely see. The demands on the 'educated eye' are extensive and young people will be taught to assess the visual data in terms of wider experiences and understandings, eventually connecting them to wider values and commitments. Again Willett's prescient remarks anticipate Pierre Bourdieu's identification of 'cultural capital', that is the advantages that tend to be transferred through knowledge, skills and education that determine an individual's status in society. Bourdieu's emphasis on the 'reproductive role' that structures and institutions play in reproducing inequality has been picked up by educational theorists, who see a correlation between the transformation of symbolic or economic inheritance (e.g. accent or property) into cultural capital (e.g. university qualifications).[7]

The framework for guaranteeing the efficacy of art education to school pupils is greatly altered since Willett's book. Gateacre Comprehensive School, Holly Lodge Girls' Grammar School and the Blue Coat School, three of the schools Willett discusses, are now subject to the same National Curriculum in Art and Design.

Tate Liverpool's Lantern project on the gallery's 20th birthday, 2008.
(© Tate Liverpool)

Family drawing activity at Tate Liverpool.
(© Tate Liverpool)

A National Curriculum, introduced in 1992, set statutory
'attainment targets' in the Key Stages of art education. The first
stipulated for 'investigating and making' and the second for
'knowledge and understanding'.[8] The National Curriculum has
undergone review with a new secondary curriculum being
introduced across England:

> To give schools greater flexibility to tailor learning to
> their learners' needs, there is less prescribed subject
> content in the new programmes of study. Pupils will still
> be taught essential subject knowledge. However, the new
> curriculum balances subject knowledge with the key
> concepts and processes that underlie the discipline of
> each subject.[9]

For example, at the Blue Coat School Key Stage 4 (GCSE) the
learning outcomes are achieved through projects:

> Most projects now begin with a visit to the Liverpool Tate
> or the Walker Gallery. Back in the art room, students are
> taught how to re-conceive and interpret what they have
> seen so as to feed and foster their individual artistic talents.
> Their powers of observation are enhanced through
> drawing, and they experiment with making imaginative
> and conceptual leaps from initial source material. Thus,
> they learn something of the true artist's ability to be
> creatively self-critical in the assessment and constant
> improvement of their own work.[10]

Atypically perhaps, visits to the Walker were often a fixture in
the art curriculum of Liverpool's schools in the 1960s and 1970s.
The value of pupils' experience of the original work of art to art
education has retained both its centrality and significance.
Willett is contemptuous of the 'colour transparency' or the slide
which he calls 'a dangerous instrument which can come to seem
more attractive than the picture itself',[11] particularly as a
substitute for the original. Today teachers are likely to be equally

dismissive of the digitised copy of the work of art, and still incline to the view that there is no substitute for experiencing works of art in the original. Consequently field visits to museums and galleries are, as at the Blue Coat School, a routine part of the curriculum – as long as they remain undeterred by the risk assessments that now precede an offsite visit.

GCSE Art and Design assesses students on the basis of a portfolio and a 'critical study', that is, a written study on an independently chosen topic. In A Level Art and Design the qualification is weighted to coursework and around a third of the assessment relates to a Personal Study in Critical and Historical Studies. At the Blue Coat School:

> Paintings, images and artifacts are analysed and evaluated in a systematic way – in order to identify their intrinsic qualities, and to serve as a point of departure for the student's own work. A deeper acquaintance with the language of art criticism and discussion is acquired, and students gain experience in casting their impressions and insights into reflective written form. This growing ability to identify the nature of artistic intentions is both a challenging intellectual exercise, and a productive technique for truly appreciating, and truly creating, worthwhile art.

The requirements for a 'deeper acquaintance' with art history and art criticism in art education match Willett's prescriptions for 'Art Appreciation' in 1967. Willett makes the case that all forms of art education are predicated on some form of 'Art Appreciation', but acknowledges that it is a 'discouraging-sounding heading'[12] and he uses the term gingerly, always expressing it in inverted commas. By the 1960s the term 'Art Appreciation' was loaded with bourgeois connotations of connoisseurship and predicated upon the privileged gaze of the disinterested viewer. Willett was writing at a time when art historians such as Arnold Hauser and John Berger were exposing the highly fraught commerce with the visual artefact through

the social history of art, and feminists were problematising the gaze. Thus Willett writes disapprovingly of the kind of 'purely passive appreciation' taking place in the extra-mural classes, populated increasingly by what he waspishly calls 'housewives', in advance of a Hellenic cruise.[13] The participants in extra-mural studies at the University of Liverpool have subsequently become part of a Continuing Education programme, and now form part of the University's Centre for Lifelong Learning. Popular short courses, including 'Investigating International Modern Art at Tate Liverpool' and 'Sculpture in Liverpool', have attracted diverse audiences.

Post-compulsory education, that is the further and higher education sector, was characterised by Willett as a 'kind of no-man's land' in Liverpool in 1967. He points out that there is

> little evidence of co-ordination or common thinking even between neighbouring institutions … Everywhere there seem to be barriers, though nothing solid and outward such as could be demolished by order; more an unquestioned tradition of boundaries, sometimes drawn so constrictingly that a kind of no-man's land is left all round: the dead ground into which the visually alert child slips after the age of sixteen.[14]

Willett scratches around in order to find evidence of visual creativity in the provisions for post-compulsory education in the city, citing the drawing exercises of trainee nurses at Mabel Fletcher College and the cake designs stamped on gingerbread at the now defunct Food College as rare examples. Today, opportunities for the 'visually alert' to pursue qualifications in art and design in the tertiary education sector are available at Liverpool Community College and Hugh Baird College. For higher education Liverpool Hope University and Liverpool John Moores University both run degree programmes in art and design. The biggest provider of tertiary art education is at Liverpool John Moores University with BA programmes in Fine Art, Architecture, Graphic Arts, Textiles, Fashion, Product

Chapter 7. Learning and Interpretation. Julie Sheldon

Design, Interior Design, and History of Art and Museum Studies.

The School of Art and Design at Liverpool John Moores University grew out of the institution that Willett knew as the Regional College of Art, and that was known colloquially and locally as 'the Art College'. It is a substantially different institution today. In the 1960s the Art College was a gateway to higher education for students without formal qualifications, particularly through its foundation course.[15] No longer autonomous, Liverpool went the way of most other UK art schools to be subsumed within polytechnics in the 1970s and 1980s,[16] and within state-controlled education systems. Overseen by the CNAA (Council for National Academic Awards), polytechnics replaced diplomas in art and design with BA and BDes degrees. In 1992, along with other UK polytechnics, the Art College became subject to the financial and organisational discipline imposed by the new Higher Education Funding Councils upon 'new universities'. In higher education 'subject benchmarks' became reference points for curriculum designers, and modules began to unitise learning by means of discrete blocks of teaching, learning and assessment. While some saw the compartmentalising of creative activities through prescriptive 'learning outcomes' and the laying of audit trails as a disruption to the holistic approach to art education, others have seen it as imposing long-needed structure on the educational experience, enhancing the quality of instruction and the accountability of its teachers.

Despite the organisational shifts of the 1970s and the 1990s that have guided the design and delivery of art courses, the training of artists has been guided less by pedagogic and cultural policy and more by changes in the wider and professional art world. For example, Willett would not have been familiar with the designation of 'fine art practice' or 'visual arts practice' as something that describes a professional involvement with contemporary art. The noun 'practice' meaning 'the habitual doing or carrying out of something' as a professional affix – medical, legal or creative – was discussed ten years after Willett's book by Raymond Williams. Williams considered the change from use of the word 'medium' to

Blue Room at the temporary Out of the Bluecoat space, 2007. The project involved adults with learning disabilities working with artists to develop creative skills, and continues three days a week at the Bluecoat with a membership of over 30 people.

(Photograph, Adela Jones)

Geraldine Pilgrim, *Traces*, a project with pupils from the Blue Coat School, commissioned for Liverpool Live at the Bluecoat, 2008, to commemorate the School's 300th anniversary.

(Photograph, Sharon Mutch)

use of the word 'practice' in discourses of art, noting that practice 'has always to be defined as work on a material for a specific purpose within certain necessary social conditions'.[17] Whereas medium or technique emphasised material production, art practice is aligned to broader culture, and to political, aesthetic and socio-economic fields. The formulation of art as practice was greatly informed by the rise of conceptual art in the 1960s, where making art was process-led. Artists are likely to regard their art training as a place where they became conscious of their own position in the wider art world, a point at which they became implicated in an ideological or methodological position. Consequently education for artists who practise has demanded theoretical rather than practical and medium-specific or skills training.

One could suggest that the art educators Willett observed in the 1960s were polarised between those who held on to lingering attitudes about the 'unteachability' of art and those who subscribed to organised educational exercises, particularly expounded by the followers of Bauhaus teaching. In between these extremes there was another type of educator – the academician who believed that rigorous visual observation and studies rooted in the exercises instituted in the academies and the industrial drawing schemes of the previous century were essential to training artists. Willett remarks particularly upon the 'Bauhaus-like exercises' at the Art College and commends the Teacher Training Department for 'finding fresh ways of relating visual expression to interests and experiences within a child's range'.[18] But Willett's approbation is measured and despite the mitigating remarks about Teacher Training in Art, he castigates fine art members of staff for not engaging more fully with the print room facilities, whilst print staff are criticised for turning out unremarkable pictures of 'the crudest calendar-illustration sort'.

In 1967 the College of Art in Hope Street was already co-opted into what he describes as 'the national art education pattern' and 'the regional character of its teaching resided not in the approaches to teaching but in the fact that many of the teachers hailed from the region', although he recognised that there was 'nothing very distinctively Liverpool about the

College'.[19] In 1967 the Art College employed many critically successful artists; but then there has never been a direct correlation between an artist's status and their capacity for teaching; and nor did their presence constitute a distinctive regional presence, either by practice or by inclination.

However, Willett did acknowledge that the College's reputation made it one of the 'the best art school[s] in a hitherto somewhat uninspired area', that is, in the area of art education in Britain.[20] To put Willett's remark in its operational context, there was critical debate in the 1960s about modernist art education. In America, at the same time, the art critic Harold Rosenberg was especially troubled by the uninspired teaching of American students in Bauhaus methods. Critics such as Rosenberg observed a worrying tendency to set students tasks that were shorthand for modernism, without making their own artistic breakthroughs. Commenting upon 'the cool, impersonal wave' of 1960s art, Rosenberg observed: '... Josef Albers' impacted color squares have become the basis of impacted-color rectangles, chevrons, circles, stripes – works bred out of works, often without the intervention of a new vision'.[21] His criticism of the practice of training artists in the methods of other artists, notably Albers, expressed a wider concern that the systematic observance of grids and circles would herald a generation of problem solvers rather than artists.

This shortcut to modernism through Bauhaus exercises that so worried Rosenberg and, to an extent, Willett is borne out by some of the images of children's art and student art that Willett uses to illustrate his chapter on art education in Liverpool. In addition to constructivist and Bauhaus school-room exercises, Willett's two images of a Fine Art spring show in 1965, in the distinctive Hope Street Gallery before its arcaded entrance was filled in to comply with fire regulations, presents a student *tour de force* of late 1950s and early 1960s modernism. Just visible are several large canvases inspired by modernist abstraction. To be fair, they are not card-carrying Bauhaus works, and some are more reminiscent of abstract expressionism; but the students' work, collectively viewed in the installation shot, is clearly

indebted to established modernist styles, and lacking perhaps an understanding of the motors for modernist breakthroughs in style. Moreover, the work is entirely unengaged with Pop Art, the principal avant-garde movement of the 1960s.

The difference between mimicking modernist styles and understanding them is achieved through a knowledge of art history. In Willett's survey of art education he writes about the centrality of art history in the education of the eye. In the 1960s an art school student could expect a large proportion of his or her studies to comprise art history and additionally to be supplemented by what was generally called liberal or complementary studies. Although common in the United States, the liberal studies curriculum was unique to art and design in the UK. The liberal studies syllabus largely consisted of a course in which students would undertake a compulsory day a week studying music, film and the arts in the broadest sense. Art history and liberal studies were often viewed as academic areas that provided antidotes to art teaching that was predicated on the twin premise that creativity is ineffable and unteachable. In 1985 Griselda Pollock, drawing upon her experiences of teaching and examining in art schools, observed that: 'There is in art schools a generation or two of teachers and artists whose sense of art and culture was formed at a different moment from that of their current students. Confrontation with deconstructive practices is found hard to accommodate to their paradigm of art and its appropriate terms of assessment (such as: does it move me?).'[22] Art school students in the 1960s would be most likely to confront 'deconstructive practices' in art history and complementary or liberal studies, where the interdisciplinarity of each runs counter to specialisation, offering the opportunity to pursue knowledge for its own sake, and learning for the sheer intellectual challenge. The role of art history, or broader liberal studies (increasingly termed 'contextual studies' in the new universities), is sadly less secure in the art school curriculum, where a number of practical programmes have abandoned the formal teaching of art history.

The impact of new technologies upon art education marks another significant shift since 1967. As a tool for teaching art, the PowerPoint presentation permits images to be projected alongside text, to be drawn over with electronic tools, or to be combined with several other images. Even if this has not always led directly to critical pedagogies in the classroom, at the very least the use of PowerPoint and digital means of reproduction have been a valuable tool for the dissemination of art images and afforded an effortless process of permitting combinations of information. The practice of art-making has also been informed by new media. Optimistically viewed, new media art is a global phenomenon: a rapidly changing and dynamic field of creative practice which crosses conventional categories and disciplinary boundaries, challenging our assumptions about art. Viewed less kindly, it is fundamentally still a medium for making art that communicates pretty much the same ideas, beliefs and messages that oil painting, acrylic or works in bronze do.

The final change in the landscape of art education since 1967 is in the increased provision for postgraduate study and research. In 1999 two pilot schemes were established for an artist teacher scheme, one at Liverpool John Moores University in partnership with Tate Liverpool. Artist teachers, that is, individuals who are in regular employment as a teacher, either in schools and colleges or in a gallery, and whose work is informed by their art practice, attend the MA to reinvigorate their practice. Other Masters schemes in art history have been short-lived: the University of Liverpool offered a Masters in Contemporary Art in collaboration with educational partners in Israel and another in Visual Art in the City; around the same time Liverpool John Moores University offered an MA in Art History and Theory. Masters programmes are often regarded as financially unviable in the market-led model of universities. Nevertheless, the first MFA (Masters in Fine Art) has been validated at LJMU in 2008 and Liverpool Hope University has begun an MA by Creative Practice. Opportunities for MPhil and PhD research in art and design practice became available after 1992 when 'new universities' were able to award research

degrees. Consequently practice-led doctorates in art and design have been a distinctive area of postgraduate provision for post-1992 universities.[23] LJMU awarded its first PhD for research in holography in the 1990s and awards have followed for research in sonic arts, fine art and installation.

<p style="text-align:center">✳✳✳</p>

Willett's evaluation of art education in the city concluded that it lacked 'purpose, consistency and continuity', citing a lack of common vision and cooperation between organisations. Is there any more common thinking today? Have the imposition of benchmarks, the standardisation of curricula, the issuing of common remits and the rhetoric of accountability upon educators answered Willett's call for 'purpose, consistency and continuity'? Or have the centrally conceived directives to educational providers become a kind of fundamentalism that has stripped away the local and the contingent? The regulatory impulses of central government might be seen as an attempt to coerce a common vision and sense of purpose. But locally, in Liverpool, the institutions that provide art education answer to different agencies (an alphabet soup of regulatory and advocate bodies – HEFCE, Ofsted, QAA, NSEAD) that make overall compliance to the greater scheme of things quite difficult. Willett's conclusions therefore still have a currency; but for different reasons. An instrumental culture of regulation has attempted to 'join up' the pieces, but the integrity of the pieces often relies on incompatibility.

[1] The reorganisation of local government in the 1970s and 1980s encouraged museums and galleries to focus on their audiences; not only to prioritise learning but to fundamentally rethink their notion of audience. The creation and maintenance of cultural policy by overseeing bodies was signalled further in 1979 when the Arts Council created its first education post in the visual art department, and began to develop policy statements on education in 1983.

[2] The organisational name for the body that oversees the operations of eight museums. The Director of Learning is responsible for all education and outreach, not simply for schools provision.

[3] bell hooks, *Teaching Community: A Pedagogy of Hope* (New York: Routledge, 2003), p. 15.

[4] At Tate 'displays' are formed in the main from works from the collection; 'exhibitions' are constituted largely by borrowed art works.

[5] *Working with Modern British Art: A Practical Guide For Teachers* (Liverpool: Tate Liverpool, 2000).

[6] Naomi Horlock (ed.), *Testing the Water: Young People and Galleries* (Liverpool: Liverpool University Press), p. 74.

[7] Pierre Bourdieu, 'The Forms of Capital', in John G. Richardson (ed.), *Handbook of Theory and Research for the Sociology of Education* (New York: Greenwood Press, 1986), pp. 241–58.

[8] *Art in the National Curriculum: A Report to the Secretary of State for Education & Science on the Statutory Consultation for Attainment Targets and Programmes of Study in Art* (York: National Curriculum Council, 1992).

[9] http://curriculum.qca.org.uk/developing-your-curriculum/what_has_changed_and_why/index.aspx

[10] http://www.bluecoatschoolliverpool.org.uk/school/subjects/arts.asp

[11] John Willett, *Art in a City* (London: Methuen, 1967; repr. Liverpool: Liverpool University Press and the Bluecoat, 2007), p. 142.

[12] Willett, *Art in a City*, p. 139.

[13] Willett, *Art in a City*, p. 141.

[14] Willett, *Art in a City*, p. 160.

[15] Foundation studies in art and design at Liverpool John Moores University ceased to operate in 1998.

[16] Although operating as autonomous institutions, most British art schools were financed and therefore regulated by government departments. One of the last remaining independent art schools, Wimbledon, become part of the University of the Arts in 2006 and Cumbria in 2007. Edinburgh College of Art and Glasgow School of Art, and the City & Guilds of London Art School are examples of the few remaining independent art schools.

[17] Raymond Williams, *Marxism and Literature* (Oxford: Oxford University Press, 1977), p. 160.

[18] Willett, *Art in a City*, p. 145.

[19] Willett, *Art in a City*, p. 143.

[20] Willett, *Art in a City*, p. 144.

[21] Harold Rosenberg, 'Educating Artists', in G. Battock (ed.), *New Ideas in Art Education* (New York: E.P. Dutton, 1973), pp. 91–102 (pp. 92–93).

[22] Griselda Pollock, 'Art, Art School, Culture: Individualism after the death of the artist', *Block* 11.6 (Winter 1985), pp. 8–18 (p. 8).

[23] Fiona Candlin, 'Practice-Based Doctorates and Questions of Academic Legitimacy', *The International Journal of Art and Design Education* 19.1 (2000), pp. 96-101.

Chapter 8. Dissenters of the Creative Universe. Cathy Butterworth.

In *Art in a City* John Willett asserted that Liverpool's environment engenders interdisciplinary practice in the arts – he cites the early happenings by Adrian Henri, in which poetry, visual art and pop music came together, and the way Stuart Sutcliffe's brief career oscillated between painting and rock 'n' roll. Willett discerned among the small bohemian scene that was at the core of his study of contemporary art practice an ease with which artists so inclined could work across boundaries. Admittedly the examples he gave, such as Henri and Sutcliffe, were few in number. However, they were indicative of two trends in Liverpool at the end of the 1950s and into the following decade, which – while part of the general post-war breaking down of old social structures and hierarchies across the UK – found particular resonance and articulation in this city.

First, there was a move towards a popularisation of culture away from its long-held position of lofty elitism – the biennial John Moores painting competitions at the Walker, for example, became genuinely popular events, attracting increasingly large and diverse audiences beyond those that the gallery already enjoyed, and when the Walker staged a memorial exhibition of the work of Sutcliffe, a previous John Moores exhibitor, some 10,000 people attended, many of them undoubtedly Beatles fans. Galleries, and the Walker in particular, had long since ceased to be the preserve of the few but this period witnessed an unprecedented opening up to a wider constituency.

Yoko Ono performance at the Bluecoat, 1967. (Photograph, Sheridon Davies, info@sheridondavies.com)

By the 1970s theatre in Liverpool too, principally the Everyman, was witnessing a greater local engagement through plays that both reflected topical issues about everyday experience in the city and captured the imagination of an increasing number of people who would not regard themselves as regular theatre-goers. Above all, the democratisation of culture in Liverpool was seen in an explosion of community activity, from the pioneering work of the Blackie to myriad neighbourhood initiatives involving an array of arts and cultural activities by and for local people, such as carnivals, photography workshops, the free school and free press movements.[1]

Secondly, the city's perceived rebellious spirit was not confined to its politics, but was beginning to be articulated through culture as well. An innate self-belief, however deluded – Yosser Hughes' 'I can do that' mantra in *Boys from the Blackstuff* – combined with a sense of going against the grain, has long characterised aspects of Liverpool's creativity. From the early 1960s we see it in the way the confidence, intelligence and quick wit displayed by the Beatles – as refreshing as their music when they first grabbed the nation's attention – came across as being distinctly un-English, not the way things were normally done. As Paul du Noyer has claimed, 'To be from Liverpool, even before the Beatles and mass media begat a certain self consciousness about the city's identity, was to be at one remove from standard English reality'.[2] Rebel voices, not necessarily oppositional, but more likely individual and maverick, have rarely struggled to be heard in the city, while local audiences – never shy of expressing an opinion – will nevertheless remain open to whatever artists present them with.

Though Willett found little more in the way of performance art to report on than Henri's live actions, his sense of the conditions being right in Liverpool for experimentation, and the cross-fertilisation of poetry, art and music, was realised in the following years when the city witnessed a growth in what was to become known as 'live art'. In 1967, the same year as *Art in a City*'s publication, Fluxus artist Yoko Ono performed in Liverpool at the invitation of Dave Clapham, a young lecturer at

Liverpool's Regional College of Art who had seen this then unknown artist in a happening at London's 'Ally Pally', in the *14 Hour Technicolour Dream* event, the coming out of London's underground alternative scene. In Liverpool, instead of performing to an exclusively hippy crowd, Ono found herself facing a packed audience at the Bluecoat comprising Beatles fans (Clapham had informed the local newspaper of Lennon's interest in this artist, whom he had met at her exhibition in London's Indica Gallery), the curious and Liverpool's avant-garde, including Adrian Henri who sat in the front row and participated in the performance, wrapping Ono in bandages. From the evidence of the short documentation, filmed by Granada TV and photographed by local students, the event was extraordinary, the artist managing to hold the audience's attention, and even involving them onstage with what must have appeared as a series of absurd invitations. The next day Ono performed at the Art School in the main lecture theatre, to the disapproval of senior management who reprimanded Clapham for allowing students to be exposed to such a lewd spectacle as Ono simulating sex inside a bag with her then husband Tony Cox.[3]

This episode is significant in relation to the reception for live art in Liverpool: a general audience that is prepared to 'give it a go' contrasted with a higher education institution uneasy with artistic experimentation. It is, however, a generalisation to claim that Liverpool audiences pack out live art gigs, or that the Art School has never embraced performance art. But Ono's experience in the city *does* reflect two key factors pertinent to the development of live art in the city: that Liverpool has provided a conducive environment and public reception for contemporary art practice presented in a live context; and that such work has had a presence in the city *despite* the absence of a focus for live art at undergraduate, graduate and emerging artist level.[4]

The lack of an established institutional framework in Liverpool has been to the detriment of live art practice, most critically in terms of producing support and a context for graduates working in this field. This has been especially so

Mark Boyle and Joan
Hills, first performance
of *Son et Lumière for
Bodily Fluids and
Functions*, Bluecoat
Society of Arts,
Liverpool, 11 January
1967. The event
included projections of
bodily fluids (blood,
sweat, urine, semen,
vomit etc.) extracted
from Boyle and Hills
during the performance.

(Image © Boyle Family)

during certain key stages in the development of an identifiable live art sector in the UK. In contrast to Nottingham, for instance, a city that claims the establishment of the National Review of Live Art in the late 1970s as part of its performance history,[5] Liverpool has not been noted for its sustained live art activity in providing opportunities for emerging artists. This comparative dearth of home-grown live art practitioners is notwithstanding the efforts of *Bomb Culture* author, Jeff Nuttall, who was head of the Art School between 1981 and 1984. Under the influence of Nuttall, whose own work straddled poetry, visual art and theatre, the school produced artists such as Bob Connolly, Phil Hughes and Robin Blackledge, all developing distinctive live art practices both in Liverpool and beyond, including internationally. All three eventually left the city, Connolly returning briefly to curate a weekend of Nordic live art during *Liverpool Live 2004*.[6]

Crucial to any discussion of live art and its development in the UK is the Bluecoat, Liverpool's combined arts venue that has – as this chapter will show – been hugely significant to artists' practice for over four decades. Following Ono's first performance at the venue – she returned some forty years later for a second performance for the arts centre's reopening programme in 2008 – the venue hosted several other events and exhibitions with a live element in the late 1960s, notably Mark Boyle and John Latham who then collaborated with the Eventstructure Group at the Blackie. Established in 1968 by Bill and Wendy Harpe (Wendy had supported multimedia art at the Bluecoat through the Bluecoat Arts Forum), the Blackie was the UK's first community arts venue. The centre, located in Liverpool's Chinatown district, pioneered participatory arts practice, collaborating with local people and artists from the international avant-garde, such as Meredith Monk, Judy Chicago and the Last Poets, working across a variety of disciplines including dance, music, poetry and visual arts. Though little of this was performance art as such, the Blackie has played an important role in the city as a venue combining artistic experimentation across art forms with audience interaction, an ingredient of much live art.

189

190 Chapter 8. Dissenters of the Creative Universe. Cathy Butterworth

In 1974 Thames & Hudson published one of the first comprehensive accounts of interdisciplinary art practice, Adrian Henri's *Environments and Happenings*, yet in Liverpool, where Henri continued to be based until his death in 2000, performance art was fairly sporadic – and undocumented – in the 1970s. It enjoyed a brief spell at the revived Liverpool Academy of Arts after the organisation relocated from its small shop front on Renshaw Street to larger renovated premises in Pilgrim Street, where, under the direction of Murdoch Lothian, artists such as Roland Miller and Shirley Cameron, Rose Garrard and John Carson performed as an integral part of the gallery programme. The decade also saw occasional performances, for instance by Stuart Brisley, at the Bridewell, the main artists' studio group in the city. Even the city's photography gallery, Open Eye, included performance. In 1980, during Alice Beberman's exhibition at the gallery on Whitechapel, she sent some students into Liverpool's shopping streets dressed in specially knitted nude 'Furbelow' outfits, only to see them arrested and imprisoned.[7] There was not, however, a recognisable centre for performance art as such, nothing to compare to Newcastle's Basement Group (later Locus +) or Nottingham's Midland Group – not until the Bluecoat picked up the mantle again in the late 1980s, by which time this area of performative practice had become known as live art.

The term 'live art' is understood in a UK context not as a singular art form or discipline, but 'as a strategy to "include" a diversity of practices and artists that might otherwise find themselves "excluded" from all kinds of policy and provision and all kinds of curatorial contexts and critical debates'.[8] Live art has become synonymous with work that does not sit easily within received structures and boundaries such as the gallery exhibition or theatre play. Commonly it finds itself within a visual art context but contains an essential live element, or it takes performance beyond the artifice of theatre. It is often temporary, ephemeral, interventionist, site-specific. Sometimes it leaves no trace. It can be intimate (Franko B's one-on-one performances) or large-scale and participatory (Mobile Academy's *Blackmarket*

Hannah Hurtzig, *Blackmarket for Useful Knowledge and Non-Knowledge, On Waste: The Disappearance and Comeback of Things and Values*, presented by Live Art Development Agency, the Bluecoat and Mobile Academy, 2008.
(Photograph, Alexandra Wolkowicz)

Jeremy Deller, *Acid Brass*, 1997, commissioned by the Bluecoat for Mixing It. The performance by the Williams Fairey Brass Band was premiered at LIPA where the MC was Factory Records' Tony Wilson, seen here centre background.
(Image courtesy of the Bluecoat)

devised by Hannah Hurtzig). As a term, 'live art' has become a powerful tool for artists who choose to operate across, and at the edges of, clearly defined art forms. By the mid-1980s the term 'live art' was evident on the UK's cultural landscape through its use in festivals such as the annual National Review of Live Art, and publications like *Live Art Now*, published by the Arts Council of Great Britain, which now had a funding stream for live art within its combined arts unit, together with an advisory panel.

From 1988 onwards the Bluecoat enjoyed several years of funding from this Arts Council source for a series of thematic live art commissions that took place both within the arts centre and at city centre sites. Liverpool provided an excellent location for such interventions, its urban fabric rich with 'found' spaces, empty properties and a distressed public realm, the unfortunate result of years of economic decline on Merseyside. It was an environment that was to be exploited by the local month-long visual arts celebration, Visionfest, which took over non-gallery sites in the city, and later with greater ambition and resources by Liverpool Biennial's sited public commissions. In 1988 the Tate opened its Northern gallery at Liverpool's Albert Dock, and in the week of its launch Liverpool performance group Visual Stress presented *Death by Free Enterprise*, their first 'Urban Vimbuza' outside the Bluecoat, in response to the new gallery's arrival. It was

> a daring multi media performance in which the Bluecoat's own slave history was 'exorcised' by a combination of Zambian ritual dance and drumming, priests abseiling from the building, plastic planes flying overhead, bikers revving up, live radio broadcast, and cacophonous music, all achieved, as the *Liverpool Echo* arts correspondent reported, 'for a fiftieth of the cost of The Invention of Tradition' (Gavin Bryars' and Bruce McLean's opening performance at the Tate).[9]

The recruitment of local people, few if any of whom would describe themselves as artists, let alone 'live artists', into an interventionist art piece, together with the group's critical

193

engagement with Liverpool's troubled history in relation to race, distinguished Visual Stress as a unique radical performance outfit – far removed from the self-proclaimed live art groups emerging in this period, such as Forced Entertainment, who were producing touring shows for arts centre venues, including the Bluecoat. Subsequent Visual Stress performances continued to interrogate Liverpool's history and to problematise its present contradictions; however, operating largely outside the mainstream and unable to attract significant funding, the group was unable to sustain its practice.

Other early Bluecoat commissions include Peter McRae's visually powerful durational piece *Avenue of Heroes* (1988), in which four women bearing huge white flags sit atop large plinths against the imposing backdrop of St George's Hall, amidst Victorian statues of now-forgotten male figures; TEA's *Baggages* from the same year, in which the group's four artists converge on the Bluecoat courtyard where they create a house from their collective costumes; and, in 1989, in a collaboration between the Bluecoat and Ark Records, Leningrad music and art collective Pop Mechanica performing for the first time in the UK at St George's Hall alongside Liverpool artists. Throughout the 1990s the Bluecoat continued to present performative work, both within the building and beyond. Much of the work would form the foundation of the Bluecoat's more sustained and consolidated live art programme today, even if the emphasis since the organisation's capital development has been on hosting events in its renovated building rather than spreading beyond it. An examination of some of the Bluecoat's work in this area, both before and during its closure for the building project, will indicate the organisation's pivotal role in supporting live art in Liverpool, and also emphasise the specific conditions that have made the city conducive to experimental performance practice.

There is the Bluecoat building itself: Janet Hodgson's work *I must learn to know my place* for the 1994 *On Location* commissions drew on the history of the former school building, with the repeated handwritten, light-projected text of the title – lines doled out as classroom punishment – inscribed onto the outside of the

Chapter 8. Dissenters of the Creative Universe. Cathy Butterworth

building. The work prompted the question of where culture resided, inside the institution or beyond it. The nature of the Bluecoat's early eighteenth-century building continues to provide artists with a striking physical context, beyond its clearly defined gallery and performance spaces, within which to develop and present work. It is also a point of reference for those whose work deals directly with the history of the city, or with the building's former role as a school (seen most recently in Geraldine Pilgrim's *Traces*, 2008). Given these resonances, it is not perhaps surprising that so many artists have been able to develop work that pushes the boundaries of performance and interdisciplinary practice there.

The aforementioned Visual Stress performances, which, like Hodgson's projected text, brought historical legacies into sharp focus by framing them in the present, were reflective of a wider black Liverpudlian performance expression that emerged in part through the annual *Oral & Black* showcases at the Bluecoat, and had such an impact on the city's live art scene in the 1990s. Arguably it was *Trophies of Empire* that provided a reference point for much of the culturally diverse live work that developed in the city in the wake of this 1992 exhibition and performance commission project – coordinated by the Bluecoat with partners in Bristol and Hull – in which artists responded to colonial legacies across venues in the three port cities. Groups such as Verbal Images, which included poets Levi Tafari and Muhammad Khalil and dancer Bisakha Sarker, Asian Voices Asian Lives, and Motsibi all fused poetry (or more precisely 'duboetry'), music, visuals and dance into new performance forms that found a natural home under the live art banner. At the same time, a processional work like Nina Edge's *Sold Down the River*, travelling from the Bluecoat to the Albert Dock, was closer in spirit to Visual Stress, bringing together elements of carnival, spoken word, performance, protest and audience interaction. It articulated betrayal, specifically the way Merseyside had been let down – not least by national government, as well as departing industries. Such interventionist works were topical, critically engaged and celebratory, and though rooted in the local (which, with the

Performances in Church Street.

Marcus Young, *Pacific Avenue*, for Liverpool Live, 2006.
(Photograph, Alexandra Wolkowicz)

Nina Edge, *Sold Down the River*, 1995.
(Photograph, Mathew Thomas)

197

onset of globalisation, was also becoming increasingly connected to international contexts), were part of a discourse in the UK and USA around black performance.[10]

The Bluecoat's exhibition programme, from 1985's *Black Skin Bluecoat* onwards, was instrumental in reflecting the work of emerging artists dealing with issues around race, identity and what was to become termed culturally diverse art practice. Live art operating in this territory found a natural home in the venue with artists such as Keith Khan, Delta Streete, David Tse, Kazuko Hohki and William Yang all performing. A series of live art commissions in 1997 interrogating the idea of independence was prompted by the gallery exhibition *Independent Thoughts*, staged, like *Trophies of Empire*, as a collaboration with other provincial galleries and with artists from the UK and the Indian subcontinent on the occasion of the fiftieth anniversary of India's independence and the partition of Pakistan. The selected artists included Liverpool-based live art practitioners Nina Edge and Asian Voices Asian Lives, and Rona Lee whose durational performance consisted of her stitching together an enormous Union Jack from white fabric, in the Bluecoat's auditorium.

The Bluecoat, principally as a result of the vision of its Artistic Director Bryan Biggs, was also well placed to develop live work at the intersection of art and popular music, commissioning some seminal works in this area, long before curated programmes of contemporary artists plundering pop became commonplace. *Live from the Vinyl Junkyard* and *Mixing It* were two such commission series in 1996 and 1997, selected from open submission. They blurred the boundaries between the genres of art and pop music, and yielded such works as Jeremy Deller's *Acid Brass*, in which England's top brass band performed a concert of acid house favourites; Iain Forsyth and Jane Pollard's *Doing it for the Kids*, a superstar tribute line-up of Jarvis Cocker, Kylie Minogue, David Bowie, Morrissey and other tribute acts; Cornford & Cross's turning the Bluecoat gallery into a record fair for a day; and Philip Jeck's *Off the Record* installation and live mix fashioned from scratchy discs in a room packed with Dansette record players. None of these could claim to be part of

the UK live art touring circuit, the context instead being the Bluecoat's long relationship to the art/pop crossover, stretching back to cult US rock musician Captain Beefheart's first ever exhibition of paintings at the venue in 1972 and the programming of visiting avant-garde music experimentalists such as Whirled Music (David Toop, Paul Burwell, Steve Beresford and Max Eastley).

Alongside its commissioning role in live art, the venue became part of the developing network of UK organisations promoting live art, programming touring productions and working with individual artists such as Richard Layzell, Bobby Baker and John Carson. *Trans:action* (2000) was an attempt to create new ways of touring live art, the selected artists, Mem Morrison and Max Factory, creating evolving works as they travelled to Liverpool and the two partner venues, Bristol's Arnolfini and Warwick Arts Centre. Since that experiment the Bluecoat has connected more closely with national strategies and policies for the development of a national live art infrastructure, becoming a founder partner in Live Art UK (LAUK), the national consortium for live art promoters and development agencies, with which it collaborated on initiatives such as *China Live*, a showcase of radical live art from Beijing, the result of LAUK research trips to China. It has also built on its existing relationship with the Live Art Development Agency (LADA) in London to develop a live art programme for the Liverpool Biennial.

The first such collaboration with LADA, *You Are Here*, took its cue from Guillermo Goméz-Peña's commission, curated by the Bluecoat for Liverpool Biennial's *International 02* exhibition. Entitled *Ex-Centris*, Goméz-Peña's performance at the opening was a wild, carnivalesque, interactive inversion of the ethnographic museum, in which the artist and his Mexican/American and UK performance art colleagues became the exhibits. *You Are Here* further developed the themes of identity and otherness with a rich programme of UK/international work, most visibly through site-specific performances at the city's main railway station (Stacy Makishi), in a hotel (Oreet Ashery) and

in the Bluecoat courtyard, where, in an ironic East v West contest, UK-based Chinese artists Mad for Real slugged it out, naked, inside a boxing ring-sized perspex box, armed only with soy sauce and tomato ketchup.

The success of this programme led to further collaborations, entitled *Liverpool Live*, in each subsequent Biennial. The conceptual focus of these events sought to link to the theme or curatorial approach of the Biennial's international exhibition, and there was invariably a 'bridging' event linking the exhibition with the live art programme – usually an artist in the *International* presenting a live work during the opening period. These events have included Amanda Coogan's *Beethoven, the Headbangers* with 100 performers headbanging to Beethoven's Ninth Symphony, conducted by the artist in the Bluecoat's front courtyard; Aleks Danko's *Rolling Home*, which interrogated the arts centre's school history and issues around regeneration and housing, employing the rolling of large blue 'Wendy houses' through Liverpool's busy Saturday shopping streets; and Humberto Velez's participative *The Welcoming* at the Albert Dock, which involved refugee and asylum seeker groups arriving by boat to be welcomed by established Liverpool immigrant communities, a counter to the hostility new immigrants to the UK were experiencing.

These artists were from Ireland, Australia and Panama respectively, and this strong international representation continues in *Liverpool Live*. An eclectic mix has seen Sebastian Solari (Peru) exploring subterranean Liverpool through its underground drainage systems, Sachiko Abe (Japan) performing obsessive paper cutting during a week-long installation, and Marcus Young (USA) walking slowly, almost imperceptibly, through the city's principal retail area, every day for a week. Other artists who have operated in a reflective and intimate way include Sandra Johnston, who brought her considerable research into notions of public space, territory and identity to Liverpool with her 48-hour site-specific performance, the final hour of which was open to an invited audience in a Portakabin in the Bluecoat's front courtyard. Denis Buckley's *Right to Think* saw

201

him retreat to the Bluecoat for a week, communicating with individuals on a one-to-one basis through an intercom system and taking to the streets for daily performances, dragging behind him a steel suitcase in an act of resistance against his self-imposed incarceration.

Another feature of *Liverpool Live* is the way that the city provides a fertile context for much of the work, especially in 2006 when the Bluecoat was closed for its capital development and its premises could not be used. This programme was curated by Tamsin Drury of Manchester-based hÅb, a significant promoter of live art in the North West region, who sought to exploit the 'ruptured' state of a city centre undergoing a major physical transition of its retail core. In this context, the intervention of German artists LIGNA, whose synchronised choreographic actions were relayed through radio headsets to a volunteer team drifting through the central shopping area of the city, played with patterns of consumer behaviour, gently subverting the shopping imperative. While the wholesale commercialisation of the city centre, largely through the recently completed Liverpool One development, has closed down options for the type of 'found' spaces that the Bluecoat was able to use in its early forays into site-specific live art, the predominantly retail environment that now surrounds the arts centre has opened up different possibilities and strategies for live art engagement. At the opening of the Liverpool One retail 'paradise' in 2008 Richard DeDomenici handed out helium-filled black balloons bearing the words 'Bored of Shopping' in white lettering. The following day he repeated the exercise at the also newly opened Bluecoat, this time with balloons bearing the legend 'Bored of Art', questioning the relationship between art and consumerism. DeDomenici's direct engagement with people on the street had seen him, four years earlier, impersonating the Conservative MP Boris Johnson (who had offended Liverpool's sensibilities in an article in the *Spectator* accusing the city of sentimental self-pity) and trudging the streets apologising to passersby for his actions.

Liverpool Live interventions into the city centre.
(Photographs, Alexandra Wolkowicz)

Sean Hawkridge, *From the Sidelines*, 2006.

LIGNA, *The Transient Radio Lab*, 2006.

Gustavo Ciríaco and Andrea Sonnberger, *Here Whilst We Walk*, 2006.

Denis Buckley, *Right to Think*, 2004.

Grace Surman, *Liverpool White*, 2004.

(Photograph, Alexandra Wolkowicz)

Institute for the Art and Practice of Dissent at Home, DIY 5, *first retreat and then advance* (banner: 'The concept of culture is deeply reactionary'), at Everton Brow.

(Photograph, twoaddthree)

Since its reopening, live art has continued to have a profile in the Bluecoat's programming. Indeed the new configuration of spaces in the building lends itself to a broader range of possibilities for live art: there has already been a mini festival, *Happenstance*, including Yoko Ono's return performance, relayed live onto the city-centre Big Screen; Rajni Shah's durational installation performance works; participation in the national *Rules & Regs* initiative which encourages artists to work to a different set of rules to those framing their normal practice; and Common Culture's intervention of a phalanx of night-club bouncers into the gallery spaces they had curated for the exhibition *Variable Capital*. With *Liverpool Live 08* featuring the UK's first *Blackmarket for Useful Knowledge and Non-Knowledge* by Hannah Hurtzig's Mobile Academy, and in 2009 another large-scale offsite event, *Twins*, by the Cologne-based Angie Hiesl, the Bluecoat – the organisation most consistently committed to an engagement with radical, subversive and challenging performance in the city – looks set to continue in this role.

There are of course other initiatives in a position to contribute to live art practice in the city: for example the A Foundation's Greenland Street premises, with its new director, former Arts Council live art officer, Mark Waugh; FACT, with its new CEO Mike Stubbs, who was instrumental in developing Hull Time Based Art as an important venue for radical art practices, including live art; and the city's artists themselves, who have generally not come through regular fine art or live art educational training routes. These include Mandy Romero, self-appointed 'Queen of Culture', whose transgender interventions and contributions to discourse have been a consistent feature of live art activity in the city for a number of years; and Gary Anderson and Lena Simic, who have established The Institute for the Art and Practice of Dissent at Home in their own house in Everton, close to where they teach at Liverpool Hope University (where the Creative and Performing Arts course is developing a robust critical framework for live art). The Institute for the Art and Practice of Dissent at Home constitutes another reflection on the idea of interdisciplinary processes that Willett

discerned in the city. Anderson and Simic bring their respective practices to the twelve-month project that, timed to contribute a dissenting voice to Liverpool's European Capital of Culture status, and seeking no funding other than a percentage of their own income, considers issues of 'the private/the public, the familial, class and money matters'.[11] Like many of the other examples given in this chapter, their initiative, which locates a critical practice within the home and opens it up to other artists, is an attempt to do away with the separation of art and everyday life, but it does so through integrating the creative process much more rigorously into their lived experience.

This brief mention of one of the most interesting live art strategies currently being explored in the city demonstrates Liverpool's continuing conduciveness to experimental art practices. As this chapter has revealed, the city has made a singular and significant contribution to the development of the live art scene in the UK since the 1960s. By and large Liverpool's chief live art proponents have resisted the institutionalising tendencies seen elsewhere in the development of a live art ecology that encompasses art school courses, dedicated venues and product designed for national touring. Though not immune to wider developments, live art in Liverpool has benefited from drawing on the particularities of place, of history and perhaps on a certain cultural separateness. As a result the live art that the city has experienced over the past forty years can be described as autonomous and distinctive – with a rich variety of contexts and voices – attempting to and often succeeding in transforming artists and audiences into active participants in visual culture.

[1] Manifestations such as the Scottie Press, the Liverpool Free Press and Scotland Road Free School were representative of a community activism that developed during the early 1970s.

[2] Paul du Noyer, 'Subversive Dreamers: Liverpool Songwriting from the Beatles to the Zutons', in Michael Murphy and Deryn Rees-Jones (eds), *Writing Liverpool: Essays and Interviews* (Liverpool: Liverpool University Press, 2007), p. 241.

[3] From a conversation between Dave Clapham and Bryan Biggs, 2007.

[4] With notable exceptions: a context is being developed through Liverpool Hope University's BA in Contemporary and Performing Arts, and across a number of BA and MA pathways at LIPA (Liverpool Institute for Performing Arts) as well as by individuals at LJMU School of Art and Design.

[5] National Review of Live Art (NRLA) can be traced back to Performance Platform, a one-day event which took place in 1979, organised by Steve Rogers at Nottingham's Midland Group arts centre. The strength of NRLA was in part due to the diversity of programming, and its commitment to providing a context and support for less experienced artists, through its 'Platform' strand of programming, which supported new artists, alongside more established figures, every year from 1984 onwards. Nottingham also produced Expo, an annual platform of performance and live art established in 1991 by a graduating student from the Contemporary Arts course at Nottingham Trent University. Expo was produced annually from its inception through to 2007, and continued to present the work of emerging artists graduating from the course at Nottingham Trent and other colleges in the city. Nottingham is an example of a city that has created a robust environment for a thriving engagement with live art practice at a number of levels, with higher education institutions and arts organisations providing a cross-fertilisation of support mechanisms, and creating a critical mass of activity.

[6] The Bluecoat's programme of live art which took place during Liverpool Biennial.

[7] For an account of this controversy see John A. Walker, '1980: Performers jailed for wearing "rude" costumes', in his *Art & Outrage: Provocation, Controversy and the Visual Arts* (London and Sterling, VA: Pluto Press, 1999).

[8] www.thisisliveart.co.uk (accessed 24 June 2008).

[9] Bryan Biggs, 'Welcome to the Pleasure Dome: Art in Liverpool 1988–1999', in Christoph Grunenberg and Robert Knifton (eds), *Centre of the Creative Universe: Liverpool & the Avant-garde* (Liverpool: Liverpool University Press in association with Tate Liverpool, 2007), p. 187.

[10] See *Let's Get It On: The Politics of Black Performance*, ed. Catherine Ugwu (London: ICA and Seattle: Bay Press, 1995), which includes contributions from Nina Edge and Kif Higgins of Visual Stress, alongside those from SuAndi, Chila Kumari Burman, Ronald Fraser-Munro, Guillermo Goméz-Peña and Keith Antar Mason from the Hittite Empire, all of whom presented work at the Bluecoat.

[11] www.twoaddthree.org (accessed 24 June 2008).

Chapter 9. **Soundings.** Compiled and Edited by Colin Fallows.

Founded by Professor Colin Fallows in 2005, *Soundings* has taken the form of a series of events, seminars, discussions, spoken word recordings and text. Previous editions of *Soundings* have taken place live at Tate Liverpool in conjunction with exhibitions at Tate, and documentation has been collected as part of the Audio Research Editions archive.

This edition of *Soundings* offers a multi-perspective on the same topic, with each contribution reinforcing Liverpool's most precious capital – its distinctive people, character and unique sense of place. The contributions were compiled from a wide range of artists, writers, cultural historians, social anthropologists, arts facilitators and representatives of arts organisations.

It has been posited that Liverpool European Capital of Culture 2008 could be regarded as a watershed for the visual arts in Liverpool, a highpoint that will be difficult to envisage the city achieving again, or alternatively a springboard from which the sector will grow even stronger. In the light of this, each of the contributors was invited to produce a written response in answer to the question: What do you see as the challenges and opportunities for the visual arts in Liverpool after 2008?

Individually each answer is a personal gift to this publication and collectively they form a weather report for the visual arts in Liverpool.

John Campbell & Henry Priestman, *Baby* 96, Live from the Vinyl Junkyard installation at the Bluecoat, 1996.

(Photograph, Leo McDonough)

Jon Barraclough, Artist, Designer and Director of Jon Barraclough and Company

When the spotlight moves away from the city it will be difficult to retain the tourists and the travellers – but not the spirit of excitement and invention that's been soaking into the streets like the summer rain. If 08 has been a year of making connections and building friendships then what lies beyond is not so difficult. To continue to import and export visual arts and the broader creative industries is what we should do. The city has a strong image and identity which curiously strengthens as you speak with others from outside the region and the country. Technology gives us instant connectivity with this wider audience – there's never been a time like it. We must develop relationships and collaborations that continuously promote Liverpool as a place to make the highest quality art and to broadcast it to the international arts and cultural industries. There's no time for insularity or cynicism. The tide comes in – and goes out. Liverpool has a rich history of importing and exporting: commodities, goods, ideas, people and culture. The warehouses are becoming studios and apartments. Get people here – and give them a good time. I think they will return.

John Brady, Freelance Curator and Events Manager

The challenges and opportunities for visual arts in Liverpool after 2008 are more or less as they were in 2007. A Guggenheim franchise in an iconic new-build somewhere between the Tate and Hope Street would have been my kind of material legacy. Conceptually, 2008 produced few mighty thoughts, transformations or pioneers. Individuals and institutions provided more of the usual, more often, with more resources in a more-is-more is good scenario. Socially, the gap between the emerging artists' scene and subsidised museums and galleries remains unfilled. Liverpool is not wealthy enough to sustain artists making careers and livings from their artworks. Accepting this provides opportunity for the artist scene and institutions to recognise and develop their common interest in attracting art-lovers. The institutions do this with their collections, retrospectives and thematic surveys. The artist scene offers engagement with something fresh, incomplete and yet to feature on an international menu. Throughout 2008 the term International Artist was one of praise and approval. Compare the world

of cuisine where 'international' is a term of contempt describing the replacement of indigenous integrity with universal solutions and unrelenting fusion. In 1994 the late Roy Stringer said 'Liverpool is poised to become the Hollywood of Multi-Media.' Is it?

Ann Bukantas, Curator of Fine Art, National Museums Liverpool

Something really simple has happened this year. 2008 has presented a shared goal – or mission, vision, aim, call it what you will – that has enabled a diversity of organisations, individuals and projects to focus on the same thing, whatever their separate approaches, resources and agendas. One of the major challenges now is to harness the common spirit that 2008 has engendered, and to find something powerful enough to replace it so that the component parts don't go flying off in separate directions when the Big Bang is over. Furthermore, while there are many tangible elements of the year that will remain, whether the new Bluecoat or Ben Johnson's painting *The Liverpool Cityscape*, the deeper legacy of 2008 isn't that which can be so easily pinned down or taken for granted. It's something that has to be carefully identified and built upon – it's the opportunities to be had in the relationships fostered, the creativity and passion shared, the audiences won. Indeed, key among the opportunities are the sharpened appetites of local people, and those who travelled to Liverpool, for the visual arts in this city. Retaining, nurturing and rewarding the heightened public passion for Liverpool's cultural scene is something that we must all now focus on.

Mike Carney, Graphic Designer

Capital of Culture has put the spotlight on Liverpool. Opportunity knocked and our cultural institutions rose to the occasion, programming a plethora of interesting shows and events. In 2008 there seems to be more happening than usual – everything feels grander and more exciting. An air of confidence has also coaxed independent organisations and individuals into setting things up and putting on their own events – there has been lots of initiative taking and a willingness from the man on the street to get involved. But what happens when the spotlight switches off and the kitty runs dry? Will Liverpool revert back to 'business as usual'? Can we take our foot off the gas? Will everyone run away? In 2009 we must keep the momentum going, stay confident and build upon all

the good work. Crucially, the city has to retain its creative practitioners and skilled arts workforce and continue to provide opportunities and outlets for them. We are developing an enviable and varied arts industry and we must nurture it. The biggest challenge for Liverpool is to keep people interested, both within its own city walls and beyond. There is no going back now. This is business as usual.

Jayne Casey, Director, Love Liverpool

Daddy will you buy me a Biennial? In 1998 when the richest Daddy in town came up with the idea of setting up Britain's first Biennial of Contemporary Art in Liverpool many of us looked on in amusement before eventually being broken down by his generous investment, his unwavering persistence and his legendary tantrums. In 1999, after a long and painful labour, the first Biennial was born. Now ten years on when I see the people of Liverpool's appreciation of the contribution that the visual artists have made to our lives, I am utterly awestruck. 'We cannot turn back', the artists and the art are forever ingrained into the very fabric of our city. They have enriched our lives, made us smile and opened our eyes to 'the possibility'. Now that Daddy, the Euro-funders and the Culture Company have all but packed away their cheque books and left town, we will remember them fondly and miss their dough dearly. But, regardless, I have no fear for the future of contemporary art in Liverpool because they have left in their wake the kind of love and commitment that money just can't buy. The Bluecoat, Biennial, Tate – I salute you – the future is safe in your hands.

Jagjit Chuhan, Professor of International Art, Liverpool JMU

The first time I visited Liverpool, to attend a lavish private view at the Walker Art Gallery, I was impressed by the dramatic grandeur of the colonial architecture rooted in Britain's imperial past. Since then I continue to be impressed by Liverpool's cultural heritage and by contemporary developments spanning areas from architecture to the performing arts. Relative to other provincial cities Liverpool remains poor in terms of the economic and employment status of its population, with less integration between different ethnic sections. However, recent regeneration initiatives are making their mark and economically the city is on the rise. Culture remains the jewel in its crown, considerably

enhanced by key cultural organisations. As an artist working in Liverpool, I value experiencing the eclectic range of visual art in the city, engagement in critical dialogues with artists, curators etc. in a 'cultural village' kind of environment encompassing people from regional to international contexts. Liverpool is a vital, stimulating and rich resource for creativity. The challenge is to build on the upward trajectory, to be more inclusive of diverse cultural constituencies within the city, and to provide greater opportunities for artists based in the region to showcase their work in international contexts.

Pete Clarke, Artist and Lecturer, University of Central Lancashire

On 12 September 2008 it will be thirty years since I arrived in Liverpool from London. The city, then as now, was more than a geographical location and a defined place but an imagined environment of contradictory social interactions and representations, almost impossible to make sense of and understand. The city from the late seventies onwards could be bleak and dark, colourful and volatile, deprived, derelict and strangely poetic, a city of many stops and starts. Then as now, there was a sense of imminence, expectation and possibilities. So what are the challenges and opportunities given the structural changes in the look and feel of the city? How do we negotiate the inevitable stops and starts? Liverpool now strangely feels like a young city for artists. However, it is reminiscent of comments attributed to Oskar Kokoschka, that 'it is very easy to be an artist when you are aged 25, very difficult when 45 and almost impossible when 75'. It is now the responsibility of artists and cultural institutions, as always in Liverpool, to do it for themselves, to sustain a creative practice with new initiatives, courage and commitment to develop an informed audience for their work, locally and internationally. Now, as then, it is possible.

Matthew H. Clough, Director, Victoria Gallery and Museum

The challenges and opportunities for the visual arts in Liverpool post-2008 are those which face the city generally. The Capital of Culture award provided an opportunity for a redevelopment of the city centre. Alongside the Liverpool One retail complex there has been a noted increase in city centre housing, often in striking high-rise buildings, and a redesign of the city's road system. In a more traditional cultural sense, it also sparked the

refurbishment of the Bluecoat, the commissioning of the new Museum of Liverpool, and the creation of the Victoria Gallery and Museum. A key question is whether these developments will bring a lasting benefit to the city. The risk of the Liverpool One project is that it will simply move the city centre sideways, rather than adding to the commercial mass, leaving empty shops in other parts of the city. 2008 has brought a remarkable increase in visitors which must be sustained. A question mark remains, however, regarding the success of the year in engaging with the people of the city. Whatever the outcome of the 2008-inspired commercial projects, the visual arts should play a key role in widening community engagement over the next decade.

Paul Domela, Programme Director, Liverpool Biennial

After showing that Liverpool is one of the best places in the UK to see art, can we also make it one of the best places for artists to work and live? What are the ingredients to make this possible? An art bookshop? Access to (inter)national networks? Collectors? Curators? Cheap rents? Reviews? Critically acclaimed Art Schools? Cutting-edge club nights? Most of these are here or within grasp. But the aim should not be simply to emulate the conditions of Liverpool's bigger neighbour London. Instead the challenge is to find a viable alternative within Liverpool's singularity. Paradoxically its bare-knuckle urbanity or 'beauty-disregarding spirit of utilitarianism' yield its most enduring aesthetic. Can art complement this brazen grace with equally audacious intent? Achieving this cannot rely solely on the city's unmoving spirit, or its often boasted inherent qualities. None of these matter if they are not brought into relation with the world. Even post-2008 this is a task by no means easy in a city still scarred by post-industrial trauma. The challenge to visual artists in Liverpool remains to articulate their vision and intellectual ambition plugged-in to the international field; to counter the cast of Liverpool as a conversational city, the visual arts answer can only be dramatic.

Alan Dunn, Artist

The challenge for Liverpool is to establish a new equilibrium between visual artists based in the city and those invited in to work on specific projects. That equilibrium must take into consideration the fact that the city's visual arts community is disparate, fragmented and lacking in any

singular style or approach. It is also a relatively small community, greatly enriched by the literary and musical sectors. For many years, the Bluecoat has been the focal point for this cross-disciplinary community and its reopening in 2008 may prove to be the single biggest influence on the visual arts in the city over the next five years. Specifically, the collaborations and dialogues with those who operated in this city in the 60s, 70s and 80s, whose ideologies were forged at a time when visual arts was less supported, is a key factor. A broader timeline on the city's visual arts demonstrates the constant role that the visual arts have played in Liverpool – through both good and bad times.

Colin Dyas, Liverpool Vision

The year has been commercially successful for many, but among the rights have been wrongs (and writs) that reinforce prejudices and stereotypes about Liverpool's competence. Issues of governance, transparency and inclusiveness made news near and far. The success of 2008 makes it easy to forget this and say 'job done'. Truth is, it's job started. One year does not make a city, and Liverpool will awaken to 2009 realising there's more to be done. Opportunities include marrying cultural and physical regeneration, which are mainly disparate. There are challenges in urban ecology, urbo-culture, the north–south divides and global networking that invite alliances, patronage, projects and networks. There is potential for art to revisit craft, and for craft to align to manufacturing enterprise. There is also freewill for artists to self-organise and determine where they want to go as individuals or as groups. Finally, it would be great if Liverpool can recall its creative diaspora. Some are global figures, Liverpool seeds scattered far and wide to sink roots in the cultural environments of other places, leaving a less fertile landscape behind. How good it would be to see them return to a re-cultivated Liverpool and help our city grow.

Max Eastley, Artist

The cultural history of Liverpool in, for example, music and the visual arts has contributed significantly to the national and international recognition of the importance of the arts to humanity. The title Capital of Culture in 2008 has been a significant raising of awareness of how much Liverpool has developed as a major centre for the arts. However,

the foundation of this success is, to a degree, dependent on the fundamentals of economics and politics, and when and if the economy experiences a downturn, the vigilance of individuals and institutions to preserve and nurture the arts will become crucial. The arts in my opinion are not a luxury but a necessity, and Liverpool continues to demonstrate this in no uncertain terms.

Professor Peter Fowler, Writer

When La Machine's spider disappeared into the tunnel, did it leave any webs behind? Because the arts in the city need those webs; the city needs those delicate, hardly visible but all-important subtle connections. It would be nice to think that the next time an art display like that takes place it would come from the city itself. That a bunch of kids somewhere, working with a school or a university, sat themselves down in a place like FACT and thought, 'Let's do this!' To do that requires a commitment to work across the city, in all its nooks and crannies. It requires partnerships that transcend the usual suspects; but it demands that the usual suspects understand that the city needs something holistic and something that, actually, they themselves might not have considered. The city needs to spring visual surprises, but it needs to have the energy and the passion to do this itself – and an understanding from above that energies are there to be facilitated and encouraged, not sidestepped by imposing visions from elsewhere. Because if you only do that, you end up with a Garden Festival. Or a spider that runs away and leaves behind only silence.

Mathew Gregory, Artist and Art Historian

The title of Capital of Culture has given Liverpool the opportunity to showcase itself as an international centre for the visual arts, not merely celebrating the city's own capacity for artistic innovation, but attracting some of the most notable artists and exhibitions from around the world. The city already has a thriving visual arts community, and of course one of the aims beyond 2008 should be to ensure continuing support for local arts organisations and emerging artists. However, the challenge is not only to celebrate and nurture the region's home-grown talent, but to have the courage to step confidently and unreservedly onto the international stage, bringing the most daring and pioneering art from around the world to the

city. This year's high-profile shows and exhibitions should not be perceived simply within the context of the Capital of Culture celebrations, but rather as an embodiment of Liverpool's ongoing engagement with the visual arts, and its record for artistic innovation. The lasting legacy of 2008 should not simply be that Liverpool is proven 'the most significant UK centre for art outside London', but rather that it establishes itself firmly as a World City, an international hub for the most dynamic and challenging visual arts activities.

Christoph Grunenberg, Director, Tate Liverpool

Liverpool 2008 developed organically out of years of steady growth, a collaborative spirit and an uncompromising commitment to quality. The Capital of Culture should provide a springboard for the visual arts to expand and grow, nurturing a genuinely international outlook. Liverpool needs to truly embrace culture, heritage and creativity as key assets that have the power to fundamentally transform it into a creative city. The arts provide a model for continuous change and development – forever surprising, challenging and providing new perspectives. Art and culture need to penetrate every aspect of thinking – from economic investment to educational policy, from housing to health and wellbeing, from transport to the cultural and creative industries. Liverpool needs to become a place of explosive creativity, a place that produces and attracts high-calibre artists and creatives through its educational and employment opportunities, its inspirational teachers, its stimulating intellectual climate, and its bohemian atmosphere with cheap studio and living space. There needs to be a realisation that the arts grow in the margins, in the unregulated spaces and, sometimes, in deliberate opposition to the mainstream. The city needs to walk the tightrope between supportive intervention and liberal laissez-faire – spaces of autonomy have to be preserved while the conditions for experimentation, networking and collaboration have to be nurtured.

Ceri Hand, Director, Ceri Hand Gallery

The challenges for Liverpool post-2008 are to remain dynamic, flexible and responsive to artists' needs and ideas; to attract more great artists to live and work in the city; to keep devising and delivering great content for an international audience, while enticing and building local and

regional audiences, sales and collectors; to further develop the visual arts undergraduate and postgraduate courses, tapping into the unique visual arts offer in the city; to not let the politics of working together outshine the reason why we are all doing it in the first place (i.e. art and artists).

Patrick Henry, Director, Open Eye Gallery

With uncharacteristic modesty Liverpool has recently claimed that it is the UK's second city for visual arts. Plenty of good art is presented in the city, and plenty of it is produced here too, often by visiting artists commissioned by the Biennial and other institutions. In recent decades, however, Liverpool has not been an easy city for artists to live and work in. To give our claim substance we need to change that. We need to do a better job of supporting the city's artists and we need to attract others to come here and stay. One of the keys to this is an Art School that is ambitious, outward-looking, engaged with and supported by the other parts of the local visual arts infrastructure. As curators, we too need to look outwards. What we do should be informed primarily by close dialogue with artists and audiences, not with an art world that is increasingly mesmerised by its own internal workings. In Liverpool there has been much talk of late about regeneration and re-branding. Liverpool already punches above its weight as an art city – maybe art is the key to its future.

Roger Hill, Artist

The challenge for all the arts on Merseyside after 2008 is to achieve more with less, and to do so without seeming needy or resentful, in fact by exhibiting an increased and more mature imagination, as befits the cultural activity of a city which has proved itself as a centre of artistic adventure and experiment. The city now can lead by example rather than dodging the issues with bursts of affected quirkiness. The boundaries between art-forms have been breaking down for some time. The Liverpool Biennial, for example, is a grab-bag of just about anything. It is therefore time for the visual arts to join forces with performance and the new media, shedding the old elitism which saw visual art as the gold standard of the creative practices. 'Consolidate' is one watch-word for the next few years – another is 'hybrid'. Not new art-forms but, as Brian Eno would put it, new artistic experiences. And in debased times, to quote the composer Michael Tippett, those experiences should include 'images of abounding, generous, exuberant beauty'.

David Jacques, Artist

The whole 08 thing has been difficult to fathom and impossible to reckon with. Going off this and previous incarnations it would take some time to make sense of any longstanding effect, if that's at all possible given the attendant mythmaking which becomes part and parcel with such projects. Whereas we have undoubtedly seen a short period of sustained activity around the visual arts, the events, public artworks etc. have seemingly followed an all-too-familiar agenda. At one turn, the city centre has seen its share of spectacles, the more grand and wacky the better – very much the feature material of in-flight magazines. The outlying districts (excepting a couple of economically strategic settlements) for the most part are still waiting for an invite to the party. As ever, the challenge for visual artists post-08 is simply to keep going and retain as much autonomy as possible. Regarding the sector, opportunities will hopefully continue to show and be shared around places and peoples alike. Who knows, we might even get a spate of sustainable projects focusing on trying to re-connect the rest of Liverpool with the city centre and the world beyond.

Philip Jeck, Artist

I can only offer the advice for artists, curators and funders alike to avoid the attractions of celebrity art, naming no names, and of corporate art like the plague. Let us not be cursed with the current British disease of bland and soulless conceptual art (42% think contemporary art is worse than 30 seconds ago) and video art (the Beckhams wake up in their own house) proffered by a few collectors, agents and gallery owners, and advertisers of the highest order. I know in the past the Church/religion were sole commissioners, but at least they believed in something. Liverpool has greater potential than all of that and of course great poetry will inevitably seep up through the cracks probably where and when we least expect it. Here endeth the lesson. Blandandalamercouturacumpamenialaohate. Amen

Kai-Oi Jay Yung, Interdisciplinary Artist

As I witnessed the launch ceremony of Liverpool 2008 around St George's Hall, I willed the event not to remind me of £20 million shortfall and controversial departures, but instead to be a valiant celebration to kick-start

Liverpool's captivating, diverse art; I was left slightly empty. Luckily, Liverpool's thriving cultural mainstays are feeding us, from the Biennial to artists' talks and regeneration of cultural spaces on the city's margins. But this would have happened despite Capital of Culture. I have been based in Liverpool for a year and a half, I have also spent time on projects overseas. What concerns me is the alternatives for emerging local artists. In order to raise the stakes of quality in art and make it relevant to the city, we must replace secrecy and complacency with a genuine interest in Liverpool's growth, supporting local artists not just as token gesture. The Capital of Culture has added a certain extra drive but we need to be aware that artists should raise their stakes and revisit values and conduct. A restructuring is called for, as well as the chance and space to grow. The continued success and respect for art stemming from Liverpool and its future depends on it; beyond boroughs, recent global economic downturn and the Mersey.

Moira Kenny, Artist and Postgraduate Researcher, Liverpool JMU

2008 was a filtering system for the arts in Liverpool. If you couldn't keep up you fell through the gap. Falling through was the key to survival and reputation. To be part of the circus was to sell out. Liverpool recently forgot it is the centre of art and passion, not money. The main challenge for the creative industries will be survival after the inevitable funding cuts post-08. The main challenge for visual arts education will be the loss of the Art School building, 68 Hope Street, with its purpose-built studios and rich history and reputation. Opportunity lies in the make-up of the people, 'we like what's right and proper'. Survival is a natural instinct. Expose the empty spaces, buildings new and old, including basic shells developed by speculators and left dormant. Take them over! Art is now. Not every two years or pending funding availability. The exploitation of the planners' mistakes will create a dynamic to be seen and heard. The opportunity of creating the first Sonic Art Headquarters is tempting, a space to invite the world, experiment, exhibit, and an in-house hostel for artists. Sound is noticeable by its absence. Audio is the future.

Robert Macdonald, Reader in Architecture, Liverpool JMU

'Much of the confusion in the art world today arises from the failure of the cultural establishment to recognise, once and for all, that elitism and permanence are dead': John McHale, *Future Shock*.

Perhaps McHale's assertion still applies in Liverpool. 2008 for the artistic establishment is well represented by the big three: Walker, Tate and Biennial. The challenges and opportunities in the next twenty-five years will be in independent art, community participation and city regeneration. The expansion of the 'Indies' have the potential to become an 'urban fringe' to challenge established art and architectural order in the same way as the Edinburgh Fringe festival. The Republic of Garston, Metal at Edge Hill, A Foundation at Greenland Street, Rotunda, Contemporary Centre and The Big Table are all challenging the contradictions of the centre. Will we see more edgy community clusters, peripheral futures and artists' networks? Because of shrinkage, over the next twenty-five years the city and its architecture could become more experimental and spontaneous. There are still many existing vacant buildings and 'brownfield' sites waiting to be deconstructed and reconstructed. 'Indie' artists and architects have much to anticipate in the future.

Vicki Maguire, PhD Researcher, Liverpool JMU

Capital of Culture organisers have sought to promote and build on Liverpool's reputation as a world leader in the field of visual arts, one of the many factors which has contributed to a great increase in visitor numbers in 2008 and which will also hopefully lead an increase in future student applications. This year has seen the welcome return of the Bluecoat and work continuing on the new Museum of Liverpool, among other things. It is obvious that there is much to celebrate; the city is thriving. Tate Liverpool's Klimt exhibition appears to have been chosen as the centrepiece of this drive to boost the local economy, with much spent on a worldwide programme of advertising. However, the city's thriving network of independent galleries and community-based visual arts organisations have also been quietly working to produce a vibrant year-long programme of exhibitions and other events, continuing to achieve and innovate with little or no support from Capital of Culture organisers in terms of both funding and promotion. As Liverpool's regeneration programme continues, I worry about the future of these independent organisations, the corporate takeover of Liverpool's public spaces and a possible decrease in opportunities for freedom of expression.

Barry Miles, Writer and Cultural Historian

For any city to maintain an arts community, what is required is cheap housing and cheap studios. Liverpool is well endowed with old warehouses that would convert easily into studio space. The reason that London's East End is now famous for having more artists per square metre than any other city on Earth is that, from the early seventies, various charities have been working to provide these two facilities. The most significant is SPACE, set up in 1968 to facilitate temporary occupancy of redundant building stock in East London which by 1970 had provided more than 200 studios and now has more than double that. The other important charity was the Acme Artists Housing Association which worked with local councils to make artists' squats into legal tenancies. Of course where there are artists, bars and restaurants soon follow, as do more artists, and it has been shown that the artists themselves, combined with market forces, will provide galleries. Property prices rise and the artists, having regenerated a neighbourhood, move on to the next, but this process takes several decades and in Liverpool would be no bad thing. Let a thousand studios bloom.

Geoff Molyneux, Artist and Lecturer, Liverpool Community College

The visual arts in Liverpool have grown immensely over the last thirty years, more artists are graduating from its universities and colleges, more are staying (or returning) to work in the city. The investment made by artists needs to be matched by investment from organisations outside the creative industries. This can take many forms, from the purchase of artworks through to the sponsorship of visual art projects, from commissioning new works to helping create a platform for critical debate. The challenge to the city is to raise awareness of the quality of visual arts and support artists that have made an investment in Liverpool. Many of Europe's major cities invest in the visual arts in this way, supporting and raising the profile of regional artists, representing works in their museums and gallery collections and offering opportunities for engagement in a critical dialogue. As a port, Liverpool's growth depended on imports and exports. The challenge for artists is to look beyond Liverpool, nationally and internationally, as a number have already. Many opportunities have been made by resident artists and visitors interested in exploring the historical and contemporary culture of Liverpool – future and further growth in the visual arts depends on extending this international dialogue.

Neil Morris, Reader in Contemporary Printmaking, Liverpool JMU

2008 will be my fiftieth year and a substantial part of that time has been spent in Liverpool, with all of my adult life (and some of my adolescent!) being engaged in a dialogue with visual culture. I am not alone in this: artists of all genres – painters, poets, writers, musicians – gravitate and cling to this city like no other in the UK. While 2008 is definitely a watershed for the city there has always been a heady cultural velocity which has existed without, and perhaps in spite of, formal structures of funding and support. These artist-led initiatives will exist long after 2008 and continue to bring a heady mix of global activities to the city – myself and fellow artists this year alone have played host to artists from Peru, Cuba, Canada, USA, Serbia and Germany, to name but a few, with reciprocal residencies, exhibitions and discursive events happening in their home countries, thus profiling Liverpool's cultural sector globally. This is one of the many indicators of the incredibly healthy outward-looking nature of the practitioners based in the region and why the challenges will always be turned into opportunities – the future is not just orange it is rainbow-coloured!

Rod Murray, Artist Holographer

Liverpool has had a strong community of artists for over two hundred years. In 1769, just one year after the founding of the Royal Academy in London, a group of local artists and gentlemen founded the Society of Artists, which was to become the Liverpool Academy of Arts in 1810. During the nineteenth century it held regular exhibitions, giving a prize of £50 to the best painting, the award to William Holman Hunt in 1857 causing a rift with its city council backers who did not appreciate the Pre-Raphaelites. However, in 1905 it famously rejected Augustus John as a member. It continued exhibiting the newest art forms even including kinetic and multiples in the 1960s until its decline in the mid-1980s. There has always been a close connection and cross-fertilisation between the various arts; Adrian Henri combining painting poetry happenings and much more into his work. I would expect this ability to see and use the best across the board to be reinforced when Liverpool John Moores University's new Art and Design Academy opens. Along with the support from John and Peter Moores and the Bluecoat gallery the city is likely to be well served for the future.

Sara-Jayne Parsons, Exhibitions Curator, the Bluecoat

In the wake of the success of 2008, the ongoing challenges facing the visual arts in Liverpool revolve around programming, artist development and critical engagement. As well as maintaining and strengthening the connection with resident audiences, venues need to keep giving people from outside the city reasons to come to Liverpool by offering unique and challenging visual arts. Dynamic partnerships and collaborations between institutions will play a key role in the triumph of this endeavour. Nurturing and supporting local artists at various stages of their career must also be a priority. A culture of collecting needs to develop alongside commissions and other economic opportunities available to artists. Academic institutions across the city should implement and encourage greater critical rigour. Liverpool shouldn't have to wait for London critics and writers to review exhibitions and projects. With the intellectual talent of artists and art professionals within the city and wider North West region, there is no reason why a serious peer review can't be home-grown. A confident periodical dedicated to critical writing about visual art in Liverpool could be a platform to greater national and international respect.

Jamie Reid, Artist

I think the challenges and opportunities after 2008 should involve looking towards what art is produced from Liverpool itself and not what is brought in from outside for outward appearances. Every opportunity should be given for young people to be inspired and to stimulate them to pursue a career in the arts, especially as art is continually being eroded from our education system. So much of the legacy of the year of culture reflects the cliques who control what art we see as being safe and appropriate to establishment standards. Liverpool's art should reflect Liverpool's radical and multicultural traditions and not the tastes of an art mafia who seem to control what art is seen in Liverpool. Urban regeneration and capital of culture years as they are just seem to make every European city look the same, with the same art, architecture and corporate shops. What should happen is the opposite to this with the originality and diversity of different places to be encouraged and nurtured. Peace is tough. All love.

Jon Savage, Writer and Cultural Historian
Using the credit crunch as an opportunity, what's needed is some kind of city council/landlord policy with regard to creative use of all the unsold/unrented shops, flats and other empty buildings in the centre of Liverpool for studios, ateliers etc., so that young artists and musicians – indeed young people in general – can live cheaply near the city centre. That way, you get a lively nightlife and the seed-bed for future culture. The alternative is a ghost town.

Laura Sillars, Head of Programme, FACT
The greatest challenges and opportunities for Liverpool lie in the precedents set by its past. This city has been a nurturer of talent, a platform for experimentation and a meeting place for ideas. As this silky shawl of the European Capital of Culture falls off the city's shoulders and is passed onto other cities in Austria and Lithuania, Liverpool will naturally take a moment's breath. The first challenge for the visual arts is to ensure that the day after the night before does not last too long. As well as the fun of dissecting the party – who was there, who said what to whom – we have more pressing concerns. Such as how, in the twenty-first century, is this city going to continue and develop an environment that attracts young artists and producers? How are we going to continue to ensure that the city offers the time, space and places for itinerant artists to meet others, try things out, think and share ideas? How are we going to ensure that the most experimental learning can take place in this city? 2008 provided Liverpool with a mirror to look at itself through the eyes of the world; what comes after the watershed year of 2008 requires both optimism and humility.

The Singh Twins, Artists
Liverpool 2008 is committed to profiling the diversity and quality of creative talent and programming in the city with a dedicated budget and team of people employed for that purpose. One challenge will be keeping that momentum, enthusiasm and investment in the arts alive beyond 2008 with what we assume will be a greatly reduced budget and manpower. In terms of opportunities, 2008 has provided greater public awareness and media exposure for many of Liverpool's artists and festivals – which can be built on to attract investment and interest beyond 2008.

08 has enabled a new direction in our work – namely, the production of our first animation, *The Making of Liverpool*, which happened through a new creative partnership forged as a spin-off from our painting *Liverpool 800*, commissioned for the 08 celebrations. For us, as for many others, such partnerships will provide opportunities beyond 2008 as the skills and shared knowledge acquired are applied to developing visual arts projects for the future. In addition, we, like other visual artists, have created new works for the city in 08, which will remain a permanent legacy and point of public contact for developing further profile and opportunities within the visual arts, well beyond 2008.

Mike Stubbs, Director, FACT

European Capital of Culture, how do you follow that? With something else. The main challenge for the visual arts, in Liverpool post-2008, is the same challenge for all art – that there is good art. Good art will surface where it can. Good art is made despite and because of the conditions. That said, creating excellent conditions, awareness and compelling situations for good art to be produced and experienced demands creative approaches to commissioning, education and exhibition. This means space for experimentation, risk and accepting failure – all things are contextual. What defines good art is a good critical context, a place for discussion, critical writing, debate with experts and general audiences alike – research, comparison and documentation. Having whetted appetites and raised expectations, the challenge for all in the city is how to maintain excellence, interest and encourage people to want to be artists in a city that has the best visual arts culture outside London. This will demand continuing support and advocacy at the highest level – city leaders, business communities and artists need to continue to recognise the strengths and range of values to the city in building a diverse society composed of confident, questioning and engaged people.

Paul Sullivan, Director, Static Gallery

Post-2008 three areas have to be addressed. First the strengthening of the current Fine Art courses provided by Liverpool John Moores University, Hope University and Wirral Metropolitan to ensure that they are leaders in contemporary artistic practice. This also includes the provision of the new MA in Fine Art at LJMU School of Art and Design (starting 2008). The

alignment of a progressive and critically regarded academic infrastructure will deliver a much better quality of graduate who will in turn feed into the second and third areas that need to be addressed, namely the provision of a critical publication and an internationally respected commercial arts sector. If these issues are addressed, Liverpool will strengthen further its already very strong visual arts infrastructure, as each year new graduates develop an ever-expanding variety of considered or reactionary practice. Liverpool's current and future arts organisations and groups must also strengthen their infrastructure to increase the provision of residencies for visiting national and international artists, architects, writers, film makers and cultural commentators. These residencies create perpetual opportunities for engagement, debate, exhibition, exchange, publicity and trade and further assist in the promotion of the city's creative reputation on a national and international level.

Art in Liverpool Timeline.

This is not a comprehensive chronology of contemporary art in Liverpool but is designed to give a flavour of the developments over the four decades since *Art in a City* was published.

1967 Commissioned by the Bluecoat Society of Arts in 1962, John Willett's study of art in Liverpool, *Art in a City*, published. An accompanying exhibition, *Art in a City: The Liverpool Look*, staged at the Institute of Contemporary Arts (ICA), London.

Edward Lucie-Smith's document of Liverpool's poetry/performance scene, *The Liverpool Scene*, published, the same year as Penguin's *The Mersey Sound* anthology of Liverpool poetry, which features Adrian Henri, a pivotal figure connecting art, poetry and performance in the city.

CBS releases LP of live readings by poets Henri and Roger McGough, *The Liverpool Scene*, the name adopted by poetry/rock group fronted by Henri, which releases several records for RCA before breaking up in 1970.

Mark Boyle and Joan Hills perform *Son et Lumière for Earth, Air, Fire and Water* and premiere *Son et Lumière for Bodily Fluids and Functions* in their exhibition at the Bluecoat, promoted by the Bluecoat Arts Forum.

Liverpool *Daily Post* describes Liverpool 8's bohemian area as the 'Left Bank of the North West'.

Yoko Ono presents *Concert of Music for the Mind* and premieres *The Fog Machine* at the Bluecoat, also performing at the Art College, at the invitation of tutor David Clapham.

228

1968 *Dada 1916–1966: Documents of the International Dada Movement* at the Walker includes works by Hans Arp, Marcel Duchamp, Man Ray, Raoul Hausmann, Georg Grosz, Max Ernst and Kurt Schwitters.

Bill and Wendy Harpe found Great Georges Community Cultural Project (the Blackie, now renamed the Black-E), the UK's first experiment in utilising avant-garde arts practice in community participation work. Meredith Monk and Judy Chicago (above) are amongst artists visiting during the following decades. For Sister to Shakespeare, part of a celebration of women writers, Chicago gave a lecture updating Virginia Woolf's *A Room of One's Own.*

1969 John Latham exhibition *Review of a Dictionary* at the Bluecoat, followed by his performance collaboration with Eventstructure Research Group (ERG) at the Blackie.

1970 Touring exhibition of prints from the Arts Council collection at the Bluecoat includes works by Richard Hamilton, Joe Tilson, Patrick Caulfield and Gillian Ayres.

1971 The Walker stages *New Italian Art, 1953–71*, the first in a series of Peter Moores Liverpool Project exhibitions.

Liverpool Regional College of Art becomes part of Liverpool Polytechnic.

Peter Stuyvesant Foundation's UK-wide *Sculpture in a City* commissions include William Turnbull's geometric metal sculpture in the Bluecoat courtyard.

1972 Adrian Henri's *Painting 1* wins Second Prize in the John Moores exhibition. He also becomes president of the Liverpool Academy of Arts, a position he holds until 1981.

Sculptor Arthur Dooley's homage to Vladimir Tatlin's unrealised tower, a podium marking the 125th anniversary of the Liverpool Trades Council, is erected at the Pier Head. Removed temporarily for a concert in memory of John Lennon in 1990, it never returns and is later discovered, dismantled and rusting, in Calderstones Park.

Cult Californian rock musician Don Van Vliet (Captain Beefheart) performs at the Liverpool Stadium, finding time to have the first public exhibition of his abstract paintings at the Bluecoat.

1973 *Filmaktion* residency at the Walker involving filmmakers David Crosswaite, Mike Dunford, Gill Eatherley, Malcolm Le Grice, Annabel Nicolson, and William Raban.

Peter Moores Liverpool Project 2, *Magic & Strong Medicine* at the Walker.

Edward Lucie-Smith's article 'The New British Realists' published in the *Sunday Times Magazine* (14 October), focusing on Liverpool photorealist painters, including John Baum and Maurice Cockrill.

Contemporary Art from Africa at the Bluecoat includes work by Ronald Moody, Uzo Egonu and Errol Lloyd.

1974 Maurice Cockrill's *Scillonian Pumps* a prizewinner in the John Moores exhibition.

Adrian Henri's *Environments and Happenings*, an historical overview of the origins of assemblage, environment and performance art, published by Thames & Hudson.

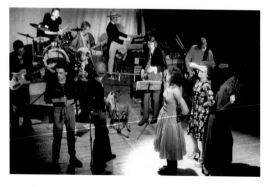

Deaf School formed by students and staff at Liverpool College of Art. The archetypal 'art school band', they go on to win the *Melody*

Maker best new band competition, securing a deal with Warner Brothers and releasing three albums.

1975 Peter Moores Project 3, *Body & Soul*, at the Walker.

1976 Liverpool Academy *The Face of Merseyside* exhibition at the Walker.

Group of artists take over derelict Bridewell building on Prescot Street. As non-profit company Artspace Merseyside they run it as studios, subsequently purchasing the complex.

The first Jung Festival held at the Liverpool School of Language, Music, Dream and Pun in Mathew Street, inspired by the Swiss psychiatrist Carl Gustav Jung who dreamt of

Liverpool in 1927 as 'the pool of life'. Established by Peter Halligan, the School becomes a hangout for the city's creative types and stages exhibitions and events including the Science Fiction Theatre of Liverpool's *Illuminatus Trilogy*, directed by Ken Campbell.

1977 Peter Moores Project 4, *Real Life*, at the Walker includes Boyle Family's *Herculaneum Dock Series* and photorealist paintings by Maurice Cockrill.

Photograph, Philip Vaughan

Open Eye Gallery opens in former pub on corner of Whitechapel and Hood Street (above), a manifestation of the Merseyside Visual Communications Unit, set up in 1973 with a mission to 'make more people aware of the many positive ways in which film, photography, video and sound recording can be used in a social, cultural and educative context'. Following an adventurous programme directed by Peter Hagerty, including publication of a regular photography magazine, the gallery relocates to Bold Street in the early 1990s, before moving to its current Wood Street premises in 1996.

1978 Liverpool Art College dropout Bill Drummond and David Balfe form Zoo Records, an independent Liverpool record label, which releases records by Echo and the Bunnymen, The Teardrop Explodes and others.

23 Photographers: 23 Directions, exhibition of conceptual photography staged at the Walker, including works by John Baldessari, Bernd and Hilla Becher, Victor Burgin and William Eggleston.

1979 *Seven in Two*, Maurice Cockrill's public art commission installed at Lime Street Station, with an exhibition of related drawings shown at the Bluecoat the following year.

Peter Moores Project 5, *The Craft of Art*, at the Walker.

1980 Liverpool Artists' Workshop established in Hope Street. It initiates projects and develops a lecture programme around the idea of art in a social context. Speakers include Terry Atkinson, Pete Dunn and Griselda Pollock.

Ian McKeever is the first artist in residence at the Bridewell, a scheme funded by the Arts Council in collaboration with the Walker, where the artists exhibit at the end of their residency. Later residents include Anish Kapoor, Graham Ashton and Jonathan Froud.

Four students participating in a street action, dressed as 'Furbelows' – knitted nude outfits devised by artist Alice Beberman as part of her exhibition at Open Eye – are arrested, charged with 'insulting behaviour likely to cause a breach of the peace', are fined and, on appeal, receive prison sentences.

1981 Following financial problems, the Liverpool Academy disbands and closes its new premises on Pilgrim Street (having relocated from its Renshaw Street home), a period marked by a lively programme of members' shows, Arts Council touring exhibitions, mail art and performance art.

Art and the Sea, a nationwide collaboration involving coastal venues and artists working around maritime themes, is shown in Liverpool at the Bluecoat and other venues.

Jeff Nuttall, author of *Bomb Culture*, becomes Head of Fine Art at Liverpool Polytechnic, staying until 1984.

Bootle community media project, Art in Action, responds to significant social issues in the city, producing touring photographic exhibitions about the People's March, housing and the Toxteth riots.

Touring ICA exhibition *Women's Images of Men* exhibition shown at the Bluecoat.

1982 Former Liverpool Academy gallery director Murdoch Lothian opens commercial gallery in Liverpool 8. It runs for five years with shows by Paul Neagu, Michael Kenny and others.

Urban Kisses at the Bluecoat, with works by New York artists including Cindy Sherman, Keith Haring and Robert Longo, on tour from ICA, London, with whom the Bluecoat has a relationship in the 1980s through collaborative and reciprocal pop culture/design themed exhibitions such as *Graphic Rap* (new commix) and *Cover Versions* (new wave record sleeves).

1983 Peter Moores Project 7, *As of Now*, staged at the Walker.

Bridget Riley mural commissions at the Royal Liverpool Hospital, following an earlier painting commission scheme in 1980 involving Adrian Henri, Clement McAleer, Don McKinlay and Peter Philip.

1984 International Garden Festival at Otterspool features major outdoor sculpture exhibition curated by Sue Grayson, including Dhruva Mistry's red sitting bull, an Allen Jones sculpture later relocated to Concert Square in the city centre, and works by Richard Deacon, David Mach, Judith Cowan and many others.

Artists, designers and craftspeople convert warehouse on Duke Street into studios. Gaining charitable status in 1986 as the British Art and Design Association, the group becomes Arena in 1997.

1985 Exhibition, *The Last Resort*, at Open Eye Gallery of photographs by Tom Wood and Martin Parr, who had both moved to Merseyside, settling in Wallasey.

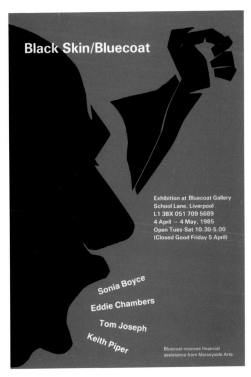

Black Skin Bluecoat, the first Liverpool exhibition to reflect the emerging Black art movement in UK, staged at the Bluecoat, featuring works by Eddie Chambers, Keith Piper, Sonia Boyce and Tom Joseph.

Merseyside galleries collectively launch *Art Around Merseyside*, a regular exhibitions listings brochure, which runs until 1995, edited by Lin Holland.

Liverpool-based ARK, run by Colin Fallows and Pete Fulwell, releases LP *Dada For Now: A Collection of Futurist and Dada Soundworks*

233

documenting rare works of early twentieth-century international sound artists, experimental composers and noise makers. In 1987 ARK release *Insect Culture* LP by Popular Mechanics, the Leningrad-based underground Russian Futurist multi-media group.

1986 Following abolition of Merseyside County Council, National Museums and Galleries on Merseyside (later National Museums Liverpool) established, giving its collections merited national status.

National graduate exhibition *New Contemporaries* shown for first time in Liverpool at Hanover Galleries and the Bluecoat.

Raleigh sculpture by Liverpool-born artist Tony Cragg installed at the Albert Dock, close to the Tate.

Connections, an exhibition exploring the links between Manchester and Liverpool, staged at Open Eye Gallery, the Bluecoat and at Cornerhouse, Manchester. Artists comprise Vanley Burke, Pete Clarke, John Davies, John Hyatt, Martin Parr and Jenny Wilson.

1987 Barbara Kruger's *We Don't Need Another Hero* billboard sited in Liverpool, including at the Albert Dock construction site of the new Tate, as part of a project initiated by Artangel.

Start of ongoing cultural exchange programme with Liverpool's twin city of Cologne, coordinated by Merseyside Arts. Over the next ten years the Bluecoat continues the exchange with Cologne's BBK Gallery, and it is superseded by artists-led project, *8 Days A Week*.

Richard Long installs *Stone Field*, made from 70 tonnes of white limestone, at disused space and former dole office, Renshaw Hall, the project organised by the Coracle Atlantic Foundation.

TSWA 3D, a public art commission series across the UK, includes *Palladia*, Holly Warburton's transformation of the inside of the Oratory, next to Liverpool's Anglican Cathedral.

1988 Tate Gallery Liverpool opens in May at the Albert Dock with *Starlit Waters: British Sculpture, an International Art 1968–1988*.

The same week the Tate opens, Liverpool performance group Visual Stress present their first 'Urban Vimbuza', *Death by Free Enterprise*, at the front of the Bluecoat.

Eddie Berg develops Merseyside Moviola into an agency commissioning and presenting work by international artists working in film, video and new media. The organisation had been set up by Josie Barnard and Lisa Haskel in 1985 to present occasional programmes of experimental film and video.

Momart artist-in-residence programme starts at Tate Liverpool. Running till 2002, its artists include Marion Coutts, Neville Gabie, Gary Perkins, James Rielly, Laura Godfrey Isaacs, Emma Rushton, Maud Sulter and Paul Rooney.

1989 ARK in collaboration with the Bluecoat, Tate Liverpool and Liverpool City Council present *Pop Mechanica: Perestroika in the Avant-Garde*, bringing emerging Russian underground musicians, artists and fashion designers from Leningrad to Liverpool for a

multi-media performance at St George's Hall, exhibitions at Tate Liverpool and the Bluecoat, where Sergei Kuriokhin gives a solo performance.

Photograph, the Bluecoat

Moviola presents the first *Video Positive* biennial at the Bluecoat, Tate Liverpool and Williamson Art Gallery. The festivals continue till 2000. Above, Mike Stubbs, *Desert Island Dread*, at the Bluecoat

1990 *New North* at Tate Liverpool is an exhibition by artists from the North of the UK, curated with input from a team of advisors from galleries in this region. It includes work by Jagjit Chuhan, Locky Morris, Steven Campbell, Lesley Sanderson and John Hyatt.

ARK release *Sputnik of Life* by the New Composers, Leningrad-based sound artists and visual stylists. Using equipment donated by Brian Eno and costume styling by Andrew Logan, the record becomes the first 12-inch techno dance-floor hit in Russia.

1991 Ken Martin establishes the View Gallery in Gostins Building, Hanover Street, presenting mainly Liverpool artists until it closes in 2002.

New Art North West, a survey of art in the region, shown at Cornerhouse and Castlefield Gallery in Manchester and at the Bluecoat and other sites in Liverpool.

1992 Virginia Nimarkoh's *The Phone Box* project involves interventions by artists, including Tracey Emin, into telephone boxes in the red light districts of London and Liverpool.

The first Visionfest annual visual arts festival takes place at mainly non-gallery sites across the city, with 90 events involving 300 artists.

Photograph, the Bluecoat

Trophies of Empire at the Bluecoat, a commission series initiated by artist Keith Piper to look at colonial legacies in Liverpool, Bristol and Hull, includes works by Juginder Lamba (*The Cry*, above, installed in the Bluecoat garden), Shaheen Merali and Liverpool artists Paul Clarkson and South Atlantic Souvenirs.

Liverpool Polytechnic becomes Liverpool John Moores University (LJMU).

Liverpool Community College formed, offering art courses. The college provides foundation courses when LJMU closes its course.

1993 Tate Liverpool presents Antony Gormley's first version of *Field for the British Isles* installation, made by local families from St Helens.

Gilbert and George's exhibition *Cosmological Pictures* at Tate Liverpool, its only UK showing, opens with a party for the artists held at the Ullet Road Unitarian Church, with its stained glass windows designed by Burne-Jones.

Inspired by New Orleans' Neighbourhood Gallery, Joe Farrag opens the Gallery, an open house for artists, poets and musicians in Sandon Street, Liverpool 8. The venue supports Liverpool black artists and brings in touring shows of African art, but is unable to attract funding necessary to survive long term.

1994 Visionfest includes *Signification*, 74 flags designed by artists and architects and sited around the city.

Merseyside Maritime Museum opens permanent gallery, Transatlantic Slavery: Against Human Dignity at the Albert Dock. Its opening programme involves contemporary artists, including Paul Clarkson and Bill Ming, responding to Liverpool's slave legacy.

Stuart Sutcliffe – An Exhibition of Works on Paper, Hamburg 1961–62 and launch of the Stuart Sutcliffe Scholarship (later Postgraduate Fellowship Award) at Liverpool Art School, Liverpool John Moores University.

1995 Liverpool Institute for Performing Arts (LIPA) founded.

Liverpool Institute of Higher Education becomes Liverpool Hope (gaining university status in 2005), establishing an arts faculty at Everton and a regular exhibition programme in its Cornerstone Gallery.

Tate Liverpool's *Making It* exhibition includes artists working in Liverpool, Janet Hodgson, Sarah Raine and Padraig Timoney.

The Bluecoat establishes a link with Senegal through an exhibition of Senegalese art for *Africa 95* and Liverpool artist Paul Clarkson's attendance at the Tenq workshop. The following year Daniel Manyika and Juginder Lamba participate in the workshop, part of the biennial *Dak'Art 96*.

Tate Liverpool hosts the first UK retrospective of Sigmar Polke, *Join the Dots*.

1996 Artists' group Common Culture form in Liverpool, comprising David Campbell,

Mark Durden, Paul Rooney and Anna Vickery, going on to curate shows as well as exhibit in the UK and internationally.

Photograph, the Bluecoat

For the Euro 96 championships, Alan Dunn is Football Artist in Residence at the Bluecoat where David Jacques also presents football banners on the building.

Visionfest's theme is 'Art, Lies and Documentation' and includes *Discreet Charm*, an installation at Croxteth Hall by Yinka Shonibare and Kate Smith, curated by Richard Hylton.

Photograph, Leo McDonough

The Bluecoat's *Live from the Vinyl Junkyard* live art commissions, looking at art/pop music crossover, include works by Philip Jeck (*Off the Record*, above) and John Campbell & Henry Priestman, Liverpool artists working at the intersection of art and pop music.

1997 A second series of Bluecoat art/pop commissions, *Mixing It*, includes the premiere of Jeremy Deller's *Acid Brass*, performed by the Williams Fairey Brass Band at LIPA, introduced by Tony Wilson of Factory Records, and works by Cornford & Cross and Jayne Pollard & Iain Forsyth.

American artist David Bunn presents *Here, There and Everywhere* at the Central Library as part of Book Works' *Library Relocations* commissions.

The theme of *Video Positive 97* is 'Escaping Gravity' and takes place in Manchester as well as Liverpool, involving 200 artists and 12 venues. Moviola changes its name to FACT (Foundation for Art and Creative Technology).

Lebanese artist Walid Sadek starts residency at LJMU, one of a series run by the Centre for Art International Research at the University, which supports artists from diverse cultural backgrounds. Artists and lecturers Bashir Makhoul and Jagjit Chuhan had been instrumental in developing this initiative with colleague Merilyn Smith.

1998 James Moores establishes the A Foundation to support the development and exhibition of contemporary art in Liverpool.

Paul Sullivan establishes Static in Roscoe Lane, offering working and exhibition space to Liverpool-based artists and architects. The organisation develops a discursive role in the city through publications, events and international connections.

Artranspennine98, a large-scale international contemporary art festival, takes place at venues across the Pennines, from Liverpool to Hull. One of the commissions, Taro Chiezo's *Superlambanana*, becomes an iconic public sculpture in Liverpool.

Tom Wood's *All Zones Off Peak*, a selection of photographs taken on buses on Merseyside over the previous two decades (above, *London Road, City Centre*, 1993, c type photograph) exhibited at the Bluecoat and Open Eye Gallery. A book of the same name was published by Dewi Lewis Publishing in 1998.

ISEA98 – the ninth *International Symposium on Electronic Art* staged in Liverpool and Manchester including two symposia and 100 artists' projects, directed by Eddie Berg (FACT), Colin Fallows (LJMU) and John Hyatt (Manchester Metropolitan University).

 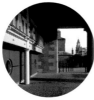

Liverpool fails in its bid to be UK City of Architecture (part of the Arts Council's Arts 2000 project), which was awarded instead to Glasgow. The process, however, is useful preparation for the city's later Capital of Culture bid.

Over 30 exhibitions and events involving Liverpool artists staged in Liverpool's twin city of Cologne under the title *Eight Days A Week*. Organised by writer and critic Jürgen Kisters with support from the Bluecoat and artists in both cities, the project develops into an artists' exchange, starting with a reciprocal festival of Cologne art in Liverpool in 2000.

John King's *Case History* sculpture installed outside the Art School building on Hope Street/Mount Street.

1999 With support from James Moores, the first Liverpool Biennial is staged across the city, including a temporary space at Exchange Flags. Its international exhibition, *Trace*, curated by Tony Bond, includes Doris Salcedo at the Anglican Cathedral, Juan Munoz at the Oratory, and Liverpool artists Susan Fitch and Amanda Ralph. The festival's independent strand of artist-led initiatives is branded *Tracey* by coordinator Jonathan Swain.

Adrian Henri retrospective at the Walker.

View Two Gallery set up in Mathew Street, building on the work of the View Gallery, focusing mainly on painting by local, national and international artists.

Duncan Hamilton publishes *Black Diamond* arts magazine in the city.

Photograph, Roohi Ahmed

First Cyfuniad international artists' workshop held in North Wales, organised by Lin Holland, Becky Shaw, Dave Lewis and a working group of predominantly Liverpool artists. Part of a global network initiated by the Triangle Arts Trust, a second workshop is held in 2001 and another, *Coast*, in 2007 at the A Foundation's Liverpool space. Above, Juan David Medina (Colombia) participating in 2008 Cyfuniad workshop.

Alan Dunn and Godfrey Burke's Liverpool Billboard Project includes works by Fiona Banner, Felix Gonzales Torres, Pierre Huyghe and Erwin Wurm.

2000 For *Up in the Air*, a collaboration with Liverpool Housing Action Trust, Leo Fitzmaurice and Neville Gabie invite other artists to work in tower blocks in Sheil Park. This is followed by *Further Up in the Air* (2001–04), whose artists and writers include Jordan Baseman, Marcus Coates and Will Self.

239

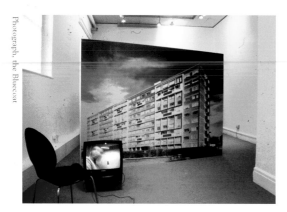

At *Video Positive*, Danish artists' collective Superflex work with tenants from a Liverpool high rise. Their 'Superchannel' project is developed by FACT and Liverpool Housing Action Trust into a long-running interactive Internet TV station, *tenantspin*.

Designer with Jann Haworth of the sleeve for the Beatles' *Sgt Pepper* record, Peter Blake exhibits *About Collage* at Tate Liverpool, reconnecting to Liverpool's pop music legacy. He returns to the gallery in 2007 for a retrospective exhibition.

2001 Consultants Modus Operandi appointed to develop a public art strategy, 'Green by Day – Light by Night', for Liverpool Housing Action Trust. Several major works realised over the next four years, including Vong Phaophanit's *Outhouse* in Woolton.

Major solo exhibition by US artist Paul McCarthy at Tate Liverpool.

2002 Modus Operandi complete a Public Art Strategy for Liverpool City Council, focusing on the city centre and how art can be used in regeneration. This follows an earlier strategy a decade before for art in public, commissioned from Public Arts Wakefield, a document that remained on the shelf.

Second Liverpool Biennial staged, curated by a home-grown team with input from Henry Moore Contemporary Projects, whose commissions take over a temporary site at Pleasant Street School. A public realm highlight is Tatsurou Bashi's *Villa Victoria* (above), which turns the Queen Victoria monument into a hotel. Over 300 artists from 36 countries participate in the Biennial. The Independent fringe grows, with many artist-led initiatives, including *All things fall and are built again* at Jump Ship Rat.

A live art programme, *You Are Here*, organised for the Biennial by the Bluecoat in collaboration with Live Art Development Agency, includes Guillermo Goméz-Peña's 'Ex-Centris' performance. Further live art programmes accompany subsequent Biennials as *Liverpool Live*.

Fluxus pioneer Ben Patterson visits Liverpool, as a Visiting Fellow at Liverpool School of Art and Design and performing at Liverpool Community College and the Bluecoat. He returns in 2004 with Eric Andersen and Emmett Williams as Visiting Fellows, performing and recording Fluxus Classics at LIPA and LJMU during Liverpool Biennial.

2003 FACT moves to new building on Wood Street designed by Austin-Smith: Lord, having been based at the Bluecoat for nearly fifteen years. Housing an art house cinema and galleries, the FACT Centre opens with a new commission, Isaac Julien's *Baltimore*.

Campaigning under the slogan 'The World in One City' (subsequently dropped), Liverpool is awarded 2008 European Capital of Culture status.

2004 The *International 04* exhibition for the Liverpool Biennial is developed with a team of international researchers. Public realm commissions include Peter Johansson's *Musique Royal*, playing Abba's 'Dancing Queen' night and day.

Conservative MP Boris Johnson is forced to apologise to Liverpool following an article knocking the city in the magazine he edits, the *Spectator*. Artist Richard DeDomenici beats him to it, impersonating the future Lord Mayor of London in a walkabout tour as part of *Liverpool Live*.

UNESCO designates Liverpool a World Heritage Site as a Maritime Mercantile City.

Jude Kelly opens Metal in a house in Kensington, a residency and project space for artists working in different art forms.

Jorge Pardo's *Penelope* sculpture, initiated by Tate Liverpool for the Liverpool Biennial 2002 and commissioned by the Liverpool Rope Walks Partnership, installed in Wolstenholme Square.

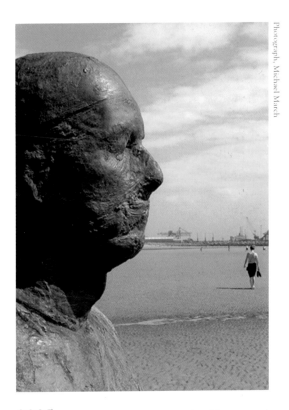

Photograph: Michael March

2005 Antony Gormley's *Another Place* installed on Crosby Beach. The sculptures prove popular with residents and tourists and a campaign to have them permanently sited is successful.

Garston Cultural Village, a campaign to regenerate this Liverpool suburb through the arts, established by Alex Corina.

The RENEW Rooms, the North West's Regeneration Centre of Excellence, established in association with the Royal Institute of British Architects. It opens with a debate on regeneration.

Tracey Emin's sculpture *Roman Standard* installed outside the Anglican Cathedral Oratory. It is subsequently stolen, then retrieved. Another – temporary – piece by Emin, a neon text entitled *For You*, is later installed in the Cathedral during the 2008 Biennial.

2006 The international show of the fourth Liverpool Biennial features 15 public realm commissions, including the Lime Street lions caged by Rigo 23 and Hans Peter Kuhn's giant illuminated question mark on the Cammell Laird shipyard. The Independents programme includes *Sinking Towards Wishy Mountain*, an exchange exhibition with 2008 non-EU Capital of Culture, Stavanger in Norway, organised by new Liverpool artists studio group The Royal Standard.

The A Foundation opens exhibition spaces in former industrial buildings in Greenland Street, participating in the Liverpool Biennial with *New Contemporaries* and exhibitions by Goshka Macuga and others.

Liverpool John Moores University decides to sell off buildings including the historic, purpose-built art school on Hope Street to finance a new Art and Design Academy, designed by Rick Mather, to be built next to the Metropolitan Cathedral.

Walk On, an exhibition by Liverpool artists curated by Bryan Biggs, is organised by the Liverpool Biennial for the Shanghai Biennale running simultaneously in Liverpool's Chinese twin city.

2007 Richard Wilson's *Turning the Place Over*, commissioned by the Liverpool Biennial for a site at Moorfields, is launched.

The Ghosts of Songs, a retrospective of the Black Audio Film Collective, curated by FACT.

The city council-commissioned painting by the Singh Twins (Amrit and Rabindra Kaur Singh), celebrating Liverpool's 800th birthday, is displayed in St George's Hall. For 2008, Liverpool Culture Company commissions another painting from the artists to mark the year's cultural programme.

2008 Liverpool starts its year as European Capital of Culture. Visual art plays a major part in the year's programme.

The first Liverpool Art Prize won by Imogen Stidworthy, the Singh Twins being the 'People's Choice'.

The Bluecoat reopens after a three-year closure, with an enlarged gallery housed in a new wing designed by Rotterdam architects Biq. Yoko Ono returns as part of the opening programme, forty years after her first performance at the venue.

Ben Johnson's *Liverpool Cityscape* painting, part of his World Panorama Series, installed at the Walker. Together with *Art in the Age of Steam* exhibition (above, Adolphe Mouron Cassandre, *Nord Express*, 1927, colour lithograph poster. Minneapolis Institute of Arts, the Modernism Collection, gift of Norwest Bank Minnesota), it is a highlight of the Walker's 2008 exhibition programme.

Ceri Hand opens commercial gallery at Cotton Street near Stanley Dock.

Gustav Klimt: Painting, Design and Modern Life in Vienna 1900 at Tate Liverpool breaks all attendance records.

Over a hundred smaller versions of Taro Chiezo's *Superlambana*, each individually decorated, appear at sites across the city.

University of Liverpool's Victoria Art Gallery & Museum opens on Brownlow Hill, housing the University's collection and presenting a changing contemporary programme, opening with a Stuart Sutcliffe retrospective.

The Liverpool Biennial's fifth edition centres on the international exhibition *Made Up*, organised by Liverpool curators. Thirty-five commissioned artists exhibit at the Bluecoat, FACT, Open Eye and Tate and in the public realm. The Biennial also commissions pavilions in Kensington, Garston and Vauxhall and there is a large Independents programme at galleries and temporary spaces across the city. Terry Duffy presents exhibition of Liverpool artists, *Liverpool International*, at the newly opened Novas Contemporary Urban Centre on Greenland Street.

John Moores Painting Prize celebrates 25 competitions held biennially at the Walker since 1957.

Le Corbusier exhibition staged at the Metropolitan Cathedral, fifty years after the Walker staged an exhibition on the architect's work.

Timeline prepared by Bryan Biggs, with thanks to Darren Pih, Robert Knifton and Colin Fallows.

Writers' Biographies.

Bryan Biggs is Artistic Director of the Bluecoat, where he has worked in various capacities, overseeing the recent capital development and a programme of contemporary visual, performance, live art and participation. He has curated numerous exhibitions, set up international exchange programmes, and positioned the Bluecoat in a network of regional UK galleries and arts centres. He has guest curated exhibitions, including *New Contemporaries*, two *Liverpool Biennials*, and an exhibition from Liverpool for the 2006 Shanghai Biennale. He has written for periodicals such as *Third Text* and *Bidoun*, catalogue essays for exhibitions, including Tate Liverpool (*Centre of the Creative Universe*) and *Susan Hefuna* (Verlag Kehrer, Heidelberg), edited the re-publication of John Willett's *Art in a City* in 2007, and written on the intersection of art and popular music. A fine art graduate, he continues to maintain a drawing practice, and has an MA in Social Enterprise from Liverpool John Moores University.

Lewis Biggs has been Director of Liverpool Biennial since 2000, and has developed its vision of commissioning and presenting the best international contemporary art, working with an ever-broadening range of partners in taking art beyond its traditional showcases, and creating a better ecology for artists. As curator at Tate Liverpool from 1987 to 1990 and then as Director to 2000, he helped build and nurture some of the most influential contemporary art organisations in the North West of England. He was co-director of Artranspennine98 (with Robert Hopper), was a Director of Oriel Mostyn, Llandudno, and is now Chair of Liverpool Culture Campus – linking Liverpool's arts organisations with its universities – and the VAiL campaign (visual arts in Liverpool). Through his leadership, Liverpool Biennial has won a place in the public imagination, expressing a passion for the power of art in public spaces shared by artists and audiences in the North West.

Cathy Butterworth is currently undertaking PhD research into curatorial practice with a focus on Live Art at Liverpool School of Art and Design, Liverpool John Moores University, where she teaches History of Art & Museum Studies. From 1999 to 2005 she was Live Art Curator at the

Bluecoat, curating performance programmes and organising several seminars and conferences, most notably *You Are Here* (2002) and *Liverpool Live* (2004), both in partnership with Liverpool Biennial. She was a founding member of Live Art UK, a consortium of Live Art promoters and agencies set up to research and develop innovative curatorial projects, including a collaboration with curators from Beijing and a UK tour of live art from China. She has published articles in the British Council's *On Tour* publication and *Dance Theatre Journal* and presented papers at conferences including Mid-West American Theatre conference, Performance Studies International, and The Arts Symposium at New York University.

Sean Cubitt is Director of the Program in Media and Communications at the University of Melbourne and Honorary Professor of the University of Dundee. His publications include *Timeshift: On Video Culture*, *Videography: Video Media as Art and Culture*, *Digital Aesthetics*, *Simulation and Social Theory*, *The Cinema Effect* and *EcoMedia*. He is the series editor for Leonardo Books at MIT Press. In Liverpool from 1989 to 2000 he taught at Liverpool John Moores University and was chair of the FACT board. His current research is on public screens and the transformation of public space; and on genealogies of digital light.

Colin Fallows is Professor of Sound and Visual Arts at Liverpool John Moores University. He has explored crossovers between sound and visual art as an artist, researcher, curator and lecturer, and produced work for live ensemble performance, recordings, exhibition, installation, radio and the Internet. His artistic and curatorial projects have featured in numerous international festivals including *Video Positive*, *ISEA98*, *Intermedia*, *Ars Electronica* and *Futuresonic*. He has directed national/international conferences including *ISEA98: Revolution* – the ninth *International Symposium on Electronic Art*; *Sciart and Science on Stage and Screen Symposium* with the Wellcome Trust; *Art–Place–Technology: International Symposium on Curating New Media Art* with FACT and Arts Council England; and *The Art School Dance: Art into Pop, Pop into Art* with Tate Liverpool. He is founder and Artistic Director of Audio Research Editions, a limited edition imprint for artists' soundworks, which since 1998 has published over 200 works by artists from over twenty countries.

Mary Jane Jacob is a curator who holds the position of Professor in the Department of Sculpture and Executive Director of Exhibitions at the School of the Art Institute of Chicago. As chief curator of the Museums of Contemporary Art in Chicago and Los Angeles, she staged some of the first US shows of American and European artists. Shifting her workplace from the museum to the street, she has critically engaged the discourse around public space, organising such site- and community-based programmes as 'Places with a Past' in Charleston, 'Culture in Action' in Chicago, and 'Conversations at The Castle' in Atlanta. She continues to serve as curator for the Spoleto Festival USA in Charleston, South Carolina. Her book *Buddha Mind in Contemporary Art* (University of California Press, 2004) is a popular reference for young artists. Her forthcoming anthology, co-edited with Jacquelynn Baas, is *Learning Mind: Experience into Art*.

Robert Knifton is an independent curator and writer based in the North West of England. He co-curated *Centre of the Creative Universe: Liverpool and the Avant-Garde* at Tate Liverpool in 2007 and *Ruinous Recollections: Artistic Drifts through Post-Industrial Manchester* at Upperspace Gallery, Manchester in 2008. His recent papers include 'Curating the City as Text: Contesting Art Display using Literary Narrative' at *Telling Stories*, Loughborough School of Art, and 'You'll Never Walk Alone: CCTV in Two Liverpool Artworks' at *Conspiracy Dwellings: Surveillance in Contemporary Art*, South Hill Park, Bracknell. For the past three years he has managed Tate Liverpool's Postgraduate Research Forum, offering postgraduates a platform for new research in the visual arts. He is research associate attached to the Centre for Museology at the University of Manchester, and is currently completing his PhD research on art exhibitions, urban space, narrative and memory at MIRIAD, Manchester Metropolitan University.

Pam Meecham has worked at the Institute of Education, University of London since 2000 after sixteen years of working in Liverpool schools and at Liverpool John Moores University. She has developed and managed several education projects with Tate Liverpool and contributed to a number of its schemes and resources. She writes and lectures on Museum and Gallery Education, Art History and cultural policy. She

manages and supervises a number of research projects based in galleries and museums in London and is on the Editorial Board of the organisation Engage. Recently she has co-authored, with Julie Sheldon, two books: *Modern Art: A Critical Introduction* (2000/2005) and *Making American Art* (2008). Her doctorate was on American Art History of the 1950s.

Sara Selwood is an independent consultant and a Professor of Cultural Policy and Management at City University, London. She has a background in fine art, aesthetics, history and theory of art, and worked as an art historian and a curator of contemporary visual art before becoming a cultural analyst. Much of her work focuses on cultural policy and the subsidised cultural sector. She has written extensively on the relationship between the expectations of policy, its implementation, funding and the publics' experience of cultural provision. She is currently chairing a review of the government-funded programme, Renaissance in the Regions. She is a Trustee of the National Portrait Gallery, a board member of Arts Research Limited, and is on the Museums Association Governing Bodies Forum.

Julie Sheldon is Reader in Art History at Liverpool John Moores University. She has a BA in Art History from the University of Leicester (1987) and a PhD from the University of Birmingham (1991). In 1992 she became a lecturer at Liverpool John Moores University where she has developed undergraduate and postgraduate programmes in Art History and supervised a number of PhD research students. In the 1990s she authored several educational resources for Tate and has co-developed a postgraduate course for teachers of art for the Open University. Recent publications include *Modern Art: A Critical Introduction* (2000/2005) and *Making American Art* (2008), co-written with Pam Meecham, and *The Letters of Elizabeth Rigby, Lady Eastlake* (2009).

Bibliography.

Abbreviations

ACE Arts Council England
ACGB Arts Council Great Britain
DCMS Department for Culture, Media and Sport
LARC Liverpool Arts Regeneration Consortium
LGA Local Government Association

ACE, *Ambitions into Actions* (London: Arts Council England, 2004).

— *Regularly Funded Organisations: Key Data from the 2005/06 Annual Submission* (London: Arts Council England, 2007).

— *Turning Point, Arts Council England: A Strategy for the Contemporary Visual Arts in England* (London: Arts Council England, 2006).

— 'Visual Arts 2006/07', *Regularly Funded Organisations: The 2006/07 Annual Submission* (London: Arts Council England, 2008).

ACGB, *Glory of the Garden. The Development of the Arts in England, A Strategy for a Decade* (London: Arts Council of Great Britain, 1984).

ACGB/Morris, G., 'Selling the Contemporary Visual Arts', unpublished report prepared for Arts Council of Great Britain, 1991.

Adorno, Theodor W., *The Culture Industry* (London and New York: Routledge, 1991).

Allen, Felicity, 'Museums and Social Inclusion: The GLLAM Report', *Engage Review* 11 (Summer 2002), pp. 68–70.

Andersson, Cecilia (ed.), *Factor X* (Liverpool: FACT, 2002).

Art in the National Curriculum: A Report to the Secretary of State for Education & Science on the Statutory Consultation for Attainment Targets and Programmes of Study in Art (York: National Curriculum Council, 1992).

Belchem, John (ed.), *Liverpool 800: Culture, Character and History* (Liverpool: Liverpool University Press, 2006).

Bell, Daniel, *The Coming of Post-industrial Society: A Venture in Social Forecasting* (Harmondsworth: Penguin, 1976).

Bianchini, Franco and Michael Parkinson, *Cultural Policy and Urban Regeneration: the West European Experience* (Manchester: Manchester University Press, 1993).

Biggs, Lewis, 'Museums and Welfare: Shared Space', in Pedro Lorente (ed.), *The Role of Museums and the Arts in the Urban Regeneration of Liverpool* (Leicester: Centre For Urban History, University of Leicester, 1996).

Bishop, Claire, 'Antagonism and Relational Aesthetics', *October* 110 (2004), pp. 51–79.

Bond, Anthony, *Trace: The Liverpool Biennial of Contemporary Art* (Liverpool: Liverpool Biennial of Contemporary Art, 1999).

BOP in partnership with Experian Business Strategies, 'Review of the Presentation of Contemporary Visual Arts. Final Survey Report', unpublished report prepared for Arts Council England, 2005.

— 'Review of the Presentation of Contemporary Visual Arts. North West Case Study. Manchester, Liverpool & Cumbria', unpublished report prepared for Arts Council England, 2005.

Bourdieu, Pierre, 'The Forms of Capital' in John G. Richardson (ed.), *Handbook for Theory and Research for the Sociology of Education* (New York: Greenwood Press, 1986), pp. 241–58.

Bryson, Bill, *Notes From a Small Island* (London: Black Swan, new edn, 1996).

Buss, David and Tom Gretton, *Art and Design. Subject Benchmark Statement* (Gloucester: Quality Assurance Agency for Higher Education, 2002).

Candlin, Fiona, 'Practice-Based Doctorates and Questions of Academic Legitimacy', *The International Journal of Art and Design Education*, 19(1) (2000), pp. 96–102.

Cavanagh, Terry, *Public Sculpture of Liverpool* (Liverpool: Liverpool University Press, 1997).

Cavendish, Dominic, 'Liverpool 08 the story so far', *New Statesman* (20 February 2008), http://www.newstatesman.com/life-and-society/2008/02/liverpool-culture-capital-city (accessed 11 July 2008).

Charman, Helen et al., *Tate Modern Teachers' Kit: Action: Planning Your Visit* (London: Tate Gallery, 2001).

Coldstream, Sir William, *The Structure of Art and Design Education in the Further Education Sector. Report of a Joint Committee of the National Advisory Council on Art Education and the National Council for Diplomas in Art and Design* (London: National Council for Diplomas in Art and Design, 1970).

Collard Paul, 'Arts in Inner Cities', unpublished report prepared for the Office of Arts & Libraries, 1988.

Comedia, *Releasing the Cultural Potential of our Core Cities* (Core Cities Group, 2002).

Commission for Architecture and the Built Environment, *Design Review: Former International Garden Festival Site* (March 2007), www.cabe.org.uk

Cork, Richard, *Art for Whom?* (London: Arts Council of Great Britain & Serpentine Gallery, 1978).

Couch, Christopher, *City of Change and Challenge. Urban Planning and Regeneration in Liverpool* (Aldershot: Ashgate, 2003).

Craig, Sandy, for Leisure Futures Ltd, *Urban Cultural Programme, Full Evaluation Report* (2007), http://www.culture.gov.uk/SearchResults.aspx?_SRH_SearchString=urban%20cultural%20programme (accessed 10 July 2008).

Culture North West, *A Snapshot of the Creative Industries in England's North West* (London: DCMS, 2004).

Curtin, Philip D., *Cross-Cultural Trade in World History* (Cambridge: Cambridge University Press, 1984).

Davies, Peter, *Liverpool Seen: Post-War Artists on Merseyside* (Bristol: Redcliffe Press, 1992).

Davis, Mike, *Planet of Slums* (London: Verso, 2006).

DCMS, 'City Heritage Guides launched in ten cities across England', media release 11 May 2004, http://www.culture.gov.uk/reference_library/media_releases/2329.aspx

— *Creating Opportunities Guidance for Local Authorities in England on Local Cultural Strategies* (London: Department for Culture, Media and Sport, 2000), http://www.culture.gov.uk/reference_library/publications/4678.aspx (accessed 10 July 2008).

— *Culture at the Heart of Regeneration* (London: Department for Culture, Media and Sport, 2004).

— 'Culture Secretary welcomes £15 million lottery grant to support European Capital of Culture legacy', media release 1 August 2004, http://www.culture.gov.uk/reference_library/media_releases/2340.aspx (accessed 10 July 2008).

— 'DCMS-sponsored Museums and Galleries in England to get £191 million capital investment over three years', media release 15 February 2007, http://www.culture.gov.uk/reference_library/media_releases/2200.aspx (accessed 10 July 2008).

— *Funding Agreement between the Department for Culture, Media and Sport (DCMS), Department for Communities and Local Government (DCLG), Department for Environment, Food and Rural Affairs (Defra) and English Heritage 2005/06-2007/08* (2006) http://www.culture.gov.uk/images/publications/EHFundingAgreement06_08.pdf (accessed 10 July 2008).

— *Funding Agreement 2005-2008 NML. Funding Agreement between The National Museum Liverpool and The Department for Culture, Media and Sport* (2006) http://www.culture.gov.uk/images/publications/fa_nml.pdf (accessed 10 July 2008).

— 'Huge Boost to Primary School Sports and Arts Facilities in England', media release, June 2002, http://www.culture.gov.uk/reference_library/media_releases/2830.aspx (accessed 10 July 2008).

— 'James Purnell announces extra Arts funding – £50 million by the third year of settlement', media release 11 July 2007, updated 22 November 2007 http://www.culture.gov.uk/reference_library/media_releases/2233.aspx (accessed 10 July 2008).

— *A New Cultural Framework* (London: Department for Culture, Media and Sport, 1998).

— '"Places to live must be living places" – Tessa Jowell sets out vision for successful cultural regeneration', media release, 8 March 2004, http://www.culture.gov.uk/reference_library/media_releases/2419.aspx (accessed 10 July 2008).

— 'Spending Review 2004 – Tessa Jowell Heralds "Record Rise" for Museums and Galleries Funding in England', media release 16 April 2004, http://www.culture.gov.uk/reference_library/media_releases/2430.aspx (accessed 10 July 2008).

— *Tate Funding Agreement 2005/06–2007/08* (2006) http://www.culture.gov.uk/images/publications/fa_tate_0506_0607.pdf (accessed 10 July 2008).

— 'Ten Museums To Receive £2 Million Cash Boost To Improve Displays', media release, 2002, http://www.culture.gov.uk/reference_library/media_releases/2885.aspx (accessed 10 July 2008).

— 'Tessa Jowell Announces £130 Million Boost for Library and Sports Projects under Private Finance Initiative', media release 11 March 2005, http://www.culture.gov.uk/reference_library/media_releases/3057.aspx (accessed 10 July 2008).

— 'Thirteen Local Authorities in England to become Cultural Pathfinders', media release 2 May 2005, http://www.culture.gov.uk/reference_library/media_releases/3068.aspx (accessed 10 July 2008).

— *Understanding The Future: Museums and 21st Century Life, The Value of Museums* (London: Department for Culture, Media and Sport, 2005)

DCMS/BERR/DIUS, 'From the Margins to the Mainstream – Government unveils new action plan for the creative industries', joint press release 1 July 2008, http://www.culture.gov.uk/reference_library/media_releases/2132.aspx (accessed 10 July 2008).

DCMS/DCSF, 'Five-hour "find your talent scheme" moves a step closer with ten pilot areas named', media release 4 July 2008, http://www.culture.gov.uk/reference_library/media_releases/5149.aspx (accessed 10 July 2008).

De Certeau, Michel, *The Practice of Everyday Life*, trans. S. Rendall (Berkeley and Los Angeles: University of California Press, 1984).

de Duve, Thierry, 'The Glocal and the Singuniversal: Reflections on Art and Culture in the Global World', *Third Text*, 21(6) (2007), pp. 681–88.

Doherty, Claire, 'Curating Wrong Places… Or Where Have All The Penguins Gone?', in P. O'Neill (ed.), *Curating Subjects* (London and Amsterdam: Open Editions and De Appel, 2007).

Doherty, Claire (ed.), *Factor 1989* (Liverpool: FACT, 1989).

— (ed.), *Factor 1991* (Liverpool: FACT, 1991).

— (ed.), *Factor 1993* (Liverpool: FACT, 1993).

— (ed.), *Factor 1995* (Liverpool: FACT, 1995).

— (ed.), *Factor 1997* (Liverpool: FACT, 1997).

— (ed.), *Factor 2000* (Liverpool: FACT, 2000).

Domela, Paul (ed.), *Made Up: The Reader of the 2008 Liverpool Biennial* (Liverpool: Liverpool University Press, 2008).

du Gay, Paul, *The Values of Bureaucracy* (Oxford: Oxford University Press, 2005).

du Noyer, Paul, *Liverpool: Wondrous Place* (London: Virgin, rev. edn, 2007).

— 'Subversive Dreamers: Liverpool Songwriting from the Beatles to the Zutons', in Michael Murphy and Deryn Rees-Jones (eds), *Writing Liverpool: Essays and Interviews* (Liverpool: Liverpool University Press, 2007), pp. 239–51.

ERM Economics, 'European City of Culture 2008. Socio-Economic Impact Assessment of Liverpool's Bid', paper for Liverpool City Council (2003), http://image.guardian.co.uk/sysfiles/Society/documents/2003/06/10/finalreport.pdf (accessed 10 July 2008).

Evans, Graeme and Phyllida Shaw, *The Contribution of Culture to Regeneration in the UK: A Review of Evidence* (London: Department for Culture, Media and Sport, 2004).

Foltz, Richard C., *Religions of the Silk Road: Overland Trade and Cultural Exchange from Antiquity to the Fifteenth Century* (New York: St Martin's Press, 1999).

Foster, S. and N. de Ville (eds), *The Artist and the Academy: issues in fine art education and the wider cultural context* (Southampton: John Hansard Gallery, 1994).

Fraser, Andrea, 'From the Critique of Institutions to an Institution of Critique', in Noah Horowitz and Brian Sholis (eds), *The Uncertain States of America Reader* (New York & Berlin: Strernberg Press, Astrup Fearnley Museum of Modern Art & Serpentine Gallery, 2006), pp. 32–39.

Furlong, June, *June – A Life Study* (Liverpool, 2000).

Future Laboratory, *The Sharpie Index UK Top Creative Towns* (London: The Future Laboratory, 2007).

Garcia, Beatriz, 'Press Impact Analysis (1996, 2003, 2005). A Retrospective Study: UK National Press Coverage on Liverpool, before, during and after bidding for European Capital of Culture status' (2006), http://www.impacts08.net/ (accessed 10 July 2008).

Garfield, Simon, *Mauve: How One Man Invented a Color That Changed the World* (London: Faber and Faber, 2000).

Gilmore, A., 'Quality of Life', in NWDA, *Culture & Image*, Evidence Paper 23 (Warrington: Northwest Development Agency, 2008).

Godfrey, Tony, 'Biennial. Liverpool', *The Burlington Magazine*, 142(1162) (2000), pp. 53–55.

_____ 'Biennial. Liverpool', *The Burlington Magazine*, 144(1196) (2002), pp. 701–03.

Grunenberg, Christoph and Robert Knifton (eds), *Centre of the Creative Universe: Liverpool and the Avant-Garde* (Liverpool: Liverpool University Press in association with Tate Liverpool, 2007).

The Guardian in association with Liverpool 08 European Capital of Culture and England's Northwest, *Finger on the Cultural Pulse* (2008).

Harpe, Bill, *Games For The New Years – A DIY Guide to Games for the 21st Century* (Liverpool: The Blackie, 2001).

Henri, Adrian, *Total Art: Environments, Happenings and Performance* (New York and Toronto: Oxford University Press, 1974).

Hignett, Sean, *A Picture to Hang on the Wall* (London: Mayflower, 1968).

Holden, Robert, 'Landscape Revisits: Liverpool Garden Festival', *Architects' Journal* (22 January 1986), pp. 68–72.

hooks, bell *Teaching Community: A Pedagogy of Hope* (New York: Routledge, 2003).

Horlock, Naomi (ed.), *Testing the Water: Young People and Galleries* (Liverpool: Liverpool University Press, 2000).

House of Commons Culture, Media and Sport Committee, *Caring for our Collections. Sixth Report of Session 2006–07* (HC176-1) (London: The Stationery Office, 2007).

Hughes, Quentin, *Seaport: Architecture and Townscape of Liverpool* (Liverpool: The Bluecoat Press, 1999 [1969]).

Hutchins, M., 'Make No Little Plans: The Regeneration of Liverpool City Centre 1999–2008. The Evidence Base' (2008), http://www.liverpoolvision.co.uk/documents/corporate.asp (accessed 10 July 2008).

Hylton, R., *The Nature of the Beast: Cultural Diversity and the Visual Arts Sector. A study of policies, initiatives and attitudes 1976–2006* (Bath: ICIA, 2007).

The Internet Governance Project, *Internet Governance: The State of Play*, Convergence Center, Syracuse University School of Information Studies, the Moynihan Institute of Global Affairs of the Maxwell School of Syracuse University and the Internet and Public Policy Project (IP3), Georgia Institute of Technology, 13 September 2004, http://www.16beavergroup.org/mtarchive/archives/002282.php (accessed 2 March 2008).

Johnson, Ben and Ann Bukantas, *Cityscape: Ben Johnson's Liverpool* (Liverpool: Liverpool University Press, 2008).

Johnson, Boris, 'The Leader: Bigley's fate', *The Spectator* (16 September 2004), http://www.spectator.co.uk/archive/the-week/12691/bigleys-fate.thtml (accessed 11 July 2008).

Jowell, Tessa, *Government and the Value of Culture* (London: Department for Culture, Media and Sport, 2004).

— 'Speech by Tessa Jowell – Culture and the Olympic Ideal' (2007) http://www.culture.gov.uk/reference_library/minister_speeches/2075.aspx (accessed 10 July 2008).

— 'Transcript of Secretary of State Tessa Jowell's speech to the Financial Times Business of Sport Conference' (2003) http://www.culture.gov.uk/reference_library/minister_speeches/2111.aspx (accessed 10 July 2008).

Keidan, Lois *Live Art UK Vision Paper: A question of Live Art* (2004) http://www.liveartuk.org/documents.html

Kwon, Miwon, 'Itinerant Artists', in Noah Horowitz and Brian Sholis (eds), *The Uncertain States of America Reader* (New York and Berlin: Strernberg Press, Astrup Fearnley Museum of Modern Art & Serpentine Gallery, 2006), pp. 45–51.

Landry, Charles, *The Creative City. A Toolkit for Urban Innovators* (London: Earthscan, 2000).

Lane, Tony, *Liverpool City of the Sea* (Liverpool: Liverpool University Press, 1997). First published as *Liverpool, Gateway of Empire* (London: Lawrence & Wishart, 1987).

LARC, *Business Case for Arts Council England Thrive! Programme 2008 to 2010. Executive Summary* (Liverpool: Liverpool Arts & Regeneration Campaign, 2008).

— 'External Communications Statement', mimeo (2008).

LGA, *A Change of Scene. The Challenge of Tourism in Regeneration* (London: Local Government Association/Department for Culture, Media and Sport, 2000).

Lewis, David, *Walks Through History: Liverpool* (London: Breedon Books, rev. edn, 2007).

Liverpool City Council, *Ward profiles. For all Liverpool City Wards*. Ward profile Series, Issue 4, October 2007 http://www.liverpool.gov.uk/Business/Economic_developme nt/Key_statistics_and_data/Ward_profiles/index.asp (accessed 10 July 2008).

Liverpool Culture Company, 'Executive Summary of Liverpool's Bid for European Capital of Culture 2008' (2002), http://www.liverpool08.com/Images/tcm21-32519_tcm79-56880_tcm146-122188.pdf (accessed 10 July 2008).

— *Strategic Business Plan 2005–2009* (2005) http://www.liverpool08.com/Images/BisPlan2-sect-1-3_tcm79-48110_tcm146-122184.pdf (accessed 10 July 2008).

Liverpool Daily Post, 'Garden festival development "must go ahead"', 12 January 2008 http://www.liverpooldailypost.co.uk/liverpool-news/regional-news/2008/01/12/garden-festival-development-must-go-ahead-64375-20342255/ (accessed 10 July 2008).

Lorente, Pedro (ed.), *The Role of Museums and the Arts in the Urban Regeneration of Liverpool* (Leicester: University of Leicester Press, Centre For Urban History, 1996).

Lowndes, S., *Social Sculpture: Art, Performance and Music in Glasgow. A social History of Independent Practice, Exhibitions and Events since 1971* (Glasgow: Stopstop publications, 2003).

McMaster, B., *Supporting Excellence in the Arts. From Measurement to Judgement* (London: Department for Culture, Media and Sport, 2008).

McNeill, William, *Plagues and Peoples* (Garden City, NY: Anchor Doubleday, 1976).

Morgan, K.O., 'The general election of 1964: forty years on', *Oxford Dictionary of National Biography* (Oxford: Oxford University Press, 2004); online edition, October 2007, http://www.oxforddnb.com/view/theme/92794 (accessed 17 April 2008).

Morris, Edward, *Public Art Collections in North-West England: A History and Guide* (Liverpool: Liverpool University Press, 2001).

Morris Hargreaves MacIntyre, *The Feasibility of a National Art Purchase Plan* (MHM, 2003).

— *A Literature Review of the Social, Economic and Environmental Impact of Architecture and Design* (Edinburgh: Scottish Executive, 2006).

— *Taste Buds. How to cultivate the art market* (London: Arts Council England, 2004).

Murray, Nicholas, *So Spirited a Town: Visions and Versions of Liverpool* (Liverpool: Liverpool University Press, 2008).

NAO, *Department of the Environment: Urban Development Corporations* (London: HMSO, 1988).

NWDA, 'Liverpool's £10 million cultural centre set to open', press release, 1 January 2003, http://www.nwda.co.uk/news—events/press-releases/200301/liverpools-£10-million-cultur.aspx (accessed 17 April 2008).

O'Connor, Freddy, *Liverpool – Our City – Our Heritage* (Liverpool: Bluecoat Press, 1994).

ODPM, *State of the English Cities*. Urban Research Summary 21 (London: Office of the Deputy Prime Minister, 2006).

Ohmae, Kenichi, *The Borderless World: Power and Strategy in the Interlinked Economy* (New York: Collins, rev. edn, 1999).

Parkinson, Michael, *Delivering an Urban Renaissance; progress and prospects for England*. Commissioned by the Dutch Presidency Review of Urban Policies in the European Union (2004), http://www.ljmu.ac.uk/EIUA/EIUA_Docs/Delivering_An_Urban_Renaissance.pdf (accessed 8 December 2008)

— *Make No Little Plans. The regeneration of Liverpool city centre 1999–2008* (Liverpool: Liverpool Vision, 2008).

— 'The Quality of Mersey', *The Observer Comment*, 19 January 1997, http://www.ljmu.ac.uk/EIUA/EIUA_Docs/The_Quality_of_Mersey.pdf (accessed 10 July 2008).

Parkinson, M., M. Hutchins, J. Simmie. G. Clark and H. Verdonk, *Competitive European Cities: Where do the Core Cities Stand?* (London: Office of the Deputy Prime Minister, 2004).

Pollock, Griselda, 'Art, Art School, Culture: Individualism after the death of the artist', *Block* 11(6) (1985), pp. 8–18.

Prevista Ltd, 'The Impact of Contemporary Visual Arts in the Public Realm', unpublished document prepared for ACE, 2005.

Ridge, M., D. O'Flaherty, A. Caldwell-Nichols, R. Bradley and C. Howell, for Frontier Economics, *A framework for evaluating cultural policy investment* (2007), http://www.culture.gov.uk/images/research/Aframeworkforev aluatingculturalpolicyinvestmentmainreport.pdf (accessed 11 July 2008).

Rosenberg, Harold, 'Educating Artists', in Gregory Battock (ed.), *New Ideas in Art Education* (New York: E.P. Dutton, 1973), pp. 91–102.

Rowson, B., *Final Live Art Consultancy Report* (Newcastle: Arts Council England North East, 2006).

Russell, H. (2001), 'A lot to do but a lot to do it with'. Parliamentary Brief, July 2001, http://www.ljmu.ac.uk/EIUA/67773.htm (accessed 11 July 2008).

Sassen, Saskia, 'Cities as Frontier Zones: Making Informal Politics', *16beaver*, 13 September 2007 (New York).

— *Cities in a Global Economy* (Thousand Oaks, CA: Pine Forge, 2nd edn, 2000).

Selwood, S., *The Benefits of Public Art. The polemics of permanent art in public places* (London: Policy Studies Institute, 1995).

— 'Towards developing a strategy for contemporary visual arts collections in the English regions', unpublished paper for ACE (forthcoming).

Selwood, S., S. Clive and D. Irving, *Cabinets of Curiosity? Art Gallery Education* (London: Arts Council of England and Calouste Gulbenkian Foundation, 1994).

Sharples, Joseph, *Liverpool* (Pevsner Architectural Guides: City Guides) (London and New Haven: Yale University Press, 2004).

Stiglitz, Joseph, *Globalization and its Discontents* (London: Penguin, 2002).

Tate Liverpool, *Economic Impact Study of the Turner Prize 2007* (Liverpool: Tate Liverpool, 2008).

Theokas, A.C., *Grounds for review: the garden festival in urban planning and design.* (Liverpool: Liverpool University Press, 2004).

Travers, T., J. Wakefield and S. Glaister for London School of Economics, *National Museums Liverpool. Its Impact on Liverpool and the North West* (2005), http://www.liverpoolmuseums.org.uk/about/corporate/documents/EconomicImpactAug05.pdf (accessed 11 July 2008).

Ugwu, Catherine (ed.), *Let's Get It On: The Politics of Black Performance* (London: ICA and Seattle: Bay Press, 1995).

van Helmond, Marij and Donna Palmer (eds), *Staying Power: Black Presence in Liverpool* (Liverpool: National Museums & Galleries on Merseyside, 1991).

Walker, John A., '1980: Performers jailed for wearing "rude" costumes', in John A.Walker, *Art & Outrage: Provocation, Controversy and the Visual Arts* (London and Sterling, VA: Pluto Press, 1999).

Willett, John, *Art in a City* (Liverpool: Liverpool University Press and the Bluecoat, new edn, 2007 [1967]).

Williams, Raymond, *Marxism and Literature* (Oxford, Oxford University Press, 1977).

Wolff, Janet and John Steed (eds), *The Culture of Capital: Art, Power and the Nineteenth-Century Middle Class* (Manchester: Manchester University Press, 1988).

Working with Modern British Art: A Practical Guide for Teachers (Liverpool: Tate Liverpool, 2000).

Yudicé, George, *The Expediency of Culture: Uses of Culture in the Global Era* (Durham, NC: Duke University Press, 2003).

www.culture.gov.uk/global/press_notices/archive 2004/dcms169_2004.htm

http://www.afoundation.org.uk

http://www.artinliverpool.com

http://www.cerihand.co.uk

http://www.independentsbiennial.org

http://www.liverpoolmuseums.org.uk

http://www.tate.org.uk/liverpool

http://www.liv.ac.uk/artgall

http://www.biennial.com

http://ljmu.ac.uk/artanddesign

http://www.la-art.co.uk/laamain.php

http://www.fact.co.uk

http://www.openeye.org.uk

http://www.static-ops.org/profile.htm

http://www.theblackie.org.uk/blackieinfo.htm

http://www.thebluecoat.org.uk

http://www.viewtwogallery.co.uk

http://www.liv.ac.uk/vgm/

http://www.arena.uk.com/

http://www.redwireredwire.com/

Index.

Acknowledgements.

The editors would like to thank the following for their help in making this book possible:

All the authors for their perceptive and illuminating essays; all ... itation with their views ... nd the artists ... ing images.

... he a foundation, the ... John Brady, FACT, ... tute for Dissent at Home, ... es University Archive, ... pool, Tate Liverpool ... mission to reproduce ... onfirm photographers ... whose authorship we

... Bloxsidge, Anthony Cond ... Press; Michael March for ... early encouragement to ... book; and to Liverpool